50 AMERICAN ARTISTS
YOU SHOULD KNOW

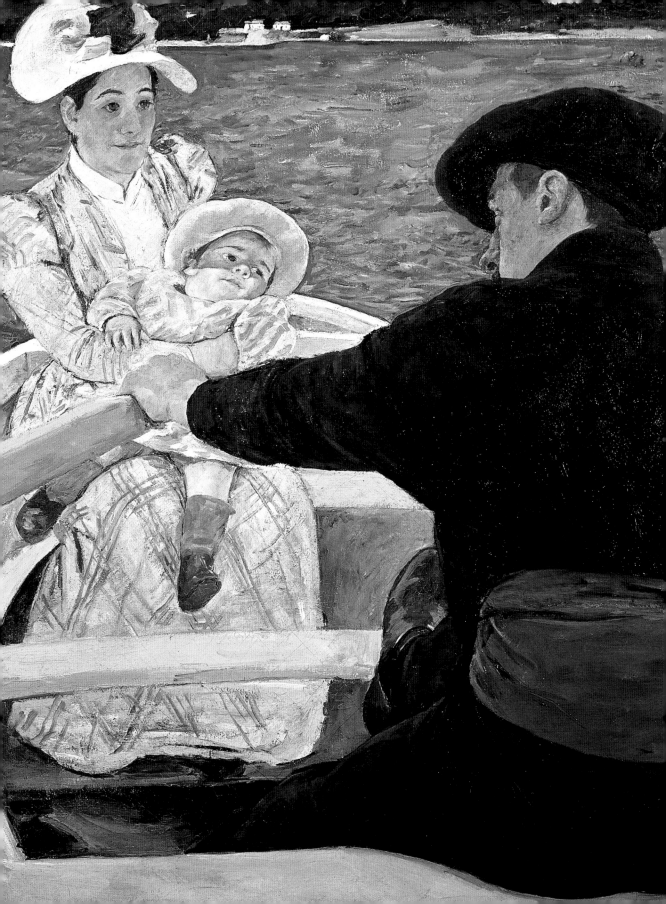

50 AMERICAN ARTISTS
YOU SHOULD KNOW

Debra N. Mancoff

Prestel

Munich · Berlin · London · New York

Front cover from top to bottom:
Mary Cassatt, *The Child's Bath*, see page 50
Jasper Johns, *Flag*, see page 124
Winslow Homer, *Snap the Whip*, see page 42
Jackson Pollock, *Autumn Rhythm No. 30*, see page 106

Frontispiece: Mary Cassatt, *The Boating Party* (detail), c. 1893/94, oil on canvas, 90 x 117 cm, The National Gallery of Art, Washington

Prestel, a member of Verlagsgruppe Random House GmbH

Prestel Verlag
Königinstrasse 9
80539 Munich
Tel. +49 (0)89 24 29 08-300
Fax +49 (0)89 24 29 08-335
www.prestel.de

Prestel Publishing Ltd.
4 Bloomsbury Place
London WC1A 2QA
Tel. +44 (0)20 7323-5004
Fax +44 (0)20 7636-8004

Prestel Publishing
900 Broadway, Suite 603
New York, NY 10003
Tel. +1 (212) 995-2720
Fax +1 (212) 995-2733
www.prestel.com

The Library of Congress Control Number: 2009943148

British Library Cataloguing-in-Publication Data: a catalogue record for this book is available from the British Library; Deutsche Nationalbibliothek holds a record of this publication in the Deutsche Nationalbibliografie; detailed bibliographical data can be found under: http://dnb.d-nb.de

Project management by Claudia Stäuble and Andrea Weißenbach
Copy edited by Laura Hensley, Chicago
Timeline by Larissa Spicker
Timeline translated from the German by Paul Aston, Rome
Cover and design by LIQUID, Agentur für Gestaltung, Augsburg
Layout and production by zwischenschritt, Rainald Schwarz, Munich
Origination by ReproLine Mediateam
Printed and bound by Druckerei Uhl GmbH & Co. KG, Radolfzell

Verlagsgruppe Random House FSC-DEU-0100
The FSC-certified *Opuspraximatt* paper in this book
is produced by Condat and delivered by Deutsche Papier.

Printed in Germany

ISBN 978-3-7913-4411-9

CONTENTS

INTRODUCTION

Fifty states, more than two centuries of national history, and a population as diverse as its terrain: How can only fifty artists represent the grand pageant of American art? From its founding as a nation, the United States has positioned individualism at the core of American identity. How, then, can a single voice speak for all?

Poet Walt Whitman celebrated the ideal of individual expression in the opening lines of his poem "One's-Self I Sing," part of the great volume of poetry *Leaves of Grass* (1855; 1867): "One's-self I sing—a simple, separate Person; / Yet utter the word Democratic, the word *En-masse*." Whitman saw the strength and beauty in the polyphonic chorus of the American experience. He asserted that it was possible to keep a distinct sense of self while also feeling at one with the nation as a whole. Each voice makes its unique contribution to the complexity that constitutes the idea of being American. With that in mind, the fifty artists you will encounter in the pages that follow were selected to present fifty views of art from an American perspective.

The primacy of individualism in the iconic American character has made it difficult—if not impossible—to narrowly define what is American about an artist's perspective. British-born landscape painter Thomas Cole struggled with that issue in his 1836 treatise "Essay on American Scenery." He praised the natural features of the terrain of his adopted homeland as sublime and varied; he felt that the land itself provided a painter with a lifetime of inspiration. The mountain vistas and scenic rivers were as picturesque as any found in Europe, while the untrammeled wilderness and the glorious colors of the forests in autumn, as well as the spectacle of Niagara Falls, were unmatched in their magnificence by any natural feature known on the continent. Cole allowed that some critics discerned "a grand defect in American scenery—the want of associations, such as arise amid the scenes of the old world." To the European eye, the primal landscape, with its absence of artifacts and relics, lacked the human history needed to give it substance and significance. But Cole noted a crucial difference between the European and American outlook: "American associations are not so much of the past as of the present and the future." He believed that the American artist drew power from observing the state of his surroundings, and imagination from the prospect that lay just beyond the horizon.

Long before European settlers came to the region they called the New World, the native peoples of the North American continent had rich, venerable, and varied art traditions. But, along with language, beliefs, and concepts of community structure and government, the settlers brought their own ideas about the arts and a definition of the artist's profession, all of which would shape American art history. The first colonial artists employed their skills to record the sights, curiosities, and natural wonders of their surroundings, bearing witness to what they discovered in documentary paintings and drawings that were created for a European audience. But as the settlers built their homesteads and developed their colonies, they wanted their own image to be preserved for posterity. As a practice,

portrait painting was a transplanted European tradition, and it thrived in the British colonies that became the thirteen original states. In the decades before the formation of the union, and for nearly a half century after, portraiture was the dominant subject in painting. This paralleled the situation in England, and even the American term "limner" was a British import kept current well after the ties to the colonial power were severed. Portraits were painted for the future, so that new generations would remember their ancestors, but a portrait painted also placed the sitter—as well as his or her accomplishments and status—in the present moment. Over the years—from the work of John Singleton Copley to that of Alice Neel and Chuck Close—portrait painting has shed its European associations to become a fully American vernacular.

Other factors kept American artists linked to European art traditions. Art training was scarce in the colonies; more practical concerns superseded the need for art academies. Throughout the eighteenth century and well into the nineteenth, ambitious artists such as Copley traveled across the Atlantic to complete their educations and launch their careers. In 1805 Charles Willson Peale co-founded the Pennsylvania Academy of the Fine Arts in Philadelphia, the first American arts institution to combine a school and a museum. Others followed this model, such as the National Academy of Design in 1825, the Chicago Academy of Design in 1866 (now the Art Institute of Chicago), and the Detroit Institute of Arts in 1885. But, in general, options remained limited, and American artists continued to seek study abroad, especially among the post–Civil War generation. Male artists enrolled in prestigious schools like the École des Beaux Arts in Paris, while female artists, barred from most official art schools, sought training with private tutors. Aspiring artists also made a grand tour of the art capitals of Europe—London, Paris, Rome—to study the masterworks of European art history. And many artists simply pursued their careers abroad, enjoying European fame while maintaining an American identity. James McNeill Whistler left the United States as a young man and never returned; John Singer Sargent spent nearly all his life in Europe. Others, such as Mary Cassatt and Henry Ossawa Tanner, found better professional opportunities abroad than at home. In 1893 novelist Henry James observed: "When today we look for 'American Art' we find it mainly in Paris."

But at the same time, there were increasing reasons for American artists to work at home. Cole's advocacy of American "scenery" redefined landscape painting as a national expression that was distinct from European precedent. It was the subject for the present and the future, ripe for interpretation, and artists heeded the call. Frederic Edwin Church painted heroic landscapes; George Inness saw nature as an allegory of the spiritual experience. Other artists sought a distinctive identity in subjects of American life. Eastman Johnson, Winslow Homer, and Thomas Eakins built a repertoire of narrative imagery that was anchored firmly in the present and in American soil.

Artists still traveled abroad, but in the last quarter of the nineteenth century, American cities—notably Philadelphia and New York City—became vital art centers focused on the future, in contrast to European capitals that were associated with traditions of the past. In 1875 a group of artists founded the Art Students League in New York City and democratized opportunities in the arts by offering reasonably priced classes as well as opportunities for women. By the turn of the century, artists such as John Sloan, who had worked in commercial illustration, turned to urban life for subjects that were deemed vital, current, and indisputably American. With Sloan, as well as with artists of a new generation such as Edward Hopper, the American scene replaced American scenery.

In the early decades of the twentieth century, American artists continued to welcome European ideas, but increasingly did so on their own terms and in their own venues. In 1908 photographer Alfred Stieglitz opened the "291" gallery in New York City, where he showcased European Modernism. But his purpose went beyond introducing the work of artists such as Rodin, Cézanne, and Matisse to a new audience; Stieglitz's gallery became a wellspring of American Modernism, cultivating the bold experiments of artists such as Marsden Hartley and Georgia O'Keeffe. The 1913 International Exhibition of Modern Art, known as the Armory Show for its location in the 69th Regiment Armory Building in New York City, placed cutting-edge works by Picasso and Duchamp before the American public. Hailed by some critics and panned by others, the Armory Show became a departure point for American Modernists to take these new ideas in their own direction. In 1931 Julien Levy featured European Surrealism in his new gallery; in the ensuing decade his gallery became a gathering spot for expatriate intellectuals, as well as an inspiration for artists such as Dorothea Tanning and Joseph Cornell.

In the 1920s grass-roots movements gained strength. New York's Harlem neighborhood became the setting for the Harlem Renaissance, a groundswell of creativity in art, poetry, dance, and music, all from an African American perspective. During the Great Depression of the 1930s, the arts were recruited to boost morale and move the nation out of the bleak hardship of the present toward a brighter future. The Regionalist movement, promoted by artists such as Grant Wood and Thomas Hart Benton, summoned an iconic and timeless vision of the hardworking American heartland, rallying the populace around shared history and values. As part of Franklin Delano Roosevelt's "New Deal," the Works Progress Administration's Federal Art Project (1935–1943) hired artists to decorate the walls of public buildings with murals that featured American motifs, and a surprising range of young artists—including Paul Cadmus, Alice Neel, Jackson Pollock, and Mark Rothko—took part. But over the course of the decade, as the American economic crisis abated and the threat of war built in Europe, displaced artists sought refuge in the United States, and the American art world once again embraced and assimilated European ideas.

Within a few years after World War II, a small circle of painters based in New York City—Pollock, Willem de Kooning, Rothko—redefined modern art. According to critic Harold Rosenberg, "the big moment came" when these artists decided "just to PAINT." Abstract Expressionism emphasized the gesture of painting; no longer rooted in an image, art became the result of action. In scale, daring, and expressive power, the work of these artists was lauded as monumental and distinctly American by the international art world.

In the decades that followed, modern art became an American enterprise, and the possibility of artistic expression expanded with each new innovation. Minimalists, such as Frank Stella and Richard Serra, stripped their work of any content extraneous to the material and the process. Jasper Johns and Robert Rauschenberg reintroduced the object, but drained it of its meaning. Pop artists, including Claus Oldenburg and Andy Warhol, erased the line between art and consumer culture. Louise Bourgeois and Nancy Spero asserted the female perspective. And younger artists have transformed media and materials. Cindy Sherman uses photographs to document characters that she creates with costumes and cosmetics. Jean-Michel Basquiat brought the subversive art of the streets into the galleries. Kara Walker has revived an old art form and revised old tales to unmask the racism of the present, as well as that of the past.

Jackson Pollock once characterized art as an act of "self-discovery," positioning the experience of the individual—not the work—at the center of artistic endeavor. And American artists have used their work to define and redefine identities, to recast history, and to bear witness to life in a society of individuals, each with his or her own distinct set of ideas—recalling the sentiment of Whitman's "simple, separate Person" whose creed is declared "En-masse." There can be no singular American perspective, and this is understood by the artist who draws upon his or her own experience and imagination to contribute to what is, in its essence, a multivalent vision. In thinking about the life of an artist in his adopted homeland, Dutch-born de Kooning mused: "An American artist must feel like a baseball player or something—a member of a team writing American history." In the pages that follow, here are fifty distinct versions of that history, each representing a unique—and uniquely American—point of view.

1620 The Pilgrim Fathers leave England
for America in the *Mayflower*

1643 Louis XIV becomes
King of France and
rules for 72 years

1656 Diego Velázquez paints
Las Meninas

1636 Harvard is founded in Cambridge, Massachusetts,
as the first American university

1666 Antonio Stradivari constructs
his first violin

1620	1625	1630	1635	1640	1645	1650	1655	1660	1665	1670	1675	1680	1685	1690	1695	1700	1705

Founding of Yale University in
New Haven, Connecticut

1716 Prussian King Frederick William I presents the
Amber Room to Russian Tsar Peter the Great

1752 Benjamin Franklin invents the
lightning conductor

1769 James Watt invents a steam engine
with a separate condenser

1787 U.S. Constitution
adopted

| 1710 | 1715 | 1720 | 1725 | 1730 | 1735 | 1740 | 1745 | 1750 | 1755 | 1760 | 1765 | 1770 | 1775 | 1780 | 1785 | 1790 | 1795 |

COLONIAL LIMNERS

Portrait painters working in the prosperous, English maritime colonies offered their clients more than a simple likeness. A skillful "face painter"—or limner—bore witness to a sitter's social rank, wealth, and identity. Often itinerant, self-taught, and anonymous, limners deployed longstanding art traditions to craft an image of a new society.

In sixteenth-century England, the term *limner* (from the Latin *illuminare*, "to paint") designated a painter of portrait miniatures who captured a sitter's likeness in what Nicholas Hilliard (c. 1547–1619), court limner to Queen Elizabeth I, called the "truth of the line." More than a century later, in the English colonies across the Atlantic, the term referred to any portrait painter, but artistic conventions—featuring a flat, decorative surface, an absence of shadows, and an expressive line—linked the practice to its origins. Limners, self-taught or apprentice-trained, perpetuated these transplanted techniques for generations.

Works of art were an impractical luxury during the early settlement years in North America, but by the later decades of the seventeenth century, farming and trade brought prosperity to mercantile centers such as Boston and New York City. Along with fine homes and imported furniture, newly affluent colonists commissioned portraits of themselves and their families. Unlike any other painted subject, a portrait proclaimed identity and social position. The upright pose demonstrated the sitter's sense of purpose and decorum, and the fine details of costume, such as the imported Spanish lace and English brocade worn by Mrs. Elizabeth Freake (c. 1674) in a portrait by an anonymous limner, boasted of substance and wealth. But most portraits were only displayed in private homes and intended to chart the life of the family for the living members as well as for posterity—similar to the practice of noting events in a family's Bible. Married couples sat for paired portraits, and children posed with their mothers or on their own.

Not all colonial limners were anonymous, and some of their work reveals more recent European influence. The self-portrait (c. 1691) of Thomas Smith (c. 1650–1691) features a full range of iconographic attributes, including a skull in reference to the transience of human life and a naval battle seen through a window as a reminder of his earlier career

as a mariner. Smith's composition, as well as his use of rounded forms shaded by the modulation of light and shadow, reveals an acquaintance with contemporary continental naturalism, but it is likely that he learned his technique secondhand, by studying engraved reproductions after European paintings. A group of portraits, painted between 1730 and 1745 in the Hudson River Valley region and formerly attributed to the anonymous Gansevoort Limner, are now believed to be the work of Dutch-born Pieter Vanderlyn (1687–1778). His style preserves the strong line and flattened surface of the Elizabethan limner style, but his range of poses and settings suggest knowledge of Baroque portrait conventions.

The limner style endured well into the early national period, particularly among self-taught, peripatetic painters. Ammi Phillips (1788–1865) traveled throughout the rural Northeast, painting severe-yet-telling likenesses such as that of the country doctor Cornelius Allerton (c. 1821), who poses with a medical text on his lap and his favorite horse in the distance. Joshua Johnson (fl. c. 1793–1824) is believed to be the first African American painter to build a named reputation. He was based in Baltimore, where he was registered as a "Free Householder of Colour," and his clientele included prominent middle-class citizens active in the abolitionist movement. William Matthew Prior (1806–1873), who launched his career in Maine and then relocated to Boston, advertised his skill in both a naturalistic style and in the "flat" style, which he offered as a "likeness without shadow or shade for one-quarter the price."

FURTHER READING
Margaretta M. Lovell, *Art in a Season of Revolution: Painters, Artisans, and Patrons in Early America*, Philadelphia 2005
Elisabeth Louise Roark, *Artists of Colonial America*, Westport, CT, 2003

Thomas Smith, *Self-Portrait*, c. 1691, oil on canvas, 62.9 x 60.4 cm, Worcester, Art Museum, Worcester, Massachusetts

1725 Antonio Vivaldi composes
The Four Seasons

1701–1714 War of the Spanish
Succession

1738 Lewis Paul and John Wyatt invent
the spinning machine

1760 George III becomes King of
Great Britain and Ireland

| 1690 | 1695 | 1700 | 1705 | 1710 | 1715 | 1720 | 1725 | 1730 | 1735 | 1740 | 1745 | 1750 | 1755 | 1760 | 1765 | 1770 | 1775 |

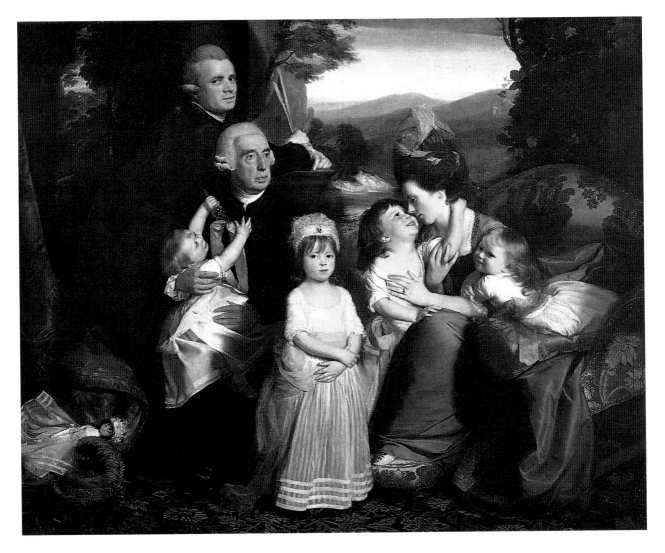

John Singleton Copley, *The Copley Family*,
1776–1777, oil on canvas, 184.1 x 229.2 cm,
National Gallery of Art, Washington, D.C.,
Andrew W. Mellon Fund

Declaration of Independence by the thirteen American colonies

1805 Battle of Trafalgar

1826 Joseph Nicéphore Nièpce takes the first photograph

1789 French Revolution breaks out

1815 Annihilating defeat of Napoleon at Waterloo

1851 First World Fair (the Great Exhibition in London)

| 1780 | 1785 | 1790 | 1795 | 1800 | 1805 | 1810 | 1815 | 1820 | 1825 | 1830 | 1835 | 1840 | 1845 | 1850 | 1855 | 1860 | 1865 |

JOHN SINGLETON COPLEY

On the eve of the American Revolution—and at the height of his acclaim—John Singleton Copley left his Boston home to advance his career in London. He never returned, but his portraits captured the distinct spirit of the emerging American identity and secured his fame as one of the founding fathers of a true American art.

Born into an Irish immigrant family of tobacco merchants, Copley's future was redefined in 1748, when his widowed mother married Peter Pelham, an English-trained artist and schoolmaster. Pelham introduced his stepson to European art theory and practice through critical writings and reproductive prints. Copley learned quickly, launching his career as a limner by the time he turned fifteen. Fueled by talent and ambition, Copley developed a repertoire of poses for his sitters based on European portrait prints and studied anatomy by copying illustrations in medical texts. Meticulous and keenly observant, he required repeated and lengthy sittings for his portraits, but the naturalistic result made his reputation. Upon viewing his portrait of the wealthy Salem merchant Epes Sargent, fellow American painter Gilbert Stuart proclaimed: "Prick that hand and blood will spurt out." A likeness by Copley elevated character over flattery, but he presented the citizens of colonial Boston as people of dignity, accomplishment, and substance.

In 1766 Copley sent a portrait of his stepbrother Henry Pelham to an exhibition in London. It caught the eye of Joshua Reynolds, the premier English society portraitist, whose praise of Copley's "very wonderfull Performance" was tempered with the advice that to fulfill his potential, Copley needed to study in Europe. Copley acknowledged the limited prospects for a painter in the colonies and lamented that his profession brought no more regard "than any other useful trade," even though he enjoyed prosperity and prominence equal to that of his clients. In 1769 Copley married Susanna Clarke, daughter of the head agent of the British East India Company in Boston. In an environment of increasing political friction, Copley's loyalties were divided. He attended a few meetings of the Sons of Liberty, and he painted impressive likenesses of outspoken patriots such as Samuel Adams, John Hancock, and Paul Revere. But his portrait of Loyalist governor Francis Bernard on display in Harvard Hall was

defaced in 1769—the heart cut out—and in 1773 his father-in-law's shipment of tea was tossed into Boston Harbor. Choosing his career over politics, Copley sailed for England in 1774. To make up for his limited art education, he made a tour of Italy, and when he returned to London the following year, his family, including his father-in-law, was already there to greet him.

Copley made his debut at London's Royal Academy with a grand scale "conversation" portrait of his own family, whom he showed engaged in a lively exchange in an idealized garden setting. The work displayed his newly heightened finesse of line and color and won him prestigious clients, but Copley was no longer content to limit himself to portraiture. In 1778 he painted *Watson and the Shark*, a bold foray into history painting that revealed a capacity for expressive drama equal to his keen observation of detail. While Copley excelled in complex pageants drawn from contemporary history, he also continued to paint portraits; near the end of his career he even counted the British royal family among his clientele. Yet his frank, naturalistic style was generally seen as best suited to the American personality. To celebrate John Adams's inauguration as the second President of the United States in 1797, the Copleys sent First Lady Abigail Adams a portrait of her son John Quincy. In it she saw his "true Character," and she praised the expressive vitality that Copley conveyed in "so pleasing a likeness."

1738 Born on July 3 in Boston, Massachusetts
1748 Mother marries artist Peter Pelham
1753 Begins career as an artist
1756 Studies anatomical drawing from books
1764 Opens a studio on Cambridge Street, in Boston
1766 Sends work to London for exhibition
1768 Reputation secures commissions in New York City
1769 Marries Susanna Clarke
1774 Family is threatened for alleged Tory sympathies; Copley leaves for London, then travels to Italy
1775 Family joins him in London
1777 Makes his debut at the Royal Academy of Art, London
1779 Elected a full member of the Royal Academy
1785 Paints portraits of the daughters of King George III
1810 Declines a commission to paint a commemoration of the death of Lord Nelson
1811 Visited by Samuel F. B. Morse, who notes a decline in Copley's health and powers
1815 Dies on September 9 in London of complications after a stroke

FURTHER READING
Emily Ballew Neff, *John Singleton Copley in England*, Houston 1995
Carrie Rebora Barratt, *John Singleton Copley in America*, New York 1995

John Singleton Copley, *Self-Portrait*, 1769, pastel on paper mounted on canvas, 60.3 x 44.5 cm, Winterthur Museum, Delaware

1695 England is the first country to pass
an act abolishing press censorship

1707 Act of Union fuses England and Scotland
as the kingdom of Great Britain

1722 Johann Sebastian Bach composes
his 48 Preludes and Fugues

1744 Auctioneer Sotheby's puts on
its first auction in London

1762 Catherine the Great ousts
her husband to become
Empress of Russia

| 1690 | 1695 | 1700 | 1705 | 1710 | 1715 | 1720 | 1725 | 1730 | 1735 | 1740 | 1745 | 1750 | 1755 | 1760 | 1765 | 1770 | 1775 |

Charles Willson Peale, *The Staircase Group: Raphaelle and Titian Ramsay Peale*, 1795,
oil on canvas, 226.1 x 100.3 cm, Philadelphia Museum of Art

1801 Thomas Jefferson becomes third
President of the United States

1830 Eugène Delacroix paints
Liberty Leading the People

1789 George Washington becomes first
President of the United States

1815 Congress of Vienna
redraws map of Europe

1848 Political upheavals
throughout Europe

1780 1785 1790 1795 1800 1805 1810 1815 1820 1825 1830 1835 1840 1845 1850 1855 1860 1865

CHARLES WILLSON PEALE

Through talent, energy, and boundless curiosity, Charles Willson Peale moved the arts in North America from the private to the public realm. A painter, a naturalist, and a self-taught man of letters, Peale founded the nation's first museum as well as a dynasty of painters who carried his ideas forward for several generations.

A chance glimpse of some poorly painted landscapes prompted Peale, who had trained as a saddler, to try his hand at painting. Aside from a few sessions with portraitist John Hesselius, he learned through experimentation, and in 1765, when he fled Annapolis for Boston to avoid his creditors, he found work in the studio of John Singleton Copley. Thanks to the generosity of a group of Maryland patrons, in 1767 he traveled to London, where he made the acquaintance of prominent artists, including the American history painter Benjamin West. He returned to Annapolis in 1769 with a strong grounding in European art practice as well as a firm commitment to the radical cause of independence. He even discarded the clothes that he purchased in London. In 1772 Peale was the first to paint a portrait of George Washington; he would paint him six more times before the general's death.

In his portraits, Peale built upon Copley's direct honesty to express his belief in the positive force of the new American spirit. He cultivated a natural aesthetic, often portraying his sitters out-of-doors and informally dressed, without conventional wigs and powdered hair. Rather than express their stern composure, his sitters were encouraged to relax and smile, as seen in the portrait of his extended family (1771–1773; 1809), whom he described as a model of "utmost harmony" in their affectionate gestures and companionable industry. By this time the Peale family industry was art: Peale's brothers painted miniatures, and he would train his sons and daughters—eleven surviving children from three marriages—in his chosen profession.

Late in 1775 Peale moved his family to Philadelphia. He wholeheartedly supported revolution, and when war broke out, he painted battle flags, designed posters, and conducted experiments to improve gunpowder and telescopic sights. Peale joined the Philadelphia militia and rose to the rank of captain. Throughout the conflict, he continued to paint, and in 1782 he mounted a portrait exhibition of American revolutionary heroes. In 1786, acting upon his conviction that the pursuit of knowledge was the "first of duties" in a democratic society, he opened the Philadelphia Museum, the first American natural history collection. Peale's displays of natural specimens, curiosities, and rare objects reflected his enlightened perspective: the greatest lessons for humanity were to be found in the comprehension of nature's order. He even raised his family in the building that housed the museum; his children painted the display backdrops and helped with the taxidermy.

Peale stopped seeking portrait commissions after about 1795, but remained fascinated with painterly techniques. He installed his full-length double portrait of his sons Raphaelle and Titian Ramsay on a staircase in his home behind a real stair; the illusion was so credible that President Washington once nodded a greeting to them. When two intact mastodon skeletons were discovered near Newburgh, New York, in 1801, Peale sponsored an expedition to unearth them and then painted a grand historical account of the event. In 1810 he retired to his farm in Belfield, outside Philadelphia, but twelve years later he resumed the management of his museum, releasing his son Rubens to found a similar collection in Baltimore. Active until his death, Peale carved a place for the arts in American society as an egalitarian endeavor that enhanced the public good.

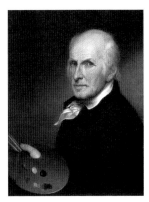

1741 Born on April 15 in Queen Anne's County, Maryland
1754–1761 Apprentices to a saddler in Annapolis, Maryland
1765 Moves to Boston; meets John Singleton Copley
1767–1769 Travels to London; studies with Benjamin West
1769 Returns to Annapolis
1772 Paints his first portrait of George Washington
1775 Moves with his family to Philadelphia
1782 Opens a portrait gallery of the American Revolution in Philadelphia
1786 Founds the Philadelphia Museum, the first American natural history museum
1801 Organizes an expedition to uncover two mastodon skeletons
1805 Co-founds the Pennsylvania Academy of the Fine Arts in Philadelphia
1805 Marries Hannah Moore
1810 Retires to his farm in Belfield, Pennsylvania
1822 Comes out of retirement to manage his Philadelphia Museum
1827 Dies on February 22 in Philadelphia

FURTHER READING
Lillian B. Miller, *The Peale Family: Creation of a Legacy, 1770–1870*, New York 1996
Edgar P. Richardson, Brooke Hindle, and Lillian B. Miller, *Charles Willson Peale and His World*, New York 1983

Charles Willson Peale, *Self-Portrait*, 1822, oil on canvas, 74.9 x 61.6 cm, The Fine Arts Museum of San Francisco

1776–1783 American
Revolution

1803 Doubling of U.S. territory by
the Louisiana Purchase

1754–1763 Seven Years' War

1788 British colonization
of Australia begins

1745	1750	1755	1760	1765	1770	1775	1780	1785	1790	1795	1800	1805	1810	1815	1820	1825	1830

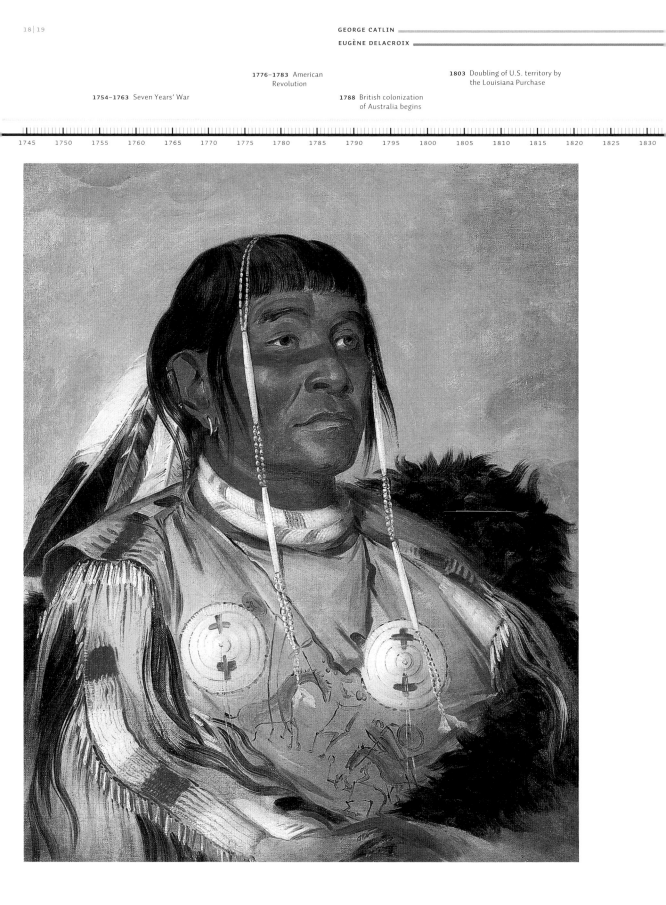

Indian Removal Act is passed

1876 Custer's Last Stand
1871 Charles Darwin publishes *The Origin of Species*

1838–1839 Cherokees
forced to relocate

1866 Civil Rights Act confers U.S.
citizenship on people of all races

1890 End of the Indian Wars

| 1835 | 1840 | 1845 | 1850 | 1855 | 1860 | 1865 | 1870 | 1875 | 1880 | 1885 | 1890 | 1895 | 1900 | 1905 | 1910 | 1915 | 1920 |

GEORGE CATLIN

George Catlin held conflicting views about the fate of the indigenous peoples of North America. He accepted the westward expansion of the United States as progress, but lamented the loss of a "truly lofty and noble race." To this end, he set out on an ambitious project: to make a pictorial record of the native peoples of North America.

After leaving a law career in the early 1820s, Catlin painted miniature portraits in Philadelphia for several years before he discovered his singular subject. A delegation of Native Americans from the tribes of the western territories came to the city, and Catlin, impressed with their distinctive costume and decorum, longed to record their appearance for posterity. Like many in his generation—believing in Manifest Destiny—Catlin regretted the loss of native culture as a dire yet inevitable aspect of the advance of "civilization." As an artist, he believed that he could make an invaluable contribution by painting the likenesses, the practices, and the material culture of all the native peoples of North America. In thrall to the romantic myth of the diminishing wilderness, he wanted to portray "a vast country of green fields, where the *men* are all *red*" and create a gallery that paid tribute to a vanishing way of life.

In 1830, after moving to St. Louis, Catlin met William Clark, who, at the turn of the century, had explored the western territories with Meriwether Lewis. Now serving as Superintendent of Indian Affairs for the Missouri Territory, Clark invited Catlin to meet with a tribal delegation at Fort Crawford, in present-day Wisconsin. During a subsequent trip to Fort Leavenworth, in present-day Kansas, Catlin painted twenty-eight portraits. In 1832 he set out on his own, traveling up the Missouri River to document life among the Teton Sioux, the Crow, the Mandan, and others. He moved swiftly, but kept a thorough record: he annotated his vibrant images with the names of sitters, their tribal affiliations, and explanations of their costumes, status, and traditions. He returned with more than 175 images, including landscapes and scenes of daily life. He made three more journeys: he joined a U.S. Army "friendship" expedition to the lands of the Comanche and Wichita in 1834; a steamboat up the Mississippi to Fort Snelling (in present-day Minneapolis–St. Paul, Minnesota) and the northern

territories in 1835; and a circuit of the Great Lakes in 1836. In 1837 he debuted his "Indian Gallery" in New York City, featuring nearly five hundred images of the likenesses and life of people he described as "the finest models in Nature."

Catlin also gave lectures to educate the public—but also to promote his gallery, which he hoped to sell to the government. When he failed to get an offer, he took his collection on tour, arriving in London in 1840 with more than three hundred portraits; nearly two hundred landscapes and cultural vignettes; a Crow lodge and other material goods; and two grizzly bears, which he soon had to sell to the London Zoo. When ticket sales began to flag, Catlin brought in Ojibwe and Iowa people to appear as "living exhibits." He published the first of his five books in 1841 and continued to give lectures, but by the end of the decade, he had yet to find a patron. In 1852 he declared bankruptcy. Over the following years, making his home in Belgium, he traveled to Central and South America, as well as the Pacific Coast, looking for a location to open a "Museum of Mankind." He returned to the United States in 1871 for an exhibition at the Smithsonian Institution but again failed to sell his collection. Catlin died feeling that he had not fulfilled his ambition, but his paintings preserve an unparalleled image of Native American life, as rich in dignity as in information and scope.

1796 Born on July 26 in Wilkes-Barre, Pennsylvania
1830 Joins General William Clark on a Mississippi journey to Fort Crawford (in present-day Wisconsin)
1832 Takes a three-month voyage up the Missouri River
1834 Travels with a U.S. Army regiment through Comanche and Wichita territory
1835 Journeys north to Fort Snelling (in present-day Minneapolis–St. Paul, Minnesota)
1836 Travels around the Great Lakes
1837 Exhibits his "Indian Gallery" in New York City
1840 Begins a tour of his "Indian Gallery" in London
1841 Publishes *Letters and Notes on the Manners, Customs, and Condition of the North American Indians*
1852 Goes bankrupt
1852–1857 Travels throughout South America
1857 Publishes *Life Amongst the Indians*
1872 Dies on December 23 in Jersey City, New Jersey
1879 Smithsonian Institution receives the contents of the "Indian Gallery" as a gift

left side
George Catlin, *Sha-Có-Pay, The Six, Chief of the Plains Ojibwa*, 1832, oil on canvas, 73.7 × 61 cm, Smithsonian American Art Museum, Washington, D.C., gift of Mrs. Joseph Harrison, Jr.

above
Unknown Photographer, George Catlin, 1870, Virginia Museum of Fine Arts, Richmond, The Paul Mellon Collection

FURTHER READING
George Gurney and Therese Thau Heyman (eds.), *George Catlin and His Indian Gallery*, Washington, DC, 2002
William H. Truettner, *The Natural Man Observed: A Study of Catlin's Indian Gallery*, Washington, DC, 1979

below
George Catlin, *Hidatsa Village, Earth-Covered Lodges on the Knife River*, 1832, oil on canvas, 28.6 x 36.8 cm, Smithsonian American Art Museum, Washington, D.C., gift of Mrs. Joseph Harrison, Jr.

right side
George Catlin, *Wi-Jún-Jon, Pigeon's Egg Head (The Light, Going to and Returning from Washington)*, 1837–1839, oil on canvas, 73.7 x 61 cm, Smithsonian American Art Museum, Washington, D.C., gift of Mrs. Joseph Harrison, Jr.

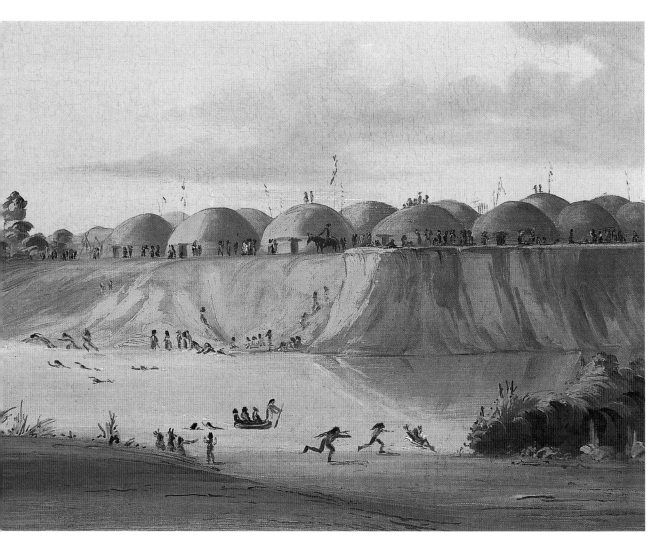

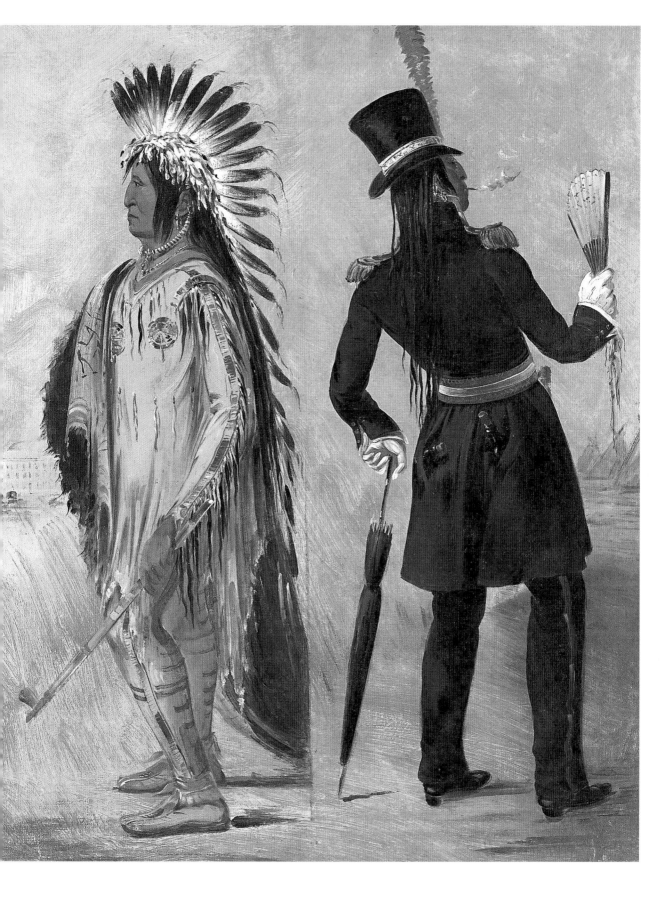

1771 Arkwright establishes
the first cotton mill

1766 Auctioneer Christie's holds
its first sale in London

1784 Jacques-Louis David paints
The Oath of the Horatians

1804 Napoleon has himself crowned
French Emperor

1825 Bolshoi Theater opens
in Moscow

| 1750 | 1755 | 1760 | 1765 | 1770 | 1775 | 1780 | 1785 | 1790 | 1795 | 1800 | 1805 | 1810 | 1815 | 1820 | 1825 | 1830 | 1835 |

Thomas Cole, *Lake with Dead Trees (Catskill)*,
1825, oil on canvas, 68.6 x 86.4 cm,
Allen Memorial Art Museum, Oberlin College,
Oberlin, Ohio, gift of Charles F. Olney

right side
above
Thomas Cole, *Self-Portrait*, c. 1836,
oil on canvas, 55.9 x 45.8 cm, The New
York Historical Society

below
Thomas Cole, *The Course of the Empire:
Destruction*, 1836, oil on canvas, 84.5 x 160.6 cm,
The New York Historical Society

1844 J. M. W. Turner paints *Rain, Steam and Speed: Great Western Railway*

1851 First issue of *The New York Times*

1869 Completion of the first transcontinental railway in the United States

1883–1885 Construction of the first skyscraper in Chicago

1893 Dvořák's Symphony No. 9 (*New World*) premieres

| 1840 | 1845 | 1850 | 1855 | 1860 | 1865 | 1870 | 1875 | 1880 | 1885 | 1890 | 1895 | 1900 | 1905 | 1910 | 1915 | 1920 | 1925 |

THOMAS COLE

Thomas Cole discovered unbounded pictorial potential in the rugged terrain of the Hudson River Valley. He revered its primal beauty and declared that "all nature here is new to Art." But he sought to paint more than a novel vista: Cole saw the wilderness as the moral arena in which nature and culture struggled for dominion.

Cole spent his boyhood in the industrialized Midlands in England, where he was apprenticed to an engraver in a calico factory. He immigrated with his family to the United States in 1820; they settled in Steubenville, Ohio, where he gave art lessons. He claimed to have learned oil painting there from an itinerant painter, and by the time he moved to Philadelphia in 1824, he had mastered the medium. In 1825 he moved to New York City, where an exhibition of his innovative landscape paintings drew wide acclaim. He quickly acquired several wealthy patrons who sponsored his sketching tours in the Hudson River Valley, as well as the admiration of established painters such as John Trumbull and Asher B. Durand, who purchased his works.

The magnificent views of the mountains and waterfalls along the Hudson motivated Cole to transcend the topographical format of traditional American landscape. Through his reading, Cole was well-versed in British landscape theory. Utilizing these ideas, he emphasized the sublime aspect of the terrain's jagged cliffs, dense forests, and glorious autumnal foliage as an embodiment of raw natural power, unspoiled by cultural intrusion. This was the wilderness, the powerful symbol of America, seen from a European perspective as a new Eden: primitive yet endowed with the bounty of providence. In his paintings of Kaaterskill Falls and the cliffs above the Hudson River, Cole created a pictorial analogue to the wilderness portrayed by American authors William Cullen Bryant and James Fenimore Cooper; Cooper's *Leatherstocking Tales* inspired Cole to include the "last Mohicans" in several works. And like these authors' vision of the wilderness, Cole's was elegiac, a Romantic evocation of the endangered natural world, sacrificed to the "ravages of the axe" on "the road society has to travel." He expressed his moral allegory through the elements of natural spectacle—seasonal change, storm-blasted trees, oncoming storms—in a tribute to the vitality of nature.

Cole made the first of two trips to Europe in 1829. He returned to the United States with an expanded vision of the moral possibilities of landscape painting, and his vast panoramic prospects provided the setting for meditations on transience and decay. In the cycle *The Course of Empire* (1835–1836), Cole anchors each of five compositions with the craggy profile of a mountain in the distance. The human imprint on the land changes, a grand society rises and falls, and after, nature reclaims the land in all the grandeur of its primal power. By this time Cole mistrusted the commercial growth and territorial expansion of his adopted nation. In essays and lectures, as well as poetry, he wrote of the dire future of a land made "destitute" in the name of progress. By the middle of the 1830s, he had moved to Catskill, New York, to live in the region that fueled his imagination. During the next decade, he took on a select number of students; the first was Frederic Edwin Church.

Cole died young, but his influence drew artists to the region. Although the new painters of the Hudson River School tempered Cole's moral message, they perpetuated his reverential appreciation for the sublime beauty of the natural landscape. The next generation seeking to portray the primal American landscape would also be stirred by Cole's interpretations, but they would be compelled to turn westward to seek the surviving wilderness.

1801 Born on February 1 in Bolton-le-Moors, Lancashire, England
1815 Is apprenticed to an engraver
1820 He and his family immigrate to the United States
1820 Teaches painting and drawing in Steubenville, Ohio
1824 Moves to Philadelphia
1825 Moves to New York City; goes on first sketching trip on the Hudson River
1829–1832 Lives in England and Italy
1832 Returns to New York City
1834 Opens a summer studio on the property of Cedar Grove, in Catskill, New York
1836 Marries Maria Bartow, whose family owns Cedar Grove; publishes "Essay on American Scenery"
1841–1842 Takes second trip to Europe
1844 Begins to teach Frederic Edwin Church
1848 Dies on February 11 in Catskill

Further Reading
Earl A. Powell, *Thomas Cole*, New York 1990
William H. Truettner and Alan Wallach (eds.), *Thomas Cole: Landscape into History*, New Haven, CT, 1994
The Thomas Cole National Historic Site can be visited online at: http://www.thomascole.org

Thomas Cole, *The Course of the
Empire: The Consumation of the Empire*,
1835–1836, oil on canvas,
130.2 x 193.51 cm, The New York
Historical Society

1798 Alois Senefelder invents
lithography

1814 Francisco de Goya paints
The Third of May, 1808

1833 Slavery abolished in the
British Empire

1851 Harriet Beecher-
Stowe publishes
Uncle Tom's Cabin

1775 1780 1785 1790 1795 1800 1805 1810 1815 1820 1825 1830 1835 1840 1845 1850 1855 1860

Eastman Johnson, *Negro Life at the South*,
1859, oil on canvas, 91.4 x 114.9 cm,
The New York Historical Society, Robert
L. Stuart Collection

1865 Abolition of slavery in the United States

–**1865** American Civil War

1872 Metropolitan Museum of Art
opens in New York

1898 Spanish–American War

1910 The first film studios
set up in Hollywood

1929 Museum of Modern Art
opens in New York

1865 1870 1875 1880 1885 1890 1895 1900 1905 1910 1915 1920 1925 1930 1935 1940 1945 1950

EASTMAN JOHNSON

Eastman Johnson won early notice for his skillfully rendered portraits of prominent citizens, but he attained enduring acclaim as a genre painter. In subjects ranging from African American life in the antebellum South and rural rituals on Nantucket Island to domestic life in Manhattan, he caught the breadth of the national spirit in a time of turmoil and transition.

After an apprenticeship as a teenager in the Boston lithography shop of John Bufford, Johnson worked his way through his home state of Maine as a crayon limner. In 1845 his father moved the family to Washington, D.C., to take a position in the Department of the Navy. Johnson joined his family, and with his skill at capturing a natural likeness—and possibly his father's connections—he made portraits of notable figures including Henry Wadsworth Longfellow, John Quincy Adams, and Dolly Madison, whom Johnson described as a "pretty frowsy old lady." In 1849 Johnson sought his first formal art training, traveling to Germany to attend classes at the Düsseldorf Akademie. By 1851 he joined Emanuel Leutze's Düsseldorf studio and made a replica of his master's iconic painting, *Washington Crossing the Delaware* (1851). Later that year, Johnson moved on to The Hague, where he spent over three years in close study of seventeenth-century Dutch painting. His command of nuanced light and shadow, particularly in painting portraits, won him the nickname "America's Rembrandt" upon his return to the United States in 1855.

After visiting his siblings in northern Wisconsin, Johnson traveled to Grand Portage, near Lake Superior, to paint among the Anishinabe (Ojibwe) people. He disdained anecdote, seeking instead to capture the people's "noble bearing" and traditions. Johnson earned his first notice for genre painting with *Life in the South* (1859; now often known as *Old Kentucky Home*), a complex ensemble of naturalistic vignettes that was praised by critics as a counterpart to Harriet Beecher Stowe's abolitionist novel *Uncle Tom's Cabin* (1852). By the outbreak of the Civil War, Johnson had settled in New York City; he made three tours with Union troops to make sketches that were published in popular journals. These illustrations deliver expected patriotic melodrama, but the paintings he made of African American life offer a more honest and nuanced portrayal of once-enslaved people taking control of their own destiny.

Throughout the war's duration, he made regular trips to his boyhood home of Fryeburg, Maine, to work on a grand-scale genre painting of the community making maple syrup. Johnson never completed *Sugaring Off*, but more than twenty-five surviving sketches reveal the extent of his ambitions.

At times, Johnson lamented that his large figure compositions tied him to his studio; he longed to "rove around as other painters do." But his marriage in 1869 made him content and prompted a series of domestic scenes that offer a glimpse of his wife at her daily routine. Portraits of wealthy patrons in their fine homes gave him the financial freedom to further explore genre subjects on a grand scale, and in the 1870s, summering on Nantucket, he succeeded in portraying humble rural rituals—cornhusking and cranberry harvesting—as subjects that transcend the sentimentality of anecdotal genre. Johnson concentrated on human action and relationships so that the power of his work came from its visual scope rather than its narrative. He employed veils of transparent color to simulate light effects; his aesthetic approach enhanced his traditional subject with the luminous naturalism associated with contemporary *plein-air* painting. During his later years, his energies were directed back to portraiture—he even painted two presidents—and he continued to paint genre, although on a more modest scale. Whether grand or small in conception, Johnson's genre scenes celebrate values that his generation regarded as essentially American: agrarian roots, hard work, and egalitarian endeavor.

1824 Born on July 29 in Lovell, Maine
1840–1842 Becomes an apprentice to lithographer John Bufford in Boston
1845 Moves to Washington, D.C., where he launches a successful portrait practice
1849 Departs for Europe and enrolls in the Düsseldorf Akademie
1851 Works in the studio of Emanuel Leutze in Düsseldorf
1851–1855 Studies the Dutch masters in The Hague
1855 Returns to the United States
1857 Travels in northern Wisconsin to paint members of the Anishinabe (Ojibwe) tribe
1859 Gains wide acclaim for the exhibition of *Life in the South*
1861–1865 Takes three trips with Union troops to document wartime events
1871 Buys property on Nantucket
1891 Paints a portrait of President Grover Cleveland
1895 Paints a portrait of President Benjamin Harrison
1906 Dies on April 5 in New York City

FURTHER READING
Teresa A. Carbone and Patricia Hills, *Eastman Johnson: Painting America*, New York 1999
Patricia Hills, *Eastman Johnson*, New York 1972

Carte de visite of Eastman Johnson, 1865, Brooklyn Museum of Art Library Collection, Schweitzer Gallery Files

left side
Eastman Johnson, *Woman Reading*,
c. 1874, oil on cardboard, 63.8 x 47.3 cm,
San Diego Museum of Art, gift of the
Inez Grant Parker Foundation

below
Eastman Johnson, *A Ride for Liberty*,
c. 1862, oil on cardboard, 55.9 x 66.7 cm,
Brooklyn Museum of Art, gift of Miss
Gwendolyn O. L. Conkling

1836 Ralph Waldo Emerson
publishes *Nature*

1793 Musée du Louvre
opens in Paris

1807–1808 Caspar David Friedrich
paints the *Tetschen Altar*

C. 1830 Founding of the
Barbizon School

1848 Beginning of the gold
rush in California

| 1775 | 1780 | 1785 | 1790 | 1795 | 1800 | 1805 | 1810 | 1815 | 1820 | 1825 | 1830 | 1835 | 1840 | 1845 | 1850 | 1855 | 1860 |

George Inness, *Niagara*, 1889, oil on canvas,
76.2 x 114.3 cm, Smithsonian American Art
Museum, Washington, D.C., gift of William
T. Evans

right side
Georges Inness, photograph

1869–1883 Construction of Brooklyn
Bridge in New York

1873 Claude Monet paints
Impression, Sunrise

1887–1889 Construction of the
Eiffel Tower in Paris

1903 Brothers Wilbur and Orville
Wright's first powered flight

1929 Wall Street crash on October 25
triggers world financial crisis

| 1865 | 1870 | 1875 | 1880 | 1885 | 1890 | 1895 | 1900 | 1905 | 1910 | 1915 | 1920 | 1925 | 1930 | 1935 | 1940 | 1945 | 1950 |

GEORGE INNESS

Although he came of age in an era that celebrated the epic American landscape, George Inness deliberately chose an intimate point of view. He equated art with theology and sought to portray the enigmatic experience of inner life in the familiar shapes and colors of the natural world.

As an aspiring painter, Inness set out to combine Thomas Cole's "lofty striving" with the more heartfelt sentiments of Asher B. Durand. He quickly embraced the ideas of the Hudson River Valley aesthetic, painting seasonal New England views from a panoramic perspective. But the grandeur of the wilderness held less interest for him; his subjects, more often picturesque than sublime, ㅤressed the harmony that he perceived in the relㅤionship of humanity and nature. Inness's fascination with European painters—known through reproduction—also ran counter to the prevailing belief that the American terrain was exceptional and American landscape artists had nothing to learn from the continental example. In the early 1850s, Inness traveled to Europe and, inspired by the ideas of the Barbizon School, a loose circle of landscape painters who settled on the edge of the Forest of Fontainebleau, he began to sketch in oil in the open air. His close observation lent an air of intimacy to sweeping scenes such as *The Lackawanna Valley* (1855).

A deeply reflective man, Inness viewed nature as a manifestation of the divine. He followed the teachings of the eighteenth-century mystic Emanuel Swedenborg, who discerned a seamless continuity between the realm of cause (divine spirit) and the realm of effect (nature). Everything in the physical world had a spiritual correspondence that gave it life and meaning. It is not known when Inness adopted these beliefs; the first known reference to him as a "disciple" of Swedenborg appears in a July 1867 profile in *Harper's Weekly*. Drawn to the religion as a body of thought rather than a code of ritual and regulation, Inness sought to explain art through Swedenborgian theology and published his ideas in the article "Color and Their Correspondences" in the *New Jerusalem Messenger*, a journal for adherents of the faith. Just as color and shape gave form to the immaterial in nature, the same elements could evoke spiritual ideas in painting. But Inness stressed

that painted imagery did not represent the spirit— rather, it conveyed its meaning through sensation. To Inness, painting itself was a spiritual practice, serving to cultivate the artist's own awareness so that he could "reproduce in other minds the impression which a scene has made upon him."

The general public may not have grasped Inness's intentions; one critic declared that "ordinary people" rarely understood his work. But his exquisitely nuanced aesthetic had an increasing appeal to a new postwar generation that preferred a more intimate view than that afforded by the bombast of epic American landscape. The rising appreciation of French naturalism in the United States also drew favor to Inness, who shared the French Impressionists' concern with the fleeting qualities of light and atmosphere. But Inness disparaged such comparisons. Impressionist work had no spiritual content, and so he regarded it as a "passing fad" and a "sham." Over the years, his convictions deepened, making his late work even more innovative. He relinquished solid form and delineation for freely brushed, luminous color and surface shimmer. He captured the spirit of Niagara Falls in a haze of delicate mist (1889), and he emphasized light over what it illuminated as the motif of his marshland paintings set in Tarpon Springs, Florida (early 1890s). His art—in line with his beliefs—bridged the span between substance and immateriality, giving him the means to express the "subjective sentiment," which he defined as "the poetry of nature," through "objective fact."

1825 Born on May 1 near Newburgh, New York
1841–1843 Works intermittently at map engravers in New York City
1843–1844 Registers for an antique class at the National Academy of Design in New York City
1851–1854 Makes two trips to Europe
1854 Resides in Brooklyn, New York
1860 Settles in Medfield, Massachusetts
1867 Publishes "Color and Their Correspondences" in the *New Jerusalem Messenger*
1868 Is baptized with his wife at the Swedenborgian New Church in Brooklyn, New York
1870–1875 Makes his third trip to Europe
1878 Moves to Montclair, New Jersey; maintains a studio in New York City
1880 Writes poetry
1887 Takes a trip to England
1890 Breaks his right arm, and so learns to paint with his left arm; begins to spend winters in Tarpon Springs, Florida
1891 Takes a trip through the South and Southwest to California
1894 Takes a final trip to Europe; dies on August 3 in Bridge-of-Allan, Scotland

FURTHER READING
Adrienne Baxter Bell, *George Inness and the Visionary Landscape*, New York 2003
Nicolai Cikovsky and Michael Quick, *George Inness*, Los Angeles 1985

George Inness, *Home at Montclair*, 1892,
oil on canvas, 77.17 x 115.27 cm, Sterling
and Francine Clark Art Institute,
Williamstown, Massachusetts

George Inness, *Pines and Olives at Albano (The Monk)*, 1873, oil on canvas, 98.1 x 162.9 cm, Addison Gallery of American Art, Phillips Academy, Andover, Massachusetts

1791 Bill of Rights enacted

1808 Johann Wolfgang Goethe
publishes *Faust, Part One*

1827 Construction of the first
U.S. railway line

1844 Silesian weavers' uprising

1775 1780 1785 1790 1795 1800 1805 1810 1815 1820 1825 1830 1835 1840 1845 1850 1855 1860

Frederic Edwin Church, *The Heart of the
Andes*, 1859, oil on canvas, 168 x 302.9 cm,
The Metropolitan Museum of Art, New York

right side
Frederic Edwin Church, c. 1860, photograph
courtesy New York State Office of Parks,
Recreation and Historic Preservation, Olana
State Historic Site, Hudson, New York

1867 United States buys Alaska from Russia

Abolition of serfdom 1876 Alexander Graham Bell 1892 The Coca-Cola Company 1907 Picasso paints *Les Demoiselles* 1927 Charles Lindbergh flies nonstop
in Russia invents the telephone is founded *d'Avignon* across the Atlantic to Paris

1865 1870 1875 1880 1885 1890 1895 1900 1905 1910 1915 1920 1925 1930 1935 1940 1945 1950

FREDERIC EDWIN CHURCH

Frederic Edwin Church's monumental landscapes fused the detailed observation of a natural scientist with the passionate sensibility of a true Romantic. He traveled the Western Hemisphere to portray the wonder of the New World's natural phenomena, and his technical mastery, as well as his ambition, elevated American landscape painting to its zenith.

In 1844 Church left his home in Hartford, Connecticut, to go to Catskill, New York, and study with Thomas Cole, who advised him to "paint things as you see them." When Cole died in 1848, Church was regarded as his heir in American landscape. But the writings of German natural scientist Alexander von Humboldt compelled Church to seek out nature's phenomena as well as its beauty and to venture beyond the Hudson River Valley. Humboldt's *Cosmos* (1845–1862; translated into English beginning in 1849), based on research gathered during an extensive journey throughout South America, asserted a unified harmony of all life that was bound together by divine providence. A devout man, Church felt a kinship with the scientist's ideas; he rose to Humboldt's challenge to painters to employ landscape painting as a way to see the world.

Success came early. In 1852 Church's expansive vista *New England Scenery* (1851) fetched an unprecedented price. He traveled to sites of natural wonders, such as the towering Mount Katahdin in Maine and the extraordinary span of the Natural Bridge in Virginia, building a repertoire of subjects as Romantic as his style. His grand-scale portrayal of Niagara Falls became a popular sensation in 1857, when it toured the country with the promise: "Niagara, with the roar left out." Ambitious, with a keen knowledge of his audience, Church transformed the exhibition of landscape painting into an adventure.

He made two trips to Ecuador in the 1850s, and during the second he trekked to Mount Chimborazo. Humboldt had extolled the region as a complete microcosm of the world's ecosystem, from low-lying rain forest to the mountain's snow-capped peak. Church made extensive pictorial notes—including oil sketches, as recommended by Humboldt—and when he returned to his studio in New York City, he synthesized his notes and memories into the epic painting *Heart of the Andes* (1859). With the colossal mountain looming in the background, Church portrayed the variety and vitality of life: primal nature with an assertion of the divine in the presence of a human-made cross. Church's imagery reflected Humboldt's theories, but the painting was conceived as a spectacle. Its grand dimensions were enlarged by a massive black-walnut frame that treated the painting as a window into another world. It debuted in a single-painting exhibition— a type known as the "Great Picture"—and the public paid a fee to enter a darkened room in which the picture was spotlit. *Heart of the Andes* went on tour to Great Britain and then though major American cities. Visitors were encouraged to bring binoculars to study its details, and descriptive pamphlets and engraved reproductions were sold to commemorate the experience. Critics hailed the work as a "grand pictorial poem" that transcended Humboldt's account.

Church journeyed to the Arctic Circle (1859) to paint icebergs, and also toured Europe and the Middle East (1867–1869). He became deeply fascinated with lighting effects such as sunsets and rainbows, which he painted as evocations of reverence. But, by the end of the 1860s, the crippling effects of rheumatoid arthritis had hampered his control, and his grand form of Romantic landscape had begun to fall out of favor. Church turned his attention to building a spectacular home on a promontory over the Hudson. The home, called Olana and designed by Calvert Vaux, showcased the treasures he gathered on his travels, but for Church, its beauty was in its setting. He wrote to a friend: "The picture from each window will be marvelous."

1826 Born on May 4 in Hartford, Connecticut
1844–1846 Studies art with Thomas Cole
1847 Establishes a studio and residence in New York City
1852 Earns a record price for *New England Scenery* (1851)
1853 Travels to Columbia and Ecuador
1856 Takes a painting trip to Niagara Falls
1857 Returns to Ecuador
1859 Exhibits *Heart of the Andes* in New York City; travels to Newfoundland and Labrador
1860–1861 *Heart of the Andes* goes on tour throughout the United States and Great Britain
1867–1869 Cole takes an extended journey throughout Europe and the Middle East
1870 Begins to design Olana
1872 Moves with his family into Olana
1883 Begins to spend winters in Mexico to alleviate the pain of rheumatoid arthritis
1900 Dies on April 7 in New York City; a memorial exhibition is held at the Metropolitan Museum of Art
1967 Olana is opened to the public as a State Historic Site

FURTHER READING
Kevin J. Avery, *Treasures from Olana: Landscapes by Frederic Edwin Church*, Hudson, NY, 2005
John K. Howat, *Frederic Church*, New Haven, CT, 2005
The Olana State Historic Site can be visited online at: http://www.olana.org

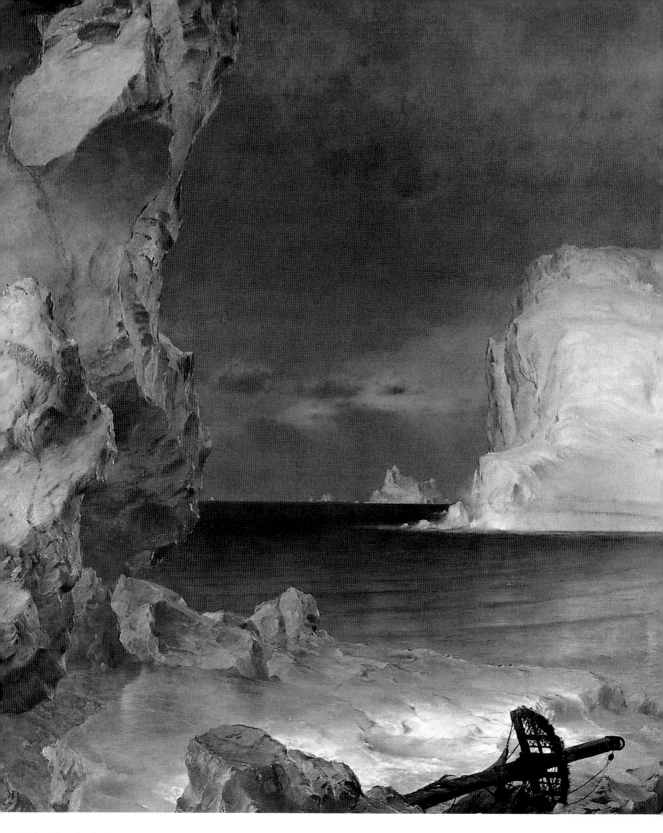

Frederic Edwin Church, *The Icebergs*,
1861, oil on canvas, 163.8 x 285.7 cm,
Dallas Museum of Art

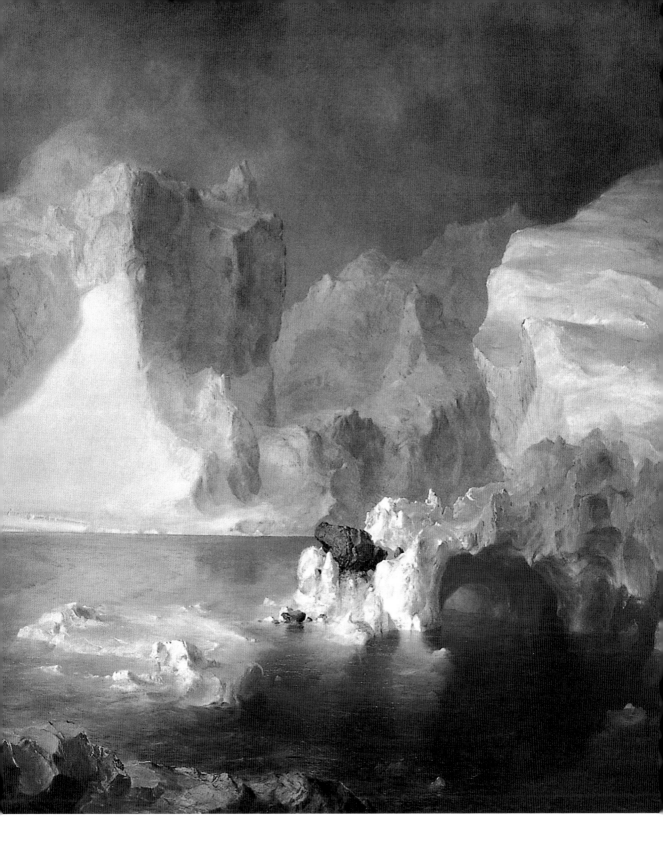

1793 Antonio Canova sculpts
Cupid and Psyche

1806 German Empire (Holy Roman
Empire) finally abolished

1824 Ludwig van Beethoven's
Symphony No. 9 is premiered

1842 China cedes Hong Kong
to Great Britain

1855 Gustave Courbet paints
The Painter's Studio

1785 1790 1795 1800 1805 1810 1815 1820 1825 1830 1835 1840 1845 1850 1855 1860 1865 1870

James McNeill Whistler, *Arrangement in Gray
and Black (Portrait of the Artist's Mother)*,
1871, oil on canvas, 144.3 x 165.2 cm, Musée
du Louvre, Paris

1877 Queen Victoria of Great Britain and Ireland
adopts the title of Empress of India

1907–1908 Gustav Klimt
paints *The Kiss*

1929 First public TV
pictures broadcast

1947 India becomes independent
of Great Britain

1898 Construction of the Secession Building in
Vienna to a design by Joseph Maria Olbrich

1875 1880 1885 1890 1895 1900 1905 1910 1915 1920 1925 1930 1935 1940 1945 1950 1955 1960

JAMES MCNEILL WHISTLER

When John Ruskin accused James McNeill Whistler of "flinging a pot of paint in the public's face," the painter sued the critic for libel. On the witness stand Whistler defended his work as proof that the value of art resided not in the hours spent at the easel, but rather in "the knowledge ... of a lifetime."

Whistler spent part of his boyhood in St. Petersburg, Russia, where his father, a U.S. Army engineer, oversaw the construction of a railroad to Moscow. At seventeen, Whistler entered the U.S. Military Academy at West Point, New York, but he was later discharged for failure to pass exams in science. During a brief appointment with the U.S. Coast and Geodetic Survey, he learned etching, and in 1855 he left for Paris; he would never return to the United States. Whistler trained in the studio of the Swiss painter Charles Gleyre and became known for his independent nature and sharp tongue, as well as his eccentric sense of fashion. He wore white suits, an "American-style" boater, and a monocle, and he groomed his long black hair to display a premature white feather in his forelock. In 1858 he published "The French Set," his first suite of etchings.

In 1859 Whistler moved to London. Yet he maintained strong ties with the French art world, and, as an advocate of "Art for Art's Sake," he asserted that art "should stand alone" as a purely visual expression free of narrative or sentiment. To this end, he gave his paintings musical titles that attributed the pictorial experience to sensation rather than explication: a "symphony" or "harmony" focused upon subtle variation in tone; "nocturnes" evoked the nuanced effects of evening light; "caprices" often featured objects from his own extensive collection of Japanese art; and "arrangements" were often portraits. In painting his mother (1871), Whistler sought only to convey "a certain harmony of color," explaining that the public does not care about the sitter's identity. Whistler believed that art should always aspire to beauty. To complete his vision, he designed frames, furniture, and even garments for his sitters. He decorated his own homes and whenever possible designed the installation of his works in private and public venues. His aesthetic was seamless, blurring the conventional division between painting and interior decoration.

Whistler's unwavering ideals led to conflicts with patrons and critics. Asked to add a few touches of color in the dining room of Frederick Leyland's London townhouse, Whistler coated the imported leather wall hangings with rich blue-green paint, embellished the walls, shutters, and ceilings with peacock and feather motifs in gold, and created a public scandal when his patron balked at paying a high price for work he did not commission. They settled the matter of the "Peacock Room," but in 1877, when Ruskin excoriated Whistler for fixing a high price on his *Nocturne in Black and Gold: The Falling Rocket* (1875), Whistler took legal action. The prosecution questioned the finish of Whistler's work, and Whistler countered that a laborer's work was counted in hours but an artist's in the extent of his vision. Whistler won, but was awarded one farthing, and the court costs drove him into bankruptcy. In the years that followed, he concentrated on smaller, yet equally innovative works—watercolors, pastels, etchings, and lithographs—as well as portraits, and he defended his aesthetic convictions.

Whistler continued to court controversy. He gave lectures and wrote essays that extolled beauty and berated critics. He enjoyed public attention and took the butterfly as his personal emblem, creating a monogram of a fickle creature with a long, stinging tail. But when it came to his work, Whistler never compromised his high aesthetic vision and never allowed his extravagant public persona to compromise his ethics in the studio. He once remarked: "I leave all the gimcracks outside the door."

1834 Born on July 11 in Lowell, Massachusetts
1843 Moves with his family to St. Petersburg, Russia
1851–1854 Attends the U.S. Military Academy at West Point, New York
1855 Moves to Paris
1859 Moves to London
1877 Decorates the "Peacock Room"
1878 Sues Ruskin for libel; begins his first experiments in lithography
1879 Declares bankruptcy; sells his London property and possessions
1880 Departs for Venice
1885 Presents the "Ten O' Clock" lecture in Princes Hall, London
1890 Publishes *The Gentle Art of Making Enemies*
1901 Closes his studio in Paris
1903 Dies on July 17 in London

FURTHER READING
Eric Denker, *In Pursuit of the Butterfly: Portraits of James McNeill Whistler*, Washington, DC, 1995
Richard Dorment and Margaret F. MacDonald, *James McNeill Whistler*, New York 1995

James McNeill Whistler, photograph December 1878, Whistler Collections, University Library, Glasgow

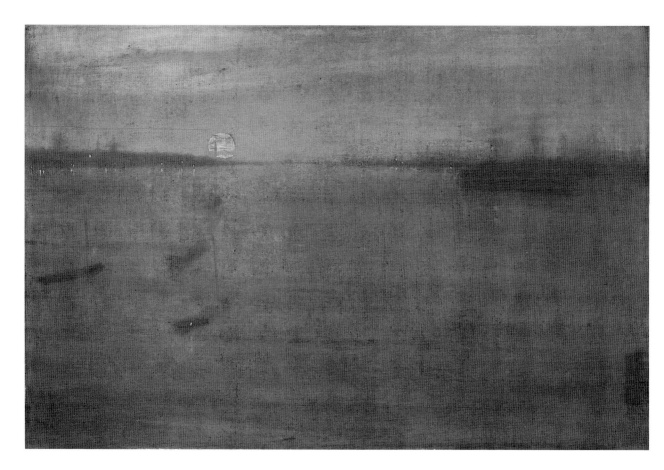

above
James McNeill Whistler, *Nocturne: Blue and Gold–Southhampton Water*, 1872, oil on canvas, 50.5 x 76.3 cm, The Art Institute of Chicago

right side
James McNeill Whistler, *Nocturne in Black and Gold: The Falling Rocket*, 1875, oil on wood, 60.3 x 46.6 cm, The Detroit Institute of Arts, gift of Dexter M. Ferry, Jr.

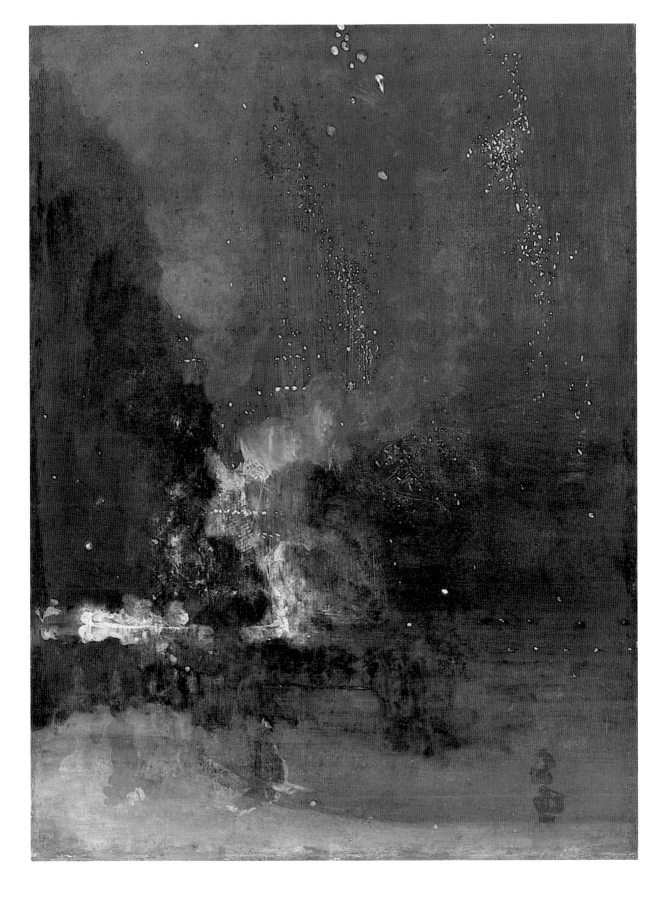

HONORÉ DAUMIER

HENRI ROUSSEAU

1815 Congress of Vienna redraws
map of Europe

1799 Napoleon's troops discover
the Rosetta Stone in Egypt

1823 Proclamation of the isolationist
Monroe Doctrine

1841 Edgar Allan Poe publishes the
Murders in the Rue Morgue

1861–1865 American
Civil War

| 1785 | 1790 | 1795 | 1800 | 1805 | 1810 | 1815 | 1820 | 1825 | 1830 | 1835 | 1840 | 1845 | 1850 | 1855 | 1860 | 1865 | 1870 |

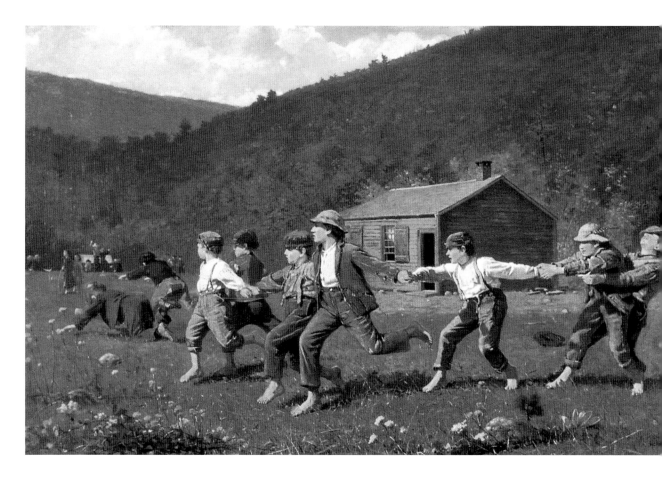

Winslow Homer, *Snap the Whip*, 1872, oil on
canvas, 55.9 x 91.4 cm, The Butler Institute
of American Art, Youngstown, Ohio

1874 First Impressionist exhibition in Paris

1891–1916 Construction of the Transsiberian Railway

1908 First Ford Model T rolls off the conveyor belt in Detroit

1928–1930 Construction of the Chrysler Building in New York to plans by William van Alen

1944 Allies land in Normandy

1875 1880 1885 1890 1895 1900 1905 1910 1915 1920 1925 1930 1935 1940 1945 1950 1955 1960

WINSLOW HOMER

In a rare interview in 1864, Winslow Homer surprised a journalist by taking him to the roof of his studio building to show him where he posed his models in the sunlight, illuminated against the sky. Homer always believed that to paint light—and the natural world—a painter had to get out of the studio.

When Homer left a two-year apprenticeship with the Boston lithographer J. H. Bufford, he chose to follow an independent path. He turned down full-time employment as an illustrator with *Harper's Weekly* to avoid further "bondage." *Harper's* hired him on a freelance basis, and in 1859 Homer moved to New York City. Intent on a painting career, he set up a studio and studied figure drawing and oil painting in his free time, but his work as an art correspondent for *Harper's* during the American Civil War took him out of the studio and into the fray during three deployments with Union forces. With his keen illustrator's eye—and his unsentimental nature—Homer crafted a genuine account of the soldiers' experiences. He also captured the resolute spirit of the home front in small oils. After the war he continued to work as an illustrator, and in 1866 he spent ten months in Paris. He returned with a greater commitment to painting in natural light and would later declare that his preference was always for pictures "composed and painted out-doors."

In the 1870s Homer adopted practices that would endure for the length of his career. To grasp the true spirit of a locale, he would settle in for an extended sojourn and concentrate on a limited number of motifs, attentive to changing light and points of view. In 1873, during a summer at the coast in Gloucester, Massachusetts, he began to work in watercolor. The translucency of the medium allowed a quick response to light's fugitive effects, and over the next three decades he painted more than seven hundred watercolors. He experimented, wetting and blotting his paper, scraping the surface for texture, and even scratching in fine details with the point of his knife. Homer's color reflected nature's changing beauty, from the autumnal hues of the Adirondacks, where he fished each fall, to the monochromatic subtleties of the evening sky over still waters.

Homer sailed to England in 1881, and after a brief stay in London, he settled for twenty months in Cullercoates, a rustic fishing village on the Northumberland coast. He matched a silver-toned watercolor palette to the cold, damp climate, and he painted on a grander scale, using large sheets of paper to ennoble the statuesque figures of the women who worked on the shore. Shortly after his return, he moved from New York City to Prout's Neck, Maine, where his brother owned property. Homer built a studio house on a rocky promontory overlooking the water, and from a porch that he dubbed "The Piazza" he painted his signature oil canvases of heroic fishermen facing rough seas. Homer's fierce independence led him to be labeled as a recluse, but his intense working habits and passion for outdoor sports simply left him little time for the social concerns of the art world. In 1884, in the company of his father, he made his first trip to the Bahamas, where the brilliant light on bright blue waters added a new dimension to his work. After that, whenever he was able he spent his winters near the Gulf Coast of Florida or the Caribbean. Homer was loathe to talk about his painting, but he summed up his convictions in a simple statement: "The sun will not rise, or set, without my notice, and thanks."

1836 Born on February 24 in Boston, Massachusetts
1855–1857 Apprentices to lithographer J. H. Bufford
1857 Begins his career as a freelance illustrator
1859 Moves to New York City
1861–1864 Deployed to the American Civil War front with the Union Army as an artist-correspondent
1866 Spends the year in Paris
1870 Takes his first trip to the Adirondacks
1872 Moves to the Tenth Street Studio building
1875 Takes his first visit to Prout's Neck, Maine
1881–1882 Paints in England
1883–1884 Builds a studio and moves to Prout's Neck
1884 Makes his first visit to the Bahamas
1899–1900 Returns to the Bahamas; takes his first trip to Bermuda
1910 Dies on September 29 in Prout's Neck

FURTHER READING
Nicolai Cikovsky and Franklin Kelly, *Winslow Homer*, Washington, DC, 1995
Martha Tedeschi, Kristi Dahm, Judith Walsh, and Karen Huang, *Watercolors by Winslow Homer: The Color of Light*, Chicago 2008
Homer's studio in Prout's Neck, Maine, can be viewed online at:
http://www.portlandmuseum.org/about/homerstudio.shtml

right
Winslow Homer, *Four Fisherwives*, 1881, watercolor on paper, 45.7 x 72.4 cm, Ruth Chandler Williamson Gallery Program at Scripps College, Claremont, California

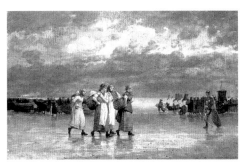

above
Napoleon Sarony, *Portrait of Winslow Homer*, c. 1880, Bowdoin College Museum of Art, Brunswick, Maine

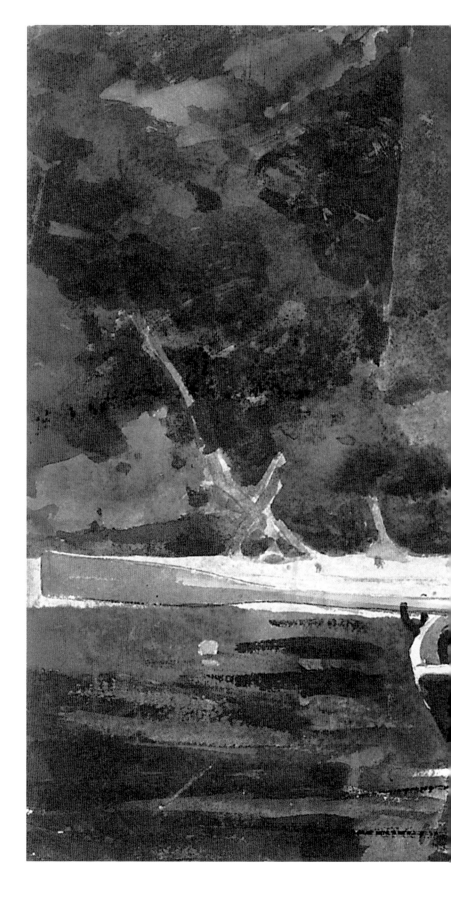

Winslow Homer, *The Adirondack Guide*,
1894, watercolor and pencil on paper,
38.4 x 54.6 cm, Museum of Fine Arts,
Boston, bequest of Mrs. Alma H.
Wadleigh

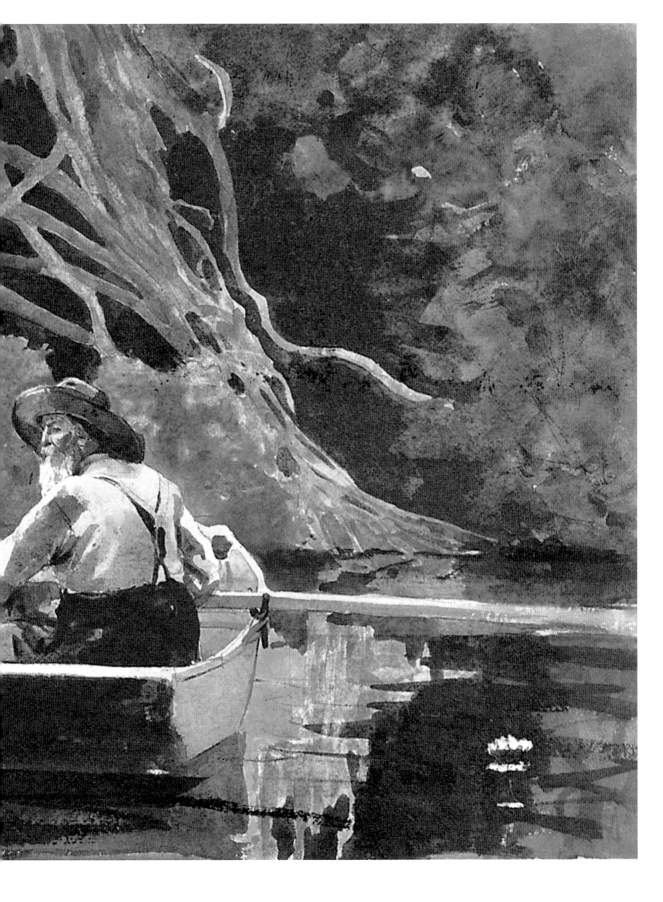

1805 Charles Willson Peale and William Rush found the Pennsylvania Academy of the Fine Arts in Philadelphia

1822 Jean-François Champollion decodes Egyptian hieroglyphics

1840 Alexander S. Walcott opens the first studio for portrait photography in the United States

1863 Édouard Manet paints the *Déjeuner sur l'Herbe*

1878 Eadweard Muybridge takes serial photos of a galloping horse

1795 1800 1805 1810 1815 1820 1825 1830 1835 1840 1845 1850 1855 1860 1865 1870 1875 1880

Thomas Eakins, *Swimming*, 1885, oil on canvas, 69.37 x 92.23 cm, Amon Carter Museum, Fort Worth, Texas

| 1894 First public film screening in New York | 1914–1918 World War I | 1929 Ernest Hemingway publishes *In Another Country* | 1945 Founding of the United Nations (UN) | 1961 First person in space (Gagarin) |

| 1885 | 1890 | 1895 | 1900 | 1905 | 1910 | 1915 | 1920 | 1925 | 1930 | 1935 | 1940 | 1945 | 1950 | 1955 | 1960 | 1965 | 1970 |

THOMAS EAKINS

In 1886 Thomas Eakins was asked to resign his position as Director of Philadelphia's Pennsylvania Academy of the Fine Arts, for removing a male model's loincloth during a lecture to a mixed-gender life class. He complied with reluctance: Eakins regarded the nude—"The most beautiful of Nature's works"—as the ultimate subject in art.

Encouraged to draw by his father, a noted penmanship master, Eakins studied at Central High School in Philadelphia and then the Pennsylvania Academy of the Fine Arts. To supplement courses in life drawing, he attended anatomy seminars at the Jefferson Medical College. In 1866 Eakins went to Paris and, through diligent work, excelled in the rigorous life classes taught by Jean-Léon Gérôme at the École des Beaux-Arts. In addition, he studied sculpture and, in 1869, spent a month in the studio of portraitist Léon Bonnat to improve his color and brushwork. Eakins also visited art collections and traveled throughout Spain at the end of his stay. He wrote to his father that he had learned the secret of great painting: "The big artist … keeps a sharp eye on Nature & steals her tools."

Upon his return to Philadelphia in 1870, Eakins opened a portrait studio. On his own time, he explored modern subjects that featured the human body in action. His passion for rowing led him to see a parallel between the classical male ideal and the contemporary athlete, and he depicted champions of the sport training on the Schuylkill River (1871–1874). In 1875 he portrayed the noted surgeon Samuel Gross lecturing at the Jefferson Medical College while his assistants removed a fragment of dead bone from a patient's leg. Previous artists, most notably Rembrandt, had depicted anatomy lessons, but Eakins's frank presentation of an operation in progress proved too real for the jury of the Centennial Exhibition in 1876. When the work was rejected, Dr. Gross arranged to have it included in a medical exhibition at the college.

Eakins assisted a drawing teacher at the Pennsylvania Academy in 1876; three years later, he became a professor. Appointed Director in 1882, he revised the curriculum to focus on life studies. He encouraged students to pose for one another outside class; he posed, too, believing that "no one should work in a life class who thinks it wrong to undress if needful." In 1883, after pioneering

photographer Eadweard Muybridge demonstrated his studies of animal locomotion at the Academy, Eakins applied the technique to his own life studies, photographing his students—as well as posing himself—in the studio and in the open air. He conducted human motion studies, assisting Muybridge and then working on his own. In pursuit of a realist, contemporary subject that would showcase his new discoveries, he painted *Swimming* (1885), featuring six men, bathing nude, in natural light. The different range of postures—diving, climbing, swimming, relaxing—reflected his motion studies, and the figures themselves revealed the benefits of anatomical, photographic, and aesthetic observation. But the painting was coolly received by critics, and Edward H. Coates, an Academy trustee who had commissioned the work, politely refused to accept it.

During his tenure as Director, Eakins's emphasis on nude study came under fire, leading to his dismissal in 1886. Students resigned in protest, but Eakins refrained from challenging the charge and turned from teaching to pursuing his own work. He continued his study of the human figure—painting prizefighters as modern-day gladiators (1898–1899)—and his late, brooding portraits express an unprecedented depth of human character. He remained steadfast in his quest "to probe deeply into American life" and to translate long-standing ideals of art into a modern American vernacular.

1844 Born on July 25 in Philadelphia
1862 Begins attending the Pennsylvania Academy of the Fine Arts
1866–1869 Studies in Paris
1869 Travels throughout Spain
1871–1874 Paints his rowing pictures
1876 Centennial Exhibition rejects *The Gross Clinic*
1879 Eakins is appointed Professor of Drawing and Painting at the Pennsylvania Academy of the Fine Arts
1882 Appointed Director of the Pennsylvania Academy of the Fine Arts
1884 Assists Eadweard Muybridge with the photographic study of motion
1886 Forced to resign his position at the Pennsylvania Academy of the Fine Arts
1892 Acts as an honorary pallbearer at Walt Whitman's funeral
1896 Has a solo exhibition of his work at Earles Galleries in Philadelphia
1914 Becomes housebound as his eyesight deteriorates
1916 Dies on June 25 in Philadelphia

FURTHER READING
Doreen Bolger and Sarah Cash, *Thomas Eakins and the Swimming Picture*, Fort Worth, TX, 1996
Darrel Sewell and Kathleen A. Foster, *Thomas Eakins*, Philadelphia 2001

Thomas Eakins, *Self-Portrait*, 1902, oil on canvas, National Academy of Design, New York

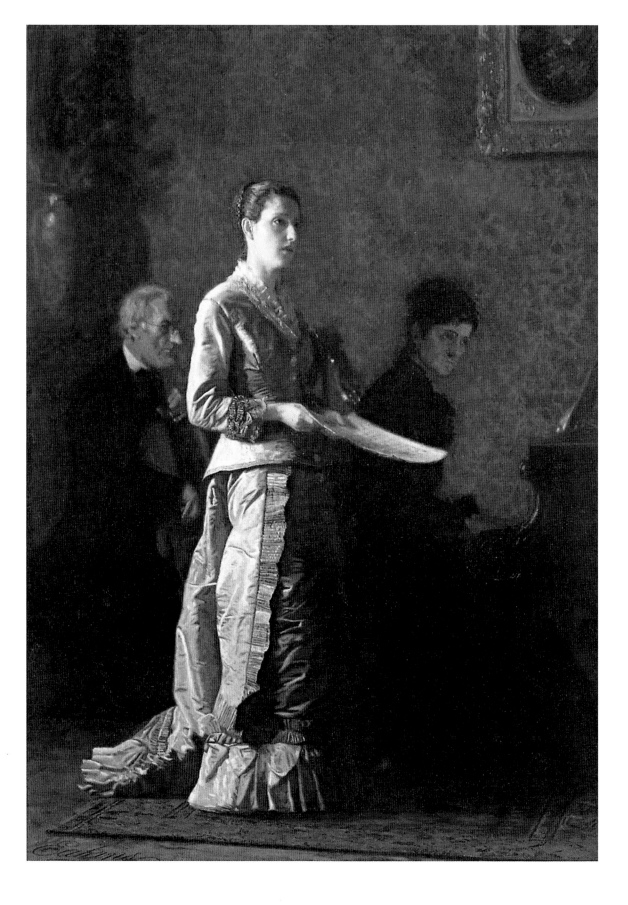

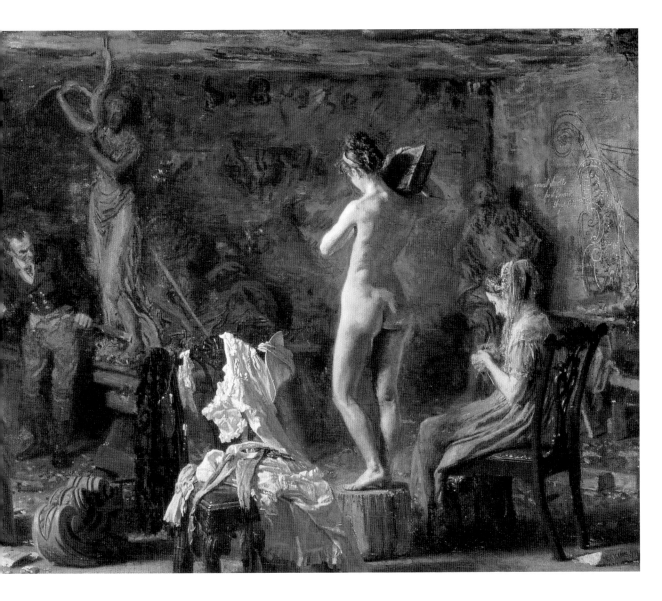

1870–1871 Franco-Pruss

1812 James Montgomery Flagg invents
American icon Uncle Sam

1848 Michael Knoedler
opens the first art
gallery in New York

1863 Charles Baudelaire
publishes *The Painter
of Modern Life*

| 1795 | 1800 | 1805 | 1810 | 1815 | 1820 | 1825 | 1830 | 1835 | 1840 | 1845 | 1850 | 1855 | 1860 | 1865 | 1870 | 1875 | 1880 |

Mary Cassatt, *The Child's
Bath*, 1893, oil on canvas,
100.3 x 66 cm, The Art Institute
of Chicago

Pierre Auguste Renoir
paints the *Moulin de la
Galette*

1900 Sigmund Freud publishes
The Interpretation of Dreams

1918–1920 A global influenza epidemic
costs over 20 million lives
1923 Founding of the USSR

1939–1945 World War II

1956–1959 Construction of the
Solomon R. Guggenheim
Museum in New York
to plans by Frank Lloyd
Wright

| 1885 | 1890 | 1895 | 1900 | 1905 | 1910 | 1915 | 1920 | 1925 | 1930 | 1935 | 1940 | 1945 | 1950 | 1955 | 1960 | 1965 | 1970 |

MARY CASSATT

Already launched toward success as an American artist in Paris, Mary Cassatt accepted an invitation from French artist Edgar Degas to exhibit her work with the Impressionists. She admired the independent path of the Impressionists and embraced the challenge: "I hated conventional art … I was beginning to live."

Upwardly mobile, affluent, and intellectual, Cassatt's parents gave their children every advantage. Cassatt spent part of her childhood in France and Germany, and by the time her family resettled in Pennsylvania in 1855, she was determined to pursue a career in the arts. At sixteen she enrolled at the Pennsylvania Academy of the Fine Arts in Philadelphia, where women took advantage of the full curriculum, except for life classes. On her own time she copied works in the Academy's collection to refine her skills, but she soon chafed at its limitations; in 1865, in the company of a like-minded female student, Cassatt departed for Paris.

Women were barred from Paris's École des Beaux-Arts, but Cassatt attended women's classes with prominent professors including Jean-Léon Gérôme and Charles Chaplin. She debuted at the annual Salon in 1868, exhibiting under her middle name, Stevenson, to avoid untoward publicity. Her return to the United States in 1870 was brief: she quickly accepted a commission from the Bishop of Pittsburgh to travel to Parma and replicate two works by Correggio for Pittsburgh's cathedral. Once in Italy, she resumed her training and journeyed on to Spain for a six-month sojourn that enriched her sense of color and added images of bullfighters to her repertoire. In 1873 she rented an apartment and studio in Paris. Her sister Lydia joined her, and Cassatt built her initial reputation painting Spanish genre scenes and portraits.

Sensing a kindred spirit in her work, Degas visited Cassatt's studio in 1877. She welcomed his interest, and they shared a lifelong, if often volatile, friendship. Cassatt—the only American to exhibit with the Impressionists—participated in the fourth Impressionist exhibition in 1879 and in three of the four remaining exhibitions (1880, 1881, and 1886). She adopted a looser brushstroke and more luminous palette and, like Degas, she portrayed contemporary life, but from a woman's point of view. Cassatt captured the absorbing but often restricted routines of upper-middle-class women: reading, grooming, sharing tea with friends, attending concerts. In 1880, when her brother visited with his young family, she discovered her signature subject in the gestural affection and trust between a woman and a child. Yet her sitters were not always mothers with their own children. Cassatt experimented by pairing friends' children with members of her household— as well as with professional models—to get the effects she desired.

Cassatt also experimented with media, working in watercolor and pastel, as well as oil paint. In 1879 she took up etching to contribute to a journal project planned by Degas. *Le Jour et la nuit* ("Day and Night") was never published, but Cassatt continued to work in etching and drypoint, claiming that the exacting technique "teaches you to draw!" In response to the woodblock prints of the Japanese master Utamaro, she created a method of color printing using copper plates, etching, and aquatint. Her suite of prints known as the "Set of Ten," published in an edition of twenty-five in 1891, presented the intimate moments of a woman's day. In 1893 Cassatt painted a grand-scale mural for the Women's Building at the World's Columbian Exposition in Chicago; *Modern Woman*, a contemporary allegory of women gathering fruit and seeking fame, is now known only through photographs.

As she aged and her sight declined, Cassatt remained active, urging American collectors to buy modern French art. But she preferred to remain in France, where she believed a woman was regarded as "someone and not something" if she did "serious work."

Mary Cassatt, undated

1844 Born on May 22 in Allegheny City, Pennsylvania
1851–1855 Takes an extended sojourn with her family in Europe
1860 Enrolls in women's classes at the Pennsylvania Academy of the Fine Arts in Philadelphia
1865 Travels to Paris to study
1870 Rejoins her family in Altoona, Pennsylvania
1871 Accepts a commission to copy works by Correggio in Parma, Italy
1872 Takes a six-month sojourn in Spain
1874 Settles in Paris
1877 Degas visits Cassatt in her studio; he invites her to exhibit with the Impressionists
1879 Cassatt exhibits her work in the fourth Impressionist exhibition (and will exhibit in three more)
1890–1891 Creates the print suite known as the "Set of Ten"
1893 Exhibits the mural *Modern Woman* at the World's Columbian Exposition in Chicago
1894 Acquires the Château Beaufresne in Mesnil-Théribus, Beauvais, France
1898 Takes a final visit to the United States
1926 Dies on June 14 in Mesnil-Théribus

FURTHER READING
Judith A. Barter, *Mary Cassatt: Modern Woman*, Chicago 1998
Debra N. Mancoff, *Mary Cassatt: Reflections of Women's Lives*, New York 1998

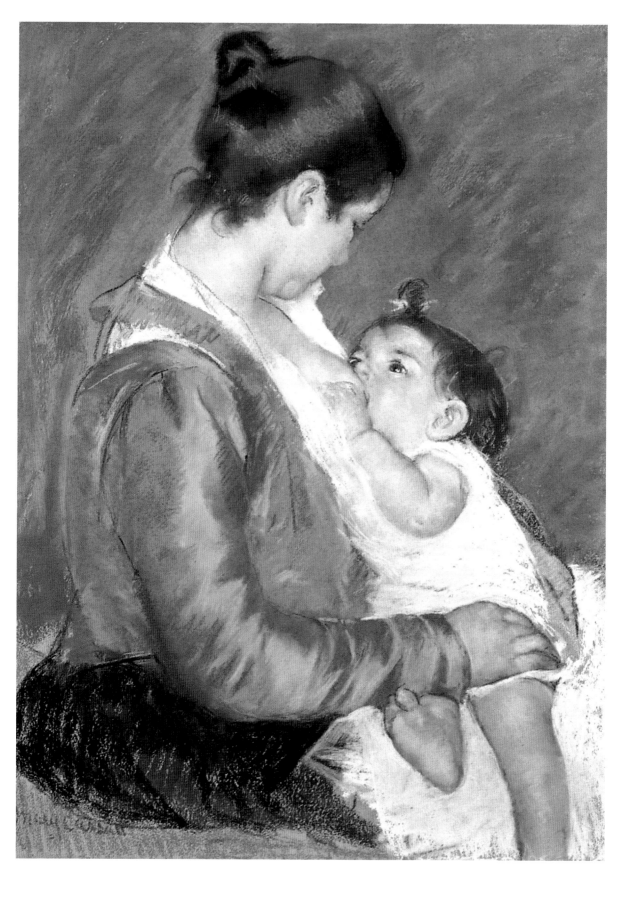

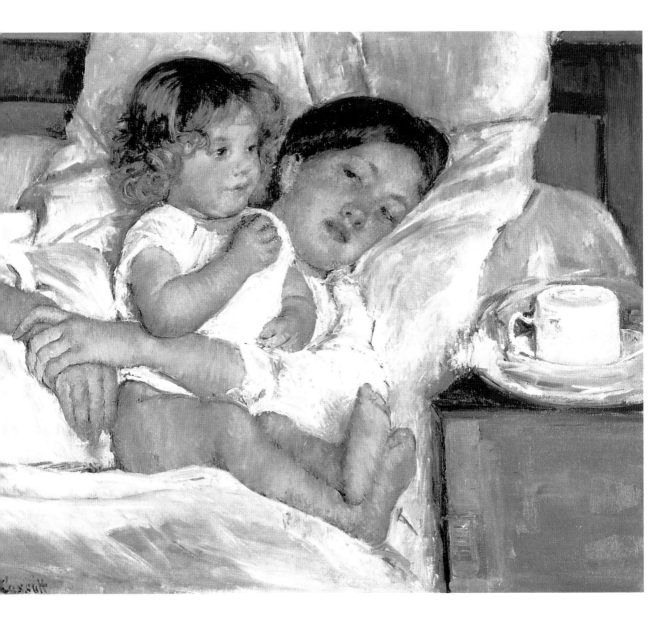

left page
Mary Cassatt, *Young Mother Nursing Her Child*, 1898, pastel on tan wove paper, 72.4 x 53.4 cm, Collection Rau, Fondation Rau, Zurich

above
Mary Cassatt, *Breakfast in Bed*, 1897, oil on canvas, 65 x 73.6 cm, Virginia Steele Scott Collection, San Marino, California

1809–1825 South American
wars of independence

1837 Louis Daguerre invents
the daguerreotype

1859 Charles Darwin publishes
The Origin of Species

1885 Karl Benz
construct
first gaso
powered c

1846–1848 Mexican–American War

1805 1810 1815 1820 1825 1830 1835 1840 1845 1850 1855 1860 1865 1870 1875 1880 1885 1890

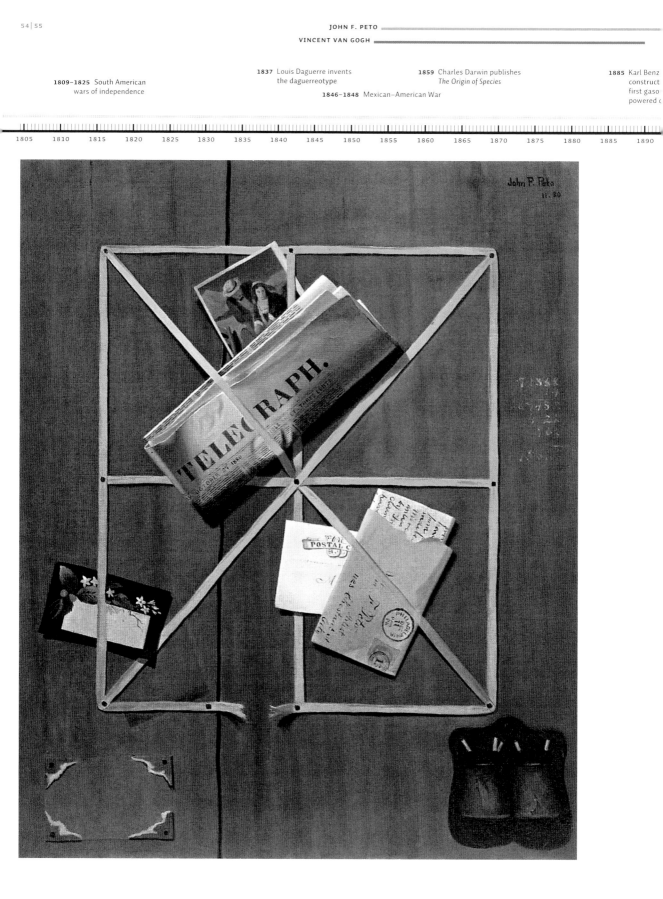

1901 First Nobel Prize awards conferred
by the Swedish King in Stockholm

1911–1913 Introduction of
montages and collages

1930–1931 Construction of the Empire
State Building in New York to
plans by William van Alen

1946 Founding of UNESCO

1965 First Op Art exhibition,
The Responsive Eye,
in New York City

1895　1900　1905　1910　1915　1920　1925　1930　1935　1940　1945　1950　1955　1960　1965　1970　1975　1980

JOHN F. PETO

A lack of documentary evidence makes it difficult to put John F. Peto's work into context. No studio record survives and, more often than not, he left his paintings unsigned, undated, and even unfinished. But his intriguing still-life compositions bear witness to his creativity and wit, as well as to his astounding powers of illusionism.

As a boy in Philadelphia, Peto drew anything that captured his attention, including animals, flowers, barns, and imaginary castles. By the time he enrolled at Philadelphia's Pennsylvania Academy of the Fine Arts in 1877, he focused upon still life as his favored subject. His matriculation there was brief, and although he was present during the tenure of Thomas Eakins, who added still life to the curriculum, Peto's exact course of study cannot be reconstructed. Working at the Academy, Peto had access to examples of *trompe l'œil* ("fool the eye") painting—notably in the work of Charles Willson Peale and his son Raphaelle—and he developed a thorough command of illusionism. After leaving the Academy, Peto set up his own studio in Philadelphia and struck a congenial friendship with former classmate and fellow still-life painter William Michael Harnett. Together, they experimented with photography, shared a repertoire of imagery, and mounted a friendly rivalry that pushed both toward greater expertise. Peto's approach was less conventional than Harnett's, distinguished by a painterly touch that brought a sensuous quality to humble objects such as mugs, pipes, and newspapers.

Peto enjoyed a solid reputation, exhibiting regularly at the Academy, and in 1887 he traveled to Cincinnati, perhaps to paint a mural for the Stag Saloon. While there, he met Christine Pearl Smith; they married soon after and in 1889 moved from Philadelphia to the resort town of Island Heights, New Jersey, on the Atlantic coast near the Toms River. From this point forward, Peto worked in relative solitude, rarely exhibiting, although selling works and supplementing his income with photography. His work became intensely personal, often featuring objects that connected to family identity, such as letters, photographs, musical instruments, and items that had belonged to his father. The character of his painted surfaces also became increasingly distinctive. Unlike most still-life painters, Peto worked *alla prima* (directly on the canvas), without preliminary sketches or underdrawing, and he often reused canvases and corrected his work by over painting. In his later works, he especially relished unusual supports—such as real palettes—and excelled in painting the effects of age and material decay.

In subject selection and composition, Peto displayed a thorough understanding of Dutch and French still-life traditions. He arranged his objects on tabletops, shelves, and window ledges and expressed a lyrical sense of comfort through the depiction of humble items. But he also engaged contemporary American forms, such as the office board, currency, and letter racks, an old-fashioned form of bulletin board on which tacked-on ribbon tapes secured printed ephemera. Peto subverted the genre with humor, using puns and double meanings, such as the sign for lodging in *Poor Man's Store* (1885) stating "Good Board" that is nailed to a scuffed and cracked wooden windowsill. Odd juxtapositions further reveal his playful spirit; *Ordinary Objects in the Artist's Creative Mind* (1887) brings together a reproduction of a French Salon painting and a copy of Winslow Homer's *Bathers* from an 1873 issue of *Harper's Weekly*, along with one of his own modest paintings and a palette, a bugle, and tattered sheet music. Some of his objects have personal reference; he was a skilled musician and, like most Americans of his generation, he felt a stirring connection to the Civil War. But his iconography is eccentric, and in his defiance of conventional explanations Peto not only fools the eye but also teases the imagination.

1854 Born on May 21 in Philadelphia
1877–1878 Attends the Pennsylvania
Academy of the Fine Arts
1887 Travels to Cincinnati, possibly to
paint a mural for the Stag Saloon
1889 Moves to Island Heights,
New Jersey
1907 Dies on November 23 in
New York City

FURTHER READING
Alfred Frankenstein, *The Reality of
Appearance*, Greenwich, CT, 1970
John Wilmerding, *Important
Information Inside: The Art of John F.
Peto and the Idea of Still-Life Painting
in Nineteenth-Century America*,
Washington, DC, 1983

left page
John F. Peto, *Rack Picture with Telegraph, Letter and Postcards*, 1880,
oil on canvas, 61 x 50.8 cm, Hirschl & Adler Galleries, James Maroney,
and Newhouse Galleries, New York

above
John F. Peto, *Self Portrait with Rack Picture* (detail), 1904, oil on
canvas, 47 x 31 cm, Private Collection

right
John F. Peto, *Palette, Mug and Pipes*, c. 1890, oil on canvas,
34.3 x 24.1 cm, Private Collection

1810–1814 Francisco de Goya produces
The Disasters of War series of aquatints

1829 Greece gains independence
from the Ottoman Empire

1848 Founding of the Pre-Raphaelite
group of artists (PRB) in London

1863 Édouard Manet paints *Olympia*

1887 Emile Berli
invents the
gramophor
record

1805	1810	1815	1820	1825	1830	1835	1840	1845	1850	1855	1860	1865	1870	1875	1880	1885	1890

left
John Singer Sargent, *Madame X*, 1884,
oil on canvas, 212.1 x 109.8 cm, The
Metropolitan Museum of Art, New York

right
John Singer Sargent, *Fumée d'ambre gris*,
1880, oil on canvas, 139.1 x 90.5 cm,
Sterling and Francine Clark Art Institute,
Williamstown, Massachusetts

1903 First Autumn Salon in Paris
1927 Premiere of *The Jazz Singer*, the first "talkie"
1916 Opening of the Cabaret Voltaire in Zurich
1941 Japanese attack Pearl Harbor
1958 Truman Capote publishes *Breakfast at Tiffany's*

1895 1900 1905 1910 1915 1920 1925 1930 1935 1940 1945 1950 1955 1960 1965 1970 1975 1980

JOHN SINGER SARGENT

John Singer Sargent never imagined that his portrait of "Madame X"—a glamorous socialite in a skintight black dress—would spark a firestorm in the sophisticated Parisian art world. But public shock did not impede his success as the premier society painter of the Gilded Age.

The child of wealthy American expatriates, Sargent acquired fluency in several languages, as well as refined social skills, at a young age. He briefly attended schools in Nice, Florence, and Dresden; his art training was more extensive, but due to his parents' restless habits, his family was always on the move. In 1874 Sargent struck out on his own and joined the studio of Carolus-Duran, the most fashionable portraitist in Paris. Carolus-Duran urged his pupils to paint quickly, layering their color directly on the canvas to simulate the movement of natural light. Sargent possessed the facility and confidence to excel at this demanding approach. A prize-winning likeness of his master (1879) launched his Parisian career, and he proved equally adept at painting modern life subjects, travel genre scenes, and stunning portraits of elegant women.

In 1884 Sargent unveiled what he believed to be his most dazzling painting: *Madame X*, a full-length portrait of the celebrity beauty Virginie Gautreau in a severe black dress. Born in New Orleans, she had married a wealthy Parisian and was renowned for her spectacular figure and pale skin, which she enhanced with luminous lavender powder. Other artists had invited her to pose, but only Sargent won a sitting. Yet even the sophisticated Paris art world found the audacious likeness scandalous. Sargent had painted one thin diamond dress strap slipping down her shoulder, prompting provocative comments such as, "One more struggle and the lady will be free." The critics savaged Sargent, and Madame Gautreau's family accused him of spoiling her reputation. Humiliated, he moved to London, but he kept the painting—retouched to put the strap firmly in place—on display in his studio.

Sargent quickly recovered. He spent his summers in English riverside resorts such as Broadway and Calcot Mill, honing his exquisite sense of light and color by working out of doors. He acquired rich and influential clients—American industrialists and British aristocrats—and by the end of the century,

being painted by Sargent was a mark of social status. His subtle flattery made his sitters look tall, graceful, and dignified, but he never disguised their individuality. Sargent gave them an air of easy nonchalance, as if their privileged position was part of their nature, but he also portrayed them as intelligent and engaged, gazing out at the viewer as if ready to converse. He called them "mug shots," but his portraits embodied the glittering era of American affluence and confidence that Mark Twain dubbed "the Gilded Age."

In 1890 Sargent accepted a commission from the Boston Public Library to paint extensive mural decorations depicting the history of world religions. He embraced the new challenge, making regular trips across the Atlantic to supervise the installation. He stopped taking commissions for portraits in 1907, but continued to paint them on his own, posing friends and family in intimate, naturally lit settings. Sargent spent the early years of World War I in North America; he painted President Woodrow Wilson (1917) as well as John D. Rockefeller (1917) and sketched in watercolor on a tour of the Canadian Rockies (1916). He returned to England in 1918 to work as a British war artist on the Western Front. He painted a "harrowing sight," a line of mustard gas victims groping their way to safety (1919), from firsthand observation. Just as he had captured the opulent spirit of the Gilded Age, he now paid respectful tribute to the tragic events that ended the era.

1856 Born on January 12 in Florence, Italy
1874–1878 Studies with Carolus-Duran in Paris
1876 Takes his first visit to the United States
1879–1880 Travels through Spain and Morocco
1884 Exhibits his portrait *Madame X* at the Paris Salon
1886 Moves from Paris to London
1890 Paints portraits in New York City and New England
1895 Has his first set of murals installed at the Boston Public Library; work there continues until his death
1903 Paints a portrait of President Theodore Roosevelt in the White House; his second set of murals is installed in the Boston Public Library
1907 Ends his career as a portrait painter; as an American citizen, he declines a British knighthood
1918 Serves in France as an official war artist for Britain
1925 Dies on April 25 in London

FURTHER READING
Trevor J. Fairbrother, *John Singer Sargent: The Sensualist*, Seattle 2000
Elaine Kilmurray and Richard Ormond, *John Singer Sargent*, London 1998
Marc Simpson, Richard Ormond, and H. Barbara Weinberg, *Uncanny Spectacle: The Public Career of the Young John Singer Sargent*, New Haven, CT, 1997

John Singer Sargent, *Self-Portrait*, 1906, oil on canvas, 76.2 x 63.5 cm, Galleria degli Uffizi, Florence

1830 July Revolution in France

1845 Premiere of Richard Wagner's opera *Tannhäuser*

1866 Civil Rights Act confers citizenship on all Americans regardless of race

1863 Founding of the International Committee of the Red Cross in Geneva

1886 Erection of the Sta of Liberty in the P of New York

| 1810 | 1815 | 1820 | 1825 | 1830 | 1835 | 1840 | 1845 | 1850 | 1855 | 1860 | 1865 | 1870 | 1875 | 1880 | 1885 | 1890 | 1895 |

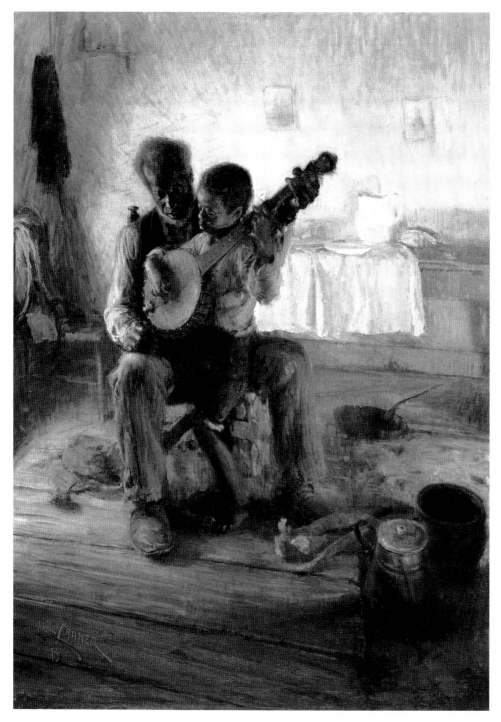

Henry Ossawa Tanner, *The Banjo Lesson*, 1893, oil on canvas, 124.46 x 90.17 cm, Hampton University Museum, Virginia

U.S. Supreme Court establishes the principle of "separate but equal" in the treatment of races

1921 Albert Einstein awarded the Nobel Prize for Physics

1940 Frank Sinatra achieves his breakthrough with *I'll Never Smile Again*

1912 Marcel Duchamp paints *Nude Descending a Staircase No. 2*

1957 Ghana is first colony in Africa to become independent post-World War II

| 1900 | 1905 | 1910 | 1915 | 1920 | 1925 | 1930 | 1935 | 1940 | 1945 | 1950 | 1955 | 1960 | 1965 | 1970 | 1975 | 1980 | 1985 |

HENRY OSSAWA TANNER

As the first African American painter to attain international acclaim, Henry Ossawa Tanner never allowed his artistry to be constrained by conventional expectations. Compelled to leave the United States to advance his career, he instilled his work with a compassionate vision of freedom, dignity, and reverence for the common human experience.

Named to honor the abolitionist John Brown's valiant stance in Osawatomie, Kansas, Tanner grew up in an atmosphere of social commitment, deep faith, hard work, and high aspirations. He was expected to follow his father, a bishop in the African Methodist Episcopal Church, into the ministry, but at age thirteen his curiosity about an artist he saw painting in a public park prompted his mother to buy him art supplies. After graduating from Roberts Vaux Grammar School, Tanner enrolled in the Pennsylvania Academy of the Fine Arts in Philadelphia in 1879. He endured racial hazing from some of the students, but his professors, notably Thomas Eakins, recognized the breadth of his potential. He pursued a number of career paths, including illustration design and running a photography gallery, but the turning point in Tanner's career came in 1891, when a group of patrons funded a tour to Rome. He visited Paris first and found it so congenial that he remained there to extend his training and launch his career. Eventually he made France his home.

Tanner studied life drawing at the Académie Julian, masterworks at the Louvre, and *plein-air* painting in Brittany. He developed a signature style that fused his firm grasp of traditional technique with a fresh, expressive approach to color. His subjects reflected his personal convictions: "I paint the things I see and believe," he said. His vignettes depicting the passage of traditional knowledge from one generation to the next, such as *The Banjo Lesson* (1893) and *The Young Sabot Maker* (1895), transcended the confines of racial genre, and his religious subjects celebrated individual strength in the face of oppression. He regularly exhibited at the Paris Salon from 1894 to 1914, winning his first honor for *Daniel in the Lions' Den* in 1896. In 1897 the French government purchased *The Raising of Lazarus*. Tanner also built a reputation in the United States, sending works for sale and display and delivering an address on the artist of color in American society at the 1893

World's Columbian Exposition in Chicago. But in his homeland, the mention of his race tainted every word of praise; in Europe, he found that his talent was assessed without any reference to color.

Tanner's travels—to Palestine and Egypt in 1897 and to Morocco in 1912—gave veracity to the settings of his religious subjects and spurred him on to a bolder handling of light and color. His marriage in 1899 confirmed his desire to stay abroad; interracial couples found greater tolerance in Europe than in the United States. During World War I, Tanner served as a lieutenant in the American Red Cross, working in the public information office, leading an innovative vegetable garden project, and painting poignant impressions of soldiers in the Red Cross canteens. After the war, many young African American artists, including William Scott, William H. Johnson, Hale Woodruff, and Augusta Savage, came to Europe to seek his advice, but advocates of the New Negro Movement, such as critic Alain Locke, reproached him for abandoning the race-centered genre that he so movingly pioneered in *The Banjo Lesson* and *The Thankful Poor* (1894). Although stung by this criticism, Tanner believed that the force of his art was not in promoting identity but in a human touch that "makes the whole world kin," and through his example of accomplishment abroad, he proved to be a gentle advance guard for the struggle of the African American artist at home.

1859 Born on June 21 in Pittsburgh
1868 Moves with his family to Philadelphia
1876 Creates his earliest dated work
1879 Enrolls at the Pennsylvania Academy of the Fine Arts in Philadelphia
1891 Departs for Rome; stays in Paris
1893 Delivers the address "The American Negro in Art" at the World's Columbian Exposition in Chicago
1896 Achieves his first major success at the Paris Salon
1897 Travels to Palestine and Egypt
1899 Marries Jessie Macauley Olssen
1914 Becomes a member of the American Negro Academy in Washington, D.C.
1917–1919 Serves in the American Red Cross
1923 Is awarded the Legion of Honor by the French government
1926 Jessie Olssen Tanner dies
1927 Tanner is elected a full member of the National Academy of Design in New York City
1937 Dies on May 25 in Paris

FURTHER READING
Marcus Bruce, *Henry Ossawa Tanner: A Spiritual Biography*, New York 2002
Dewey F. Mosby, *Across Continents and Cultures: The Art and Life of Henry Ossawa Tanner*, Kansas City, MO, 1995

Henry Ossawa Tanner, c. 1900

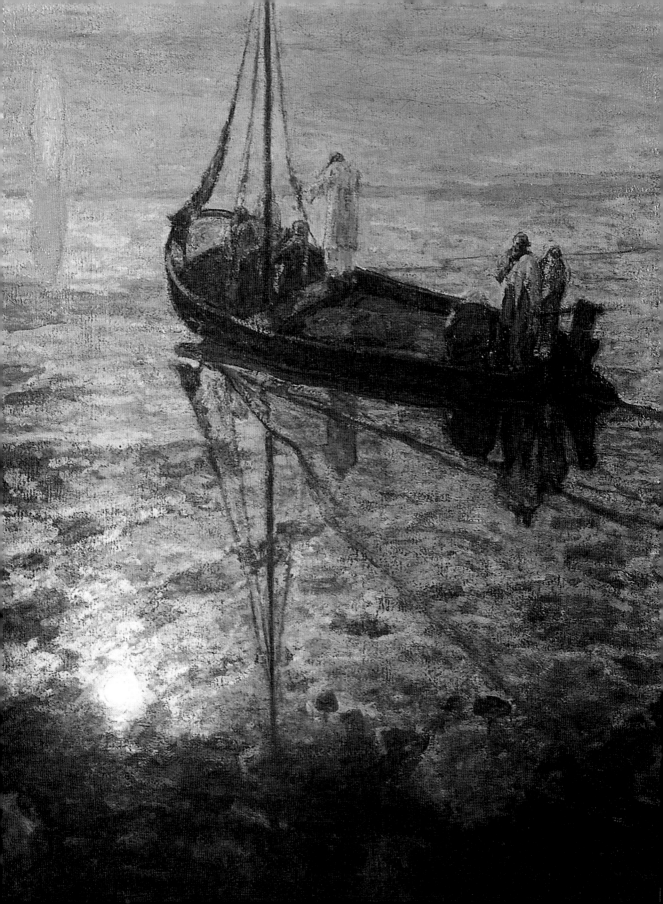

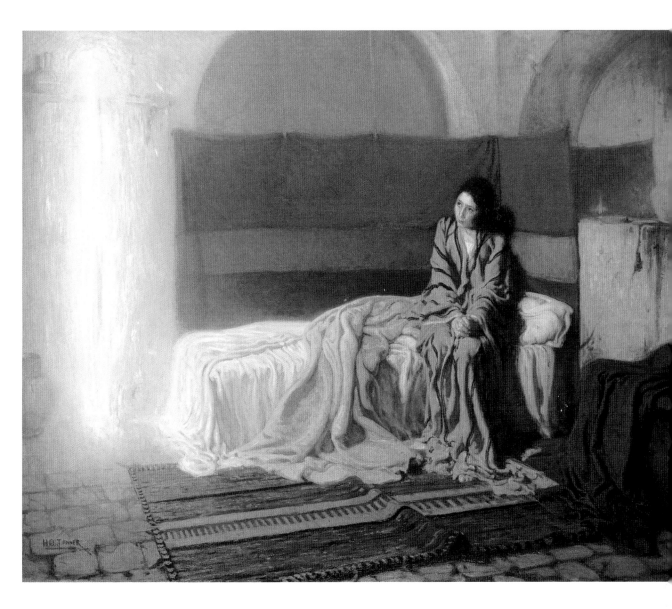

left side
Henry Ossawa Tanner, *The Disciples See
Christ Walking on the Water*, c. 1907,
oil on canvas, 130.81 x 106.68 cm,
Des Moines Art Center, gift of the
Des Moines Association of Fine Arts

above
Henry Ossawa Tanner, *The Annunciation*,
1898, oil on canvas, 144.78 x 181.61 cm,
Philadelphia Museum of Art

1842 Founding of the American
Art Union, with an annual
painting lottery for all
members

1857–1868 Charles Baudelaire
publishes *Les Fleurs du Mal*

1902 Alfred Stieglitz fou
the Photo-Secessio
in New York

1887 Emile Berliner invents the
gramophone record

1820	1825	1830	1835	1840	1845	1850	1855	1860	1865	1870	1875	1880	1885	1890	1895	1900	1905

John Sloan, *Election Night*, 1907, oil on
canvas, 64.5 x 80.6 cm, Memorial Art
Gallery of the University of Rochester,
New York, Marion Stratton Gould Fund

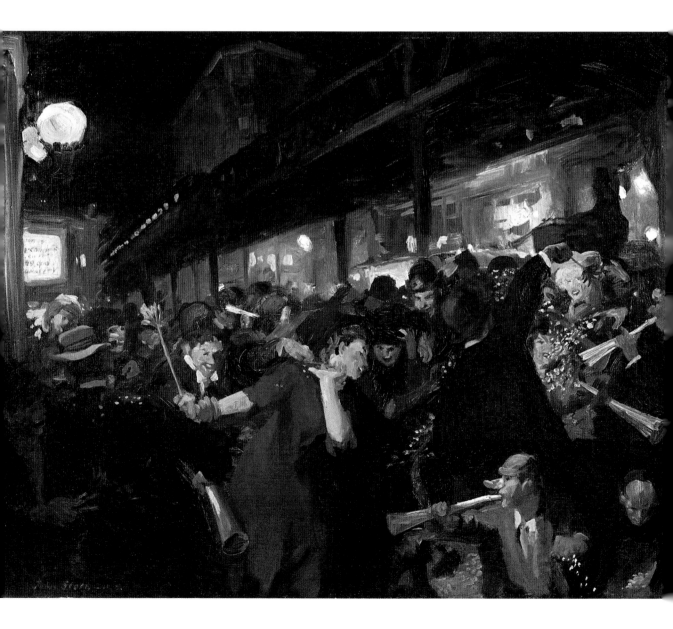

1913 The Armory Show in New York introduces the European avant-garde to the American art scene

1942 Edward Hopper paints *Nighthawks*

1969 Stonewall Riots in Christopher Street in New York

1931–1972 The Empire State Building in New York is the highest building in the world

1957 Leonard Bernstein's musical *West Side Story* premieres on Broadway

1981 First flight of a space shuttle (Columbia)

1910 1915 1920 1925 1930 1935 1940 1945 1950 1955 1960 1965 1970 1975 1980 1985 1990 1995

JOHN SLOAN

With keen observation—and a twist of wit—John Sloan captured the gritty urban spirit of New York City in the early twentieth century. He described his subject as "the noble commonplace" and sought it in the streets and bars, on the tenement rooftops, and through the view out his studio window.

Sloan left school as a teenager to earn a living in the commercial arts. He made copies of Old Master prints, lettered signs and posters, and learned to etch. By the time he turned twenty, Sloan was an accomplished illustrator who rendered the habits of his time in the manner of his favorite novelists: Dickens, Balzac, and Zola. But in 1892, the same year that he secured a post in the art department of the *Philadelphia Inquirer*, Sloan enrolled for the evening antique class at Philadelphia's Pennsylvania Academy of the Fine Arts. It was there that he met Robert Henri, who became a lifelong friend and whose influence prompted Sloan to take up oil painting.

A set of illustrations begun in 1902, designed for a deluxe edition of novels by Charles Paul de Kock, won Sloan initial acclaim, but when he moved from Philadelphia to New York City in 1904, his paintings were dismissed as "homely realism." Undeterred, Sloan immersed himself in the life of his adopted city, reveling in subjects that encapsulated the raw energy of modern urban life. He painted blowsy hairdressers in their shops, working girls out on the town, carousing drunkards, and raucous crowds on election night. While he continued to take illustration jobs, he explored more intimate themes in etching, giving in to his "peeper instinct" in subjects glimpsed through windows and on rooftops of the tenements near his studio. He developed a loose, descriptive brushstroke and a dark-toned, vibrant palette for his city scenes. In 1908 Sloan mounted an exhibition with Henri and six other urban painters; they were known as The Eight, but critics, shocked at what they perceived as tawdry scenes of street life, dubbed them the Ashcan School.

Sloan's genuine sympathy with working people led him to run for the New York State Assembly on the Socialist Party ticket in 1910. He lost, but two years later he became the art editor for the radical journal *The Masses*. He revamped the journal's image, creating striking, clean-line designs for the cover and publishing the drawings of young artists such as George Bellows and Stuart Davis. But, weary of party politics, he resigned in 1916. By that time, a teaching appointment at the Art Students League in New York City freed him from taking commercial commissions, and summers spent in Gloucester, Massachusetts, ignited his interest in landscape.

Over the years, Sloan's students included Alexander Calder, Reginald Marsh, and Barnett Newman. He remained open to new ideas, especially in his technical approach. In 1909 Henri had introduced him to Hardesty Maratta, who had created a system of prepared pigments based on intervals analogous to the musical scale. Sloan used the system for twenty years to serve as the formal structure for his vivid vignettes. He never relinquished representational subject matter—he called abstract painters the "ultramoderns"—but he believed that a painting drew strength from the pictorial elements of color and form rather than its anecdotal imagery. In his late work, he concentrated on large figures, notably the female nude, and he published his thoughts on painting in *Gist of Art* in 1939. He emphasized that the abstract order "hidden under the cloak of representation" was essential to good painting. For Sloan, fidelity to the language of art underscored honest expression, and honesty was the essential criterion for his vision of modern life untainted by pretense or sentiment.

1871 Born on August 2 in Lock Haven, Pennsylvania
1892 Works in the art department of the *Philadelphia Inquirer*; enrolls at the Pennsylvania Academy of the Fine Arts in Philadelphia
1902 Begins illustrating a deluxe edition of Charles Paul de Kock's novels
1904 Moves to New York City
1905–1906 Publishes *New York City Life*, a set of ten etchings
1908 Exhibits with The Eight at the Macbeth Gallery in New York City
1909 Adopts the Maratta color system
1910 Joins the Socialist Party
1912 Becomes the art editor of the *Masses*
1913 Exhibits in the International Exhibition of Modern Art (the Armory Show)
1914–1918 Spends his summers in Gloucester, Massachusetts
1916 Resigns from the *Masses*; joins the faculty of the Art Students League in New York City
1918 Is elected President of the Society of Independent Artists
1939 Publishes *Gist of Art*
1951 Dies on September 7 in Hanover, New Hampshire

FURTHER READING
Heather Campbell Coyle and Joyce K. Schiller, *John Sloan's New York*, New Haven, CT, 2007
David W. Scott and E. John Bullard, *John Sloan: 1871–1951: His Life and Paintings*, Washington, DC, 1971

Berenice Abbott, John Sloan, c. 1948, Collection of Delaware Art Museum

1830 Eugène Delacroix paints
Liberty Leading the People

1848 Karl Marx and Friedrich Engels
publish the *Communist Manifesto*

1869–1870 The First Vatican Council
formulates the doctrine of papal
infallibility

1889 Vincent van Gogh paints
the *Starry Night*

1905 Foundir
Die Brü
group c
in Dres

1825　1830　1835　1840　1845　1850　1855　1860　1865　1870　1875　1880　1885　1890　1895　1900　1905　1910

Marsden Hartley, *The Ice-Hole, Maine*,
1908–1909, oil on canvas, 86.4 x 86.4 cm,
New Orleans Museum of Art

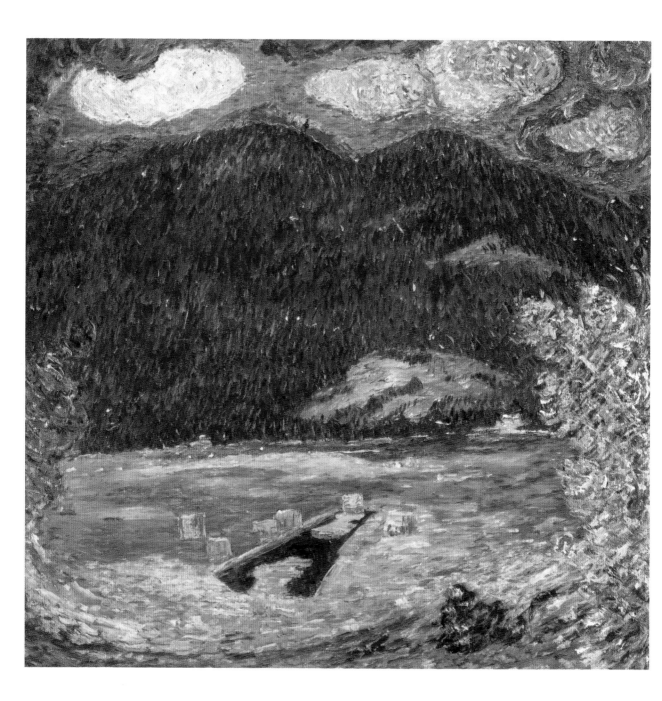

founding of *Der Blaue Reiter* group of artists in Munich

1933 Nazis come to power in Germany

1948 Berlin Airlift

1959 Alaska becomes 49th and Hawaii the 50th U.S. state

1980 First award of the Alternative Nobel Prizes in Stockholm

| 1915 | 1920 | 1925 | 1930 | 1935 | 1940 | 1945 | 1950 | 1955 | 1960 | 1965 | 1970 | 1975 | 1980 | 1985 | 1990 | 1995 | 2000 |

MARSDEN HARTLEY

Marsden Hartley lived a restless life, moving around the art capitals of Europe and seeking out remote locations in the United States and Mexico. His art served as the connecting thread, and by following it he sought a new definition of beauty and an American response to European Modernism.

Throughout his childhood, Hartley experienced dislocation. The death of his mother broke up his family; he stayed in Maine with an aunt while his father built a new life in Cleveland. At sixteen Hartley followed, and in his youth, as he took up art, he read Ralph Waldo Emerson's *Essays* (1841; 1844), to which he attributed "the religious element" in his experience. Rather than a belief in the divine, Hartley was drawn to what Emerson called the "noblest ministry of nature." Writings ranging from the poetry of Walt Whitman to the meditations of mystic Jakob Böhme developed his reliance on intuition and self-expression.

To advance his training, Hartley moved to New York City in 1899; from there he traveled back to Maine to paint. As he gained critical notice, he changed his given name, Edmund, to his stepmother's maiden name, Marsden. In 1909 Alfred Stieglitz, the owner of the cutting-edge "291" gallery, took an interest in Hartley's bold depictions of Maine's mountains. Stieglitz introduced Hartley to the works of Matisse, Cézanne, and Picasso, which inspired him to travel to Paris in 1912. Influenced by Gertrude Stein, Hartley embraced European Modernism; he sought to purge his painting of "objective things" and embarked on arrangements of forms and symbols that he described as "subliminal or cosmic cubism." By the end of the year, he moved on to Berlin, where he met Vasily Kandinsky and explored subjective ideas in two painting series: *Amerika* and *War Motifs*. Against boldly patterned and vigorously painted backgrounds, Hartley arranged symbols— thunderbirds and wigwams or spiked helmets and German military regalia—with the intention to convey instinctive feeling rather than emblematic meaning. But his use of these provocative symbols did have a deep personal significance. *Portrait of a German Officer* (1914) commemorated the death of his intimate friend Karl von Freyburg during World War I; upon seeing the *War Motifs* paintings,

American critics branded Hartley as a German sympathizer.

Hartley returned to the United States in 1915. He sought to rid his art of subjective "illusions" and painted "movements" based on a more purely objective vocabulary. He traveled to Bermuda and to New Mexico, but in 1921 he went back to Europe; he stayed there, with occasional visits to the United States, until 1930. Over the next decade, he continued to travel across the United States, to Mexico, to Canada, and always back to Maine. He reconfirmed his reliance on subjective interpretation, often working from memory, and his visual style gained scope and power. Using thick brushstrokes and bold color, Hartley discovered a rugged beauty in downtrodden settings such as Dogtown, Massachusetts, and the rough fishing villages along the northeastern coast.

Hartley also gave his profound fascination with the heroic male body free reign. Once again he courted controversy—he was a gay man in an intolerant society—but his hypermasculine figures, drawn from working-class models, also reflected an iconic American identification with the common man. Hartley's men were lumberjacks, fishermen, and prize-fighters, and he exaggerated their brawn with jagged outlines and brutal brushstrokes. More than a mere incarnation of homoerotic desire, Hartley's men represent the kind of essentialist beauty and rooted strength that he had sought for decades through his art. He also found it in "the tall timbers" and "granite cliffs" of his home state: through a life of wandering he recognized that Maine had always been his touchstone.

1877 Born on January 4 in Lewiston, Maine
1893 Joins his family in Cleveland
1899 Enrolls at the Chase School of Art in New York City
1900 Enrolls at the National Academy of Design in New York City
1906 Teaches painting in Lewiston
1908 Replaces his birth name, Edmund, with his stepmother's maiden name, Marsden
1909 Meets Alfred Stieglitz
1912 Goes to Paris and then Berlin
1915 Returns to the United States
1918 Travels to New Mexico
1921–1930 Primarily resides in Europe
1931 Begins his *Dogtown* series
1932 Spends a year in Mexico on a Guggenheim travel grant
1935 Travels to Nova Scotia
1943 Dies on September 2 in Ellsworth, Maine

FURTHER READING
Elizabeth Mankin Kornhauser (ed.), *Marsden Hartley*, New Haven, CT, 2002
Patricia McDonnell, *Marsden Hartley: American Modern*, Minneapolis 2006

Unknown Photographer, Marsden Hartley, c. 1900, Bates College, Museum of Art, Olin Arts Center, Lewiston, Maine. Marsden Hartley Memorial Collection

1844 Eugène Viollet-le-Duc begins
restoration of Notre Dame in Paris

1865 Assassination of U.S. President
Abraham Lincoln

1883 Opening of the Metropolitan
Opera in New York

1895 First Venice Biennale

1909 Sergei Dia
founds th
Ballets Ru
in Paris

1830 1835 1840 1845 1850 1855 1860 1865 1870 1875 1880 1885 1890 1895 1900 1905 1910 1915

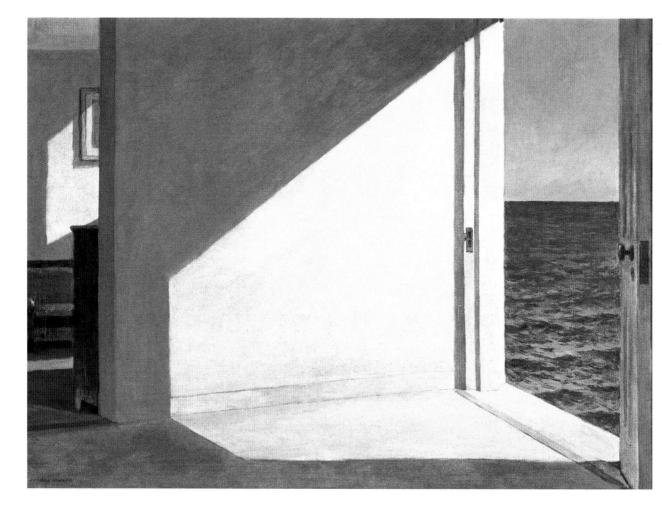

Edward Hopper, *Rooms by the Sea*, 1951,
oil on canvas, 37.7 x 101.9 cm, Yale University
Art Gallery, New Haven, Connecticut

1943 Premiere of Michael Curtiz's
film *Casablanca*

1990–1991 First Gulf War

1996 First mammal
cloned (Dolly
the sheep)

1929 Wall Street crash on October 25
triggers world financial crisis

1966 Barnett Newman paints *Who's
Afraid of Red, Yellow and Blue?*

.920 1925 1930 1935 1940 1945 1950 1955 1960 1965 1970 1975 1980 1985 1990 1995 2000 2005

EDWARD HOPPER

Even when in the company of others, the people in Edward Hopper's paintings appear to be alone. They brood over cups of coffee or gaze out windows that open on to empty streets. Hopper's solitary characters in their spare settings tell no tales, yet their self-containment has an evocative power that needs no explanation.

Hopper struggled for decades to win recognition as a painter. Throughout his early career in New York City, critics, as well as patrons, neglected his scenes of modern life. He easily found work in commercial illustration, where his keen observation and impeccable technique were highly valued. Hopper created illustrations and designed book jackets and movie posters, but he found the work distasteful, resenting editors who wanted lively figures who were "grimacing and posturing." In 1915 Hopper learned to etch. The precision of the medium was well suited to his candid scrutiny of life in the city. But he was also fascinated with natural light; *The Mansard Roof* (1923), a sun-washed watercolor of an old Victorian house, marked his first success. The Brooklyn Museum of Art purchased it after featuring it in an exhibition, and in 1924 Hopper sold every work in his first solo exhibition with a major gallery. The following year Hopper completed his last commission for book covers for Scribner's and then turned his full attention to painting.

In contrast to other urban scene painters, Hopper portrayed a quiet city. His night scenes feature empty streets and locked storefronts, illuminated by the moody glow of artificial light. His point of view was that of the passerby catching glimpses of anonymous people lingering in doorways or drinking coffee at the Automat. Wrapped in their own thoughts, they do not engage the viewer, yet the intensity of their self-containment commands attention. His scenes are both familiar and strange; his figures engage in everyday activities, but the isolation and stillness that surrounds them is impossible to penetrate. Hopper believed that "the inner life of a human being is a vast and varied realm," and his figures' motives defy anecdotal explanation. Even when they share their space, as the customers and counterman do in the diner in *Nighthawks* (1942), they keep to themselves.

Hopper's settings derive their stasis from his command of compositional structure and architectonic forms. He saw a stark beauty in the planes of brick and stone and the spans of concrete that make up a city's architecture. But his vision was never exclusively urban. As early as 1912, Hopper spent his summers in the coastal villages of Massachusetts, eventually building a home in Truro, on Cape Cod, in 1934. He repeatedly painted the old frame homes and lighthouses of the region to capture the radiant light effects on their bright, bleached-out surfaces. He saw no disparity between his fascination with urban and coastal locales and approached them with the same deep engagement, explaining, "I'm a realist and I react to natural phenomena." Despite his success, Hopper kept a low profile throughout his long career. His fascination with natural light increased over the years, and his late paintings often feature illuminated interior spaces that open out on to expanses of sand or water. When figures do appear, they warm themselves in sunlight that steams in through a window or they sunbathe on a porch, but they are as silent and as inscrutable as his urban denizens of earlier decades. For Hopper, painting was a matter of preserving his visual impressions through form, light, and color. He never intended to tell a story, explaining, "If I could say it in words there would be no reason to paint."

1882 Born on July 22 in Nyack, New York
1899–1900 Enrolls in the New York Correspondence School of Illustrating
1900–1906 Attends the New York School of Art
1906–1910 Makes three trips to Europe
1907–1925 Works as a freelance commercial illustrator
1913 Moves into a Greenwich Village studio; sells his first painting at the Armory Show
1915 Learns etching
1923 Sells *The Mansard Roof* for $100 to the Brooklyn Museum of Art
1924 Sells all the paintings at his first solo exhibition at the Frank K. M. Rehn Gallery in New York City
1928 Stops making prints
1934 Builds a summer house in Truro, Massachusetts
1937 Featured in a *Life* magazine profile with the title "Hopper Is a Realist"
1941 Takes a trip to the West Coast
1966 Receives an honorary doctorate of fine arts from the Philadelphia College of Art
1967 Dies on May 15 in New York City

FURTHER READING
Gail Levin, *Edward Hopper: An Intimate Biography*, New York 1995
Carol Troyen, *Edward Hopper*, Boston 2007
Sheena Wagstaff, David Anfam, and Brian O'Doherty, *Edward Hopper*, London 2004

Edward Hopper in Cape Elizabeth, Maine, 1927, Private Collection

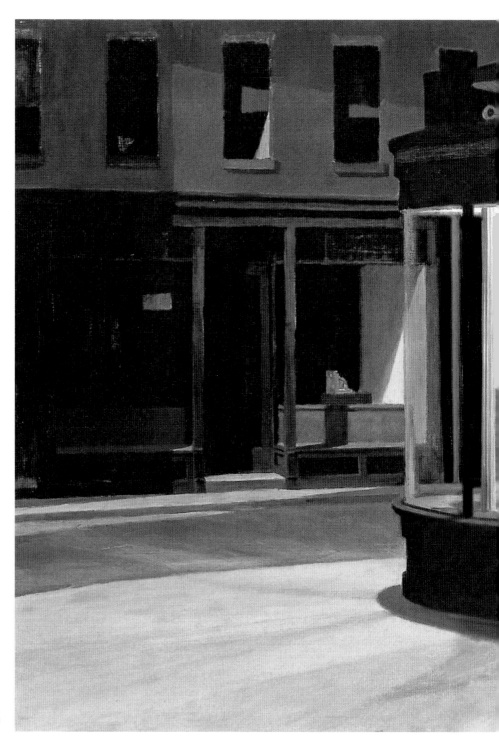

Edward Hopper, *Nighthawks*, 1942, oil on canvas, 84.1 x 152.4 cm, The Art Institute of Chicago

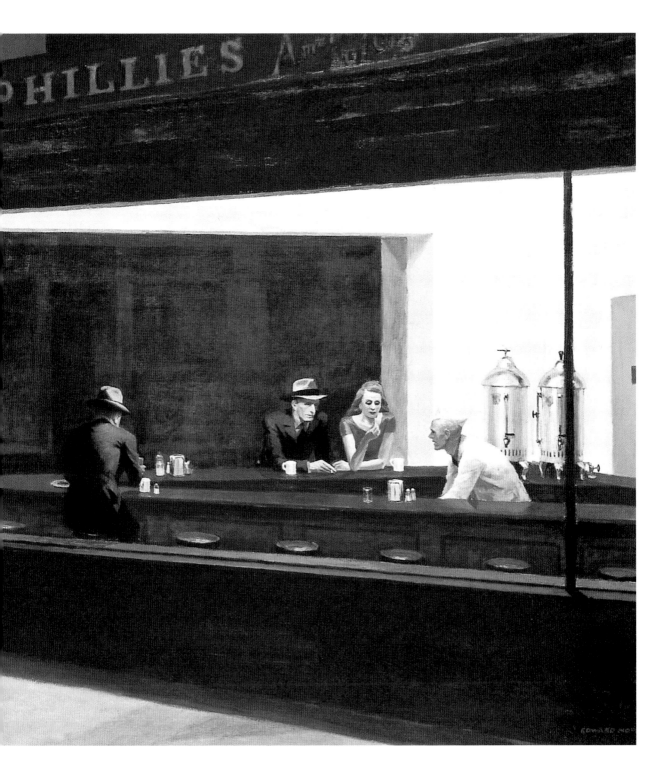

1865 Founding of the Ku Klux Klan

1905 Alfred Stieglitz opens the
"291" gallery in New York

1851 First issue of *The New York Times*

1893 Edvard Munch paints *The Scream*

| 1835 | 1840 | 1845 | 1850 | 1855 | 1860 | 1865 | 1870 | 1875 | 1880 | 1885 | 1890 | 1895 | 1900 | 1905 | 1910 | 1915 | 1920 |

Georgia O'Keeffe, *City Night*, 1926, oil on canvas,
121.9 x 76.2 cm, The Minneapolis Institute of Arts

1924 André Breton publishes the
first Surrealist manifesto

1942 Peggy Guggenheim opens the Art of
This Century Gallery in New York

1973 The *Roe v. Wade* verdict by the U.S.
Supreme Court declares abortion
fundamentally permissible

e Treaty of Versailles
rmally ends World War I

1957 The Treaty of Rome founds the
European Economic Community (EEC)

1992 The Treaty of Maastricht creates
the European Union (EU)

.925 1930 1935 1940 1945 1950 1955 1960 1965 1970 1975 1980 1985 1990 1995 2000 2005 2010

GEORGIA O'KEEFFE

Georgia O'Keeffe scoffed at critics who insisted on reading erotic content into her signature motifs, seeing "things that never entered my mind." Her quest was for form rather than meaning, and her brilliant imagery allows the viewer to see the natural world through her discerning eyes.

Late in 1915, O'Keeffe, an art teacher at a small college in South Carolina, sent a parcel of her newest charcoal drawings to her friend Anita Pollitzer in New York City. After years of working in a naturalist manner, O'Keeffe had turned to abstraction, inspired by the writings of Arthur Wesley Dow and Wassily Kandinsky. Without O'Keeffe's knowledge, Pollitzer took the drawings to Alfred Stieglitz. As director of the "291" gallery, Stieglitz promoted American Modernism, and he included O'Keeffe's drawings in his current exhibition. Soon after, O'Keeffe moved to New York City, where she pursued her abstract investigations with confidence and an individual vision, although she never fully relinquished representation. Over the next decade, she honed the eloquence of her calligraphic line and the dynamic expression of her shapes and colors in a limited repertoire of motifs that included the skyscrapers she viewed from her New York City apartment window and the trees and barns at Stieglitz's family retreat in Lake George, New York. In these early years she learned to work "by selection, by elimination, by emphasis," using close and repeated scrutiny to "get the real meaning of things."

During the early 1920s, O'Keeffe sought the "real meaning" of flowers by isolating the shape of a blossom against a neutral background, enlarging its scale, and looking deep into its center to explore organic form and resplendent color. Whether painting an iris, a rose, or a jack-in-the-pulpit, she chose her model for its pictorial allure rather than for symbolic meaning. Her opulent tones and undulant forms are clearly sensuous; her intent was to draw the viewer in close to experience the formal possibilities of color, line, and shape. The object is significant only in that it peaked O'Keeffe's curiosity; through her engaged observation, she redefined content as form. Despite her ongoing frustration with critics who projected sexual metaphors on to her flowers, she maintained that their misguided fascination bore witness to the success of her approach: "I made you take time to look at what I saw."

In 1929 O'Keeffe traveled to Santa Fe and Taos, New Mexico. Enthralled with the severe terrain and dazzling light, she returned each year to paint while Stieglitz stayed behind in New York. In 1934 she made her first visit to the Ghost Ranch, near Abiquiu, New Mexico; six years later she bought a small house named Rancho de los Burros on the property. O'Keeffe found inspiration in the rugged beauty of the desert, and the isolation suited her nature and energized her work. She painted the mesas and the sky, and the bones that she found bleaching out in the desert sun drove her work in a new direction. She took them back to her studio and painted their strong shapes against bare backgrounds, capturing every nuance of pale tonal modulation and shadow. She paired a ram's skull with flowers and looked at the vast expanse of the sky through the circle of a pelvic bone. New Mexico became her home; she bought a second house in Abiquiu in 1945, and after Stieglitz died, she made it her permanent residence. O'Keeffe remained active well into old age, finding new stimulus in travel but keeping to a limited repertoire of subjects. She acknowledged that she took her time getting to know her motifs, comparing the process to getting acquainted with other people and admitting, "I don't get acquainted easily."

1887 Born on November 15 near Sun
Prairie, Wisconsin
1905–1906 Enrolls at the School of the
Art Institute of Chicago
1907–1908 Studies at the Art Students
League in New York City
1912–1914 Becomes the supervisor of
art and penmanship in the public
schools of Amarillo, Texas
1915 Teaches art at Columbia College
in Columbia, South Carolina
1916 Begins a correspondence with
Alfred Stieglitz
1917 Has her first solo show at the
"291" gallery in New York City;
takes her first trip to New Mexico
1918 Moves to New York City
1924 Marries Alfred Stieglitz
1929 Begins to spend her summers in
New Mexico
1934 Makes her first visit to the Ghost
Ranch, near Abiquiu, New Mexico
1946 Stieglitz dies
1949 O'Keeffe leaves New York City for
New Mexico
1971 Loses her central field of vision
1984 Stops making art; moves to Santa
Fe
1986 Dies on March 6 in Santa Fe
1989 The Georgia O'Keeffe Foundation
is founded in Abiquiu

FURTHER READING
Barbara Buhler Lynes, *Georgia O'Keeffe Museum Collections*, New York 2007
Lisa Mintz Messinger, *Georgia O'Keeffe*, New York 1988
The Georgia O'Keeffe Museum can be visited online at:
http://www.okeeffemuseum.org

Alfred Stieglitz, Georgia O'Keeffe, 1932

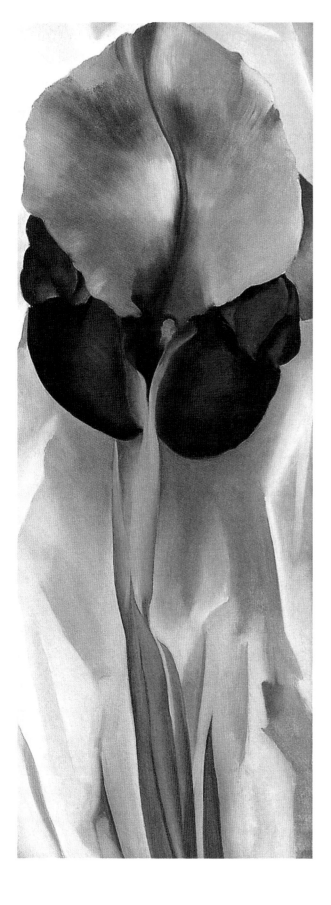

Georgia O'Keeffe, *Iris (Dark Iris I)*, 1927, oil on canvas, 81.3 x 30.5 cm, Colorado Springs Fine Arts Center

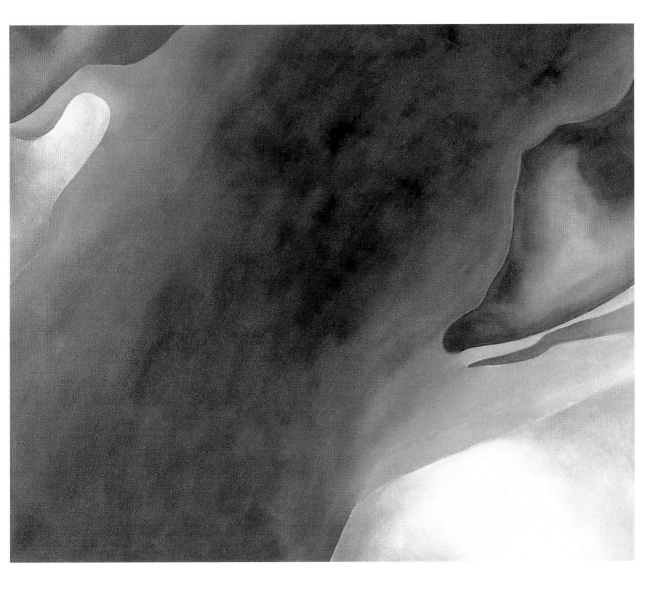

Georgia O'Keeffe, *Blue B*, 1959, oil on canvas, 76.2 x 91.4 cm, Milwaukee Art Museum

THOMAS HART BENTON

GIORGIO DE CHIRICO

MAX ERNST

1851 Herman Melville publishes
Moby Dick

1868 Richard Wagner's opera The Mastersingers
of Nuremberg premieres

1880 First issue of Science periodical

1901 Theodore Roosevelt becomes
26th President of the United States

1912 The Titanic sinks in
the North Atlantic

1840 1845 1850 1855 1860 1865 1870 1875 1880 1885 1890 1895 1900 1905 1910 1915 1920 1925

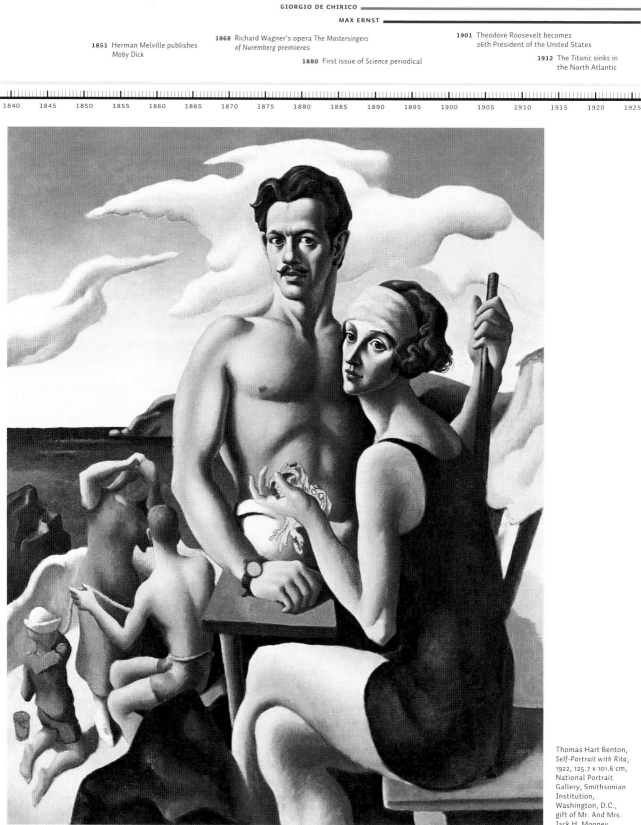

Thomas Hart Benton,
Self-Portrait with Rita,
1922, 125.7 x 101.6 cm,
National Portrait
Gallery, Smithsonian
Institution,
Washington, D.C.,
gift of Mr. And Mrs.
Jack H. Mooney

THOMAS HART BENTON

A leading figure in the Regionalist movement, Thomas Hart Benton drew his subjects from local legends, midwestern history, and everyday experience. In sweeping murals, teeming with sinewy figures in action, he portrayed an epic image of America, grand in scope and populist in vision.

As a boy, Benton attended political rallies in Missouri with his father—a U.S. congressman—and when the family moved to Washington, D.C., he took art lessons at the Corcoran Gallery. But when they returned to Neosho, Missouri, in 1905, Benton's father objected to his son's aspirations to pursue a career in the arts. Benton rebelled and moved to Joplin, Missouri, to take a job as a newspaper cartoonist. He moved on to Chicago and then to Paris to continue his studies. By the time he returned to the United States in 1912, Benton had embraced a wide range of influences, ranging from the innovations of Picasso and Delaunay to the illusionism of Rubens and Tintoretto. After a brief visit home, he settled in New York City, entering a phase of imitation and experimentation during which he was "rocked by every boat that came along." He was most influenced by Synchromism, a combination of brilliant tones and fragmented Cubist forms, but after a stint in the U.S. Navy, he became convinced that content, rather than form, gave art its value.

Throughout the 1920s, Benton focused on "American subjects" with "American meaning." He undertook an extensive cycle called the *American Historical Epic* (1919–1926) representing the nation's westward expansion, for which he planned complex compositions by modeling his figures in plasticine and staging them in three-dimensional vignettes. To fulfill his desire to paint on a grand scale, believing that it was "more expressive of society," Benton secured the mural commission *America Today* (1930) for the New School of Social Research in New York City. His near-life-sized figures—limber, long-limbed, and muscular—seemed to leap off the wall in his depictions of hard work and hard play. His early influences were evident in his vibrantly aggressive colors and rhythmic compositions.

Many of Benton's contemporaries dismissed the murals as banal "tabloid art" expressing "cheap nationalism," but *America Today* led to another,

more prominent commission: a mural cycle for the Indiana state pavilion at the 1933 "Century of Progress" World's Fair in Chicago. It was a vast project, and Benton delivered a panoramic ensemble of vigorous figures jostling for space and attention in a panoramic setting that mapped the transformation of the wilderness into thriving farms and bustling cities. Benton called his approach "social history," which presented the real experience of real people. It was too real for some Indiana residents, who objected to his depiction of a recent miners' strike and a meeting of the Ku Klux Klan. But the mural won national acclaim, and, hailed as the leader of a new art movement that celebrated the American Scene, Benton was featured on the cover of *Time* magazine in 1934.

Benton seized the opportunity to advocate his now-ironclad conviction that the spirit of American art should be regional. He gave lectures on Regionalism throughout the Midwest, infuriated the New York City art world with his dismissive criticism of Modernism, and moved back to Missouri to take a teaching position at the Kansas City Art Institute. He painted a social history of his home state for the capital building in Jefferson City (1936), in which he freely mixed boyhood memories, civic history, and local lore. It, too, stirred controversy for its depiction of a lynching and the persecution of the Mormons. Always opinionated and confrontational, Benton relished defending his art as a true national expression. He was working on a mural for the Country Music Hall of Fame in Nashville, Tennessee, on the day that he died.

1889 Born on April 15 in Neosho, Missouri
1896–1904 Takes art classes at the Corcoran Gallery in Washington, D.C.
1908–1911 Studies art in Paris
1912 Settles in New York City
1918–1919 Serves in the U.S. Navy documenting shipyards
1926–1935 Teaches at the Art Students League in New York City; Jackson Pollock is among his students
1933 Commissioned to paint *The Social History of the State of Indiana* for the "Century of Progress" World's Fair in Chicago
1935 Moves to Kansas City, Missouri
1935–1941 Teaches at the Kansas City Art Institute; is fired over a dispute with the Board of Governors
1936 Paints the mural *The Social History of the State of Missouri* in Jefferson City
1937 Publishes his autobiography, *An Artist in America*
1939 Illustrates John Steinbeck's *Grapes of Wrath*
1941 Paints patriotic paintings as part of the war effort
1959–1962 Paints murals for the Harry S. Truman Library in Independence, Missouri
1975 Dies on January 19 in Kansas City

FURTHER READING
Henry Adams, *Thomas Hart Benton: An American Original*, New York 1989

Thomas Hart Benton in his Navy uniform, 1918

HENRI ROUSSEAU

GEORGE GROSZ

1908 First Ford Model T rolls off
the conveyor belt in Detroit

1871 Giuseppe Verdi's opera *Aida*
premiered in Cairo

1855 Courbet's "Realism"
exhibition

1891 Paul Gauguin's first trip to Tahiti

1917 United States
enters World Wa

| 1840 | 1845 | 1850 | 1855 | 1860 | 1865 | 1870 | 1875 | 1880 | 1885 | 1890 | 1895 | 1900 | 1905 | 1910 | 1915 | 1920 | 1925 |

Grant Wood, *American Gothic*,
1930, oil on pressed wood
panel, 74.3 x 62.6 cm,
The Art Institute of Chicago

right side
below
Grant Wood, *Daughters of
Revolution*, 1932, oil on
pressed wood panel,
50.8 x 101.6, Cincinnati Art
Museum, The Edwin and
Viginia Irwin Memorial

above
Grant Wood in his summer
studio in Clear Lake, Iowa,
1941, Cedar Rapids Museum
of Art Archives

1935–1944 Walker Evans and Dorothea Lange photograph rural poverty in the United States on behalf of the Farm Security Administration (FSA)

1951 J. D. Salinger publishes *Catcher in the Rye*

1966–1973 Construction of the World Trade Center in New York

1981 Ronald Reagan becomes 40th President of the United States

1997 UN climate conference concludes with Kyoto Protocol

1930 1935 1940 1945 1950 1955 1960 1965 1970 1975 1980 1985 1990 1995 2000 2005 2010 2015

GRANT WOOD

After a decade of traveling to Europe, Grant Wood settled in his hometown of Cedar Rapids, Iowa, to paint the world as he had known it since his childhood. Using clean lines and clear colors, Wood captured the spirit of regional America, portraying the plainspoken people and the farmlands of the Midwest.

Wood began drawing as a schoolboy in Cedar Rapids, and in his youth he designed sets for the local theater, organized exhibitions, and volunteered at the Cedar Rapids Art Association, helping with everything from installing art to guard duty. He attended art school in Minneapolis, Iowa City, and Chicago, studying design, metalwork, and life drawing, but never completed his studies. Wood enlisted in the U.S. Army in 1917, painting camouflage on weaponry, and after the war, he taught art in his hometown's schools. Two trips to Paris inspired him to adopt a heavy-handed Impressionistic style. In 1928 he stayed in Munich, where he oversaw the fabrication of a stained-glass window that he designed for the Veterans' Memorial Building in Cedar Rapids; in Berlin he found more compelling inspiration in the "rationalism" of Northern Renaissance painters such as Hans Memling. When he returned to his studio, he sought to translate the aesthetic strength of these artists' "cohesive compositions" into his own vernacular.

Wood's new style was immediately evident in portrait commissions of the late 1920s, but he quickly turned to local generic subjects featuring the farmlands, the townscapes, and the solid citizens of his region. No detail escaped his delineation, and he used a hard-edged approach that he described as "especially suggestive of Middle West civilization."

Wood chose a high perspective that exaggerated the vast sweep of the prairie for his landscapes, and he achieved a monumentality for his plain figures by portraying them in half length on the front plane of the foreground against a panoramic view. He constructed a true image of the world he knew based on observation as well as memory; to aid his work in the studio he took photographs, built models, and studied the merchandise in the Sears Roebuck catalogue.

On a drive to the small town of Eldon, Iowa, Wood discovered a white frame building that inspired the painting *American Gothic* (1930). He dressed his sister in an apron trimmed with rickrack and his dentist in overalls and posed them in front of the facade of the "Carpenter Gothic" farmhouse. Exhibited in Chicago in 1930, the painting won Wood acclaim; it was widely reproduced and hailed as an indelible image of iconic American character. In a country mired in economic depression, Wood's stoic couple embodied the bedrock values of the nation and the resolve needed to survive the crisis. With like-minded artists such as Thomas Hart Benton, Wood represented the spirit of small-town America in a style that he promoted as Regionalism.

Wood was an activist and a populist. He headed the Works Progress Administration's Public Works of Art Project in Iowa and gave lectures on Regionalist art. He joined the faculty of fine arts at the State University of Iowa (now the University of Iowa) in Iowa City in 1934, and for the remainder of his life he divided his attentions among teaching, public commissions, and increasingly personal depictions based on his memories of childhood in a farming community. Determined to share art with a general audience, Wood took up lithography in 1936 to produce book illustrations and affordable prints. But by the end of the 1930s, the art world's interest in Regionalism waned in favor of a more international, Modernist view. Wood resisted the change; in defense of the straightforward style and colloquial repertoire of his paintings and prints, he declared: "Art that loses contact with the public is lost."

1891 Born on February 13 near Anamosa, Iowa
1910–1911 Studies at the School of Design, Handicraft, and Normal Art in Minneapolis, Minnesota
1916 Enrolls at the School of the Art Institute of Chicago
1917–1918 Joins the U.S. Army; paints camouflage
1919–1925 Teaches art in Cedar Rapids, Iowa
1920 Takes his first trip to Paris
1923–1924 Travels in Europe
1924 Moves into his Cedar Rapids studio
1928 Travels to Munich
1930 The Art Institute of Chicago purchases *American Gothic* for $300
1932 Grant co-founds the Stone City Art Colony and School outside Cedar Rapids
1934 Is appointed the Iowa State Director of the Public Works of Art Project and also Associate Professor of Fine Arts at the State University of Iowa in Iowa City
1942 Dies on February 12 in Iowa City, Iowa

FURTHER READING
Wanda M. Corn, *Grant Wood: The Regionalist Vision*, New Haven, CT, 1983
Jane C. Milosch (ed.), *Grant Wood's Studio: Birthplace of American Gothic*, New York 2005
The Grant Wood Studio in Cedar Rapids, Iowa, can be visited online at: http://www.crma.org/Content/Grant_Wood/Grant_Wood_Studio.aspx

1855 First edition of *The Daily Telegraph*

1871 James McNeill Whistler paints
Portrait of the Artist's Mother

1895 Wilhelm Conrad Röntgen
discovers X-rays

1905–1911 Construction of the Palais Stoclet
in Brussels to plans by Josef Hoffmann

1919 Founding of
the Bauhaus
Weimar

| 1840 | 1845 | 1850 | 1855 | 1860 | 1865 | 1870 | 1875 | 1880 | 1885 | 1890 | 1895 | 1900 | 1905 | 1910 | 1915 | 1920 | 1925 |

Henry Darger, *Spangled Blengins. ~~Edible~~.
Boy King Islands. One is a young
Tuskerhorian the other a human headed
Dortherean*, collage, watercolor,
pencil, and carbon tracing on paper,
35.6 x 43.2 cm, Collection Kiyoko Lerner

1937 Pablo Picasso paints *Guernica*

1962–1965 Second Vatican Council flags
Roman Catholic readiness for dialogue
with other faiths and non-believers

1995 Japanese launch Tamagotchi
electronic toys

1945 Atomic bombs dropped on Hiroshima and Nagasaki

1979 Islamic Revolution in Iran led by
Ayatollah Ruhollah Khomeini

| 1930 | 1935 | 1940 | 1945 | 1950 | 1955 | 1960 | 1965 | 1970 | 1975 | 1980 | 1985 | 1990 | 1995 | 2000 | 2005 | 2010 | 2015 |

HENRY DARGER

Every night, after working a menial job at a local hospital, Henry Darger took part in an epic, international struggle to free innocent children from enslavement. The warring parties and the children were Darger's invention; he brought them to life in a fifteen-volume saga illustrated with hundreds of extraordinary drawings.

Darger's childhood in Chicago was marked by loss. In 1896 his mother died in childbirth and his infant sister was put up for adoption. Four years later, when his disabled father needed nursing-home care, Darger was sent to a boys' home. His behavior was unruly, and on the diagnosis by a school doctor that his "heart is not in the right place," Darger was sent to the Asylum for Feeble-Minded Children in Lincoln, Illinois. In 1907, after news of his father's death, he made several attempts to escape. He succeeded in 1908, returned to Chicago, and found work doing menial tasks at St. Joseph's Hospital.

In 1930 Darger moved into a room on Webster Street in Chicago's Lincoln Park neighborhood, where he lived the rest of his life. His neighbors remember him as quiet and self-contained, a man whose whole life seemed to consist of going to work and to mass. After his death in 1973, when landlord Nathan Lerner began sort through the contents of Darger's cluttered apartment, he was astonished to find among the piles of newspapers, magazines, and balls of twine a fifteen-volume, 15,000-page manuscript titled *The Story of the Vivian Girls, in what is Known as the Realms of the Unreal, of the Glandeco-Angelinnian War Storm, Caused by the Child Slave Rebellion.*

Darger's saga, likely written between 1909 and the early 1930s, takes place on an unnamed planet, where the evil men of the powerful nation of Glandelinia have enslaved all the children, including seven angelic princesses called the Vivian Sisters. These bold girls rally their fellow child slaves to revolt, and they are helped by Catholic soldiers of the nation of Abbiennia. Darger identified himself as the "author of this thrilling story"; he also gave his name to the finest of the Abbiennian heroes. Darger also wrote battle songs, made lists of the dead and wounded, and produced hundreds of drawings—some on pieced-together paper to create a 10-foot- (3-meter-) long strip—to illustrate his tale.

Although untrained in the arts, Darger's methods were meticulous and inventive. He used carbon and tracing paper to transfer found images from magazines, newspapers, and coloring books to create complex ensembles that depicted the bloody battles, narrow escapes, and shocking scenes of terror so essential to his tale. He also used collage, and sometime in the 1940s he began to have photographic enlargements made of favorite images that he traced repeatedly into his compositions. Darger painted with watercolor sets that he bought at the dime store. His image sources included comic strips, advertisements, and pictures of child stars, but his iconography was all his own. Each army has distinctive uniforms—the Glandelinian soldiers wear Confederate army jackets and mortarboard hats—and Darger drew maps and designed flags. The seven Vivian Sisters have gleaming blonde curls and wear garments that were in fashion for girls in the 1920s. He also created the fantastic but kindhearted Blengigomeneans, called Blengins for short. Some look like dragons, while others are beautiful nude girls with rams' horns and butterfly wings. Since the discovery of his illustrated epic, along with another novel about the Vivian Sisters and an autobiography, Darger's private world has become public, inspiring elaborate analyses by scholars as well as art, poetry, and music by Grayson Perry, John Ashbery, and Natalie Merchant.

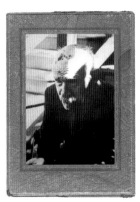

1892 Born on April 12 in Chicago, Illinois

1900 When his father moves into an assisted-living facility, Darger is sent to a Catholic boys' home

1905 Transferred to the Asylum for Feeble-Minded Children in Lincoln, Illinois

1908 Runs away from the asylum; employed as a menial worker at St. Joseph's Hospital in Chicago

1909 Probably begins to write *In the Realms of the Unreal*

1917 Drafted into the U.S. Army

1918 Discharged for eye problems; resumes employment at St Joseph's Hospital

1930 Moves into a room in the Lincoln Park neighborhood of Chicago

1939 Writes *Crazy House: Further Adventures in Chicago*

1944 Begins his earliest documented use of photographic enlargements

1957–1967 Keeps detailed weather journals

1963 Forced to retire due to illness

1966 Begins to write *My Life History*

1973 Dies on April 13 in Chicago

FURTHER READING
Klaus Biesenbach, *Henry Darger*, Munich 2009
A film about Darger is *In the Realms of the Unreal*, dir. Jessica Yu, 2004

David Berglund, Henry Darger, c. 1970, courtesy American Folk Art Museum, New York

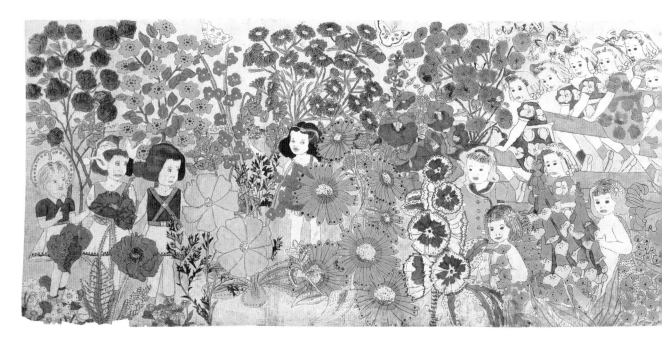

Henry Darger, *Untitled (overall flowers)*,
watercolor, pencil, and carbon tracing on
pieced paper, 61 x 274.3 cm, Collection
Kiyoko Lerner

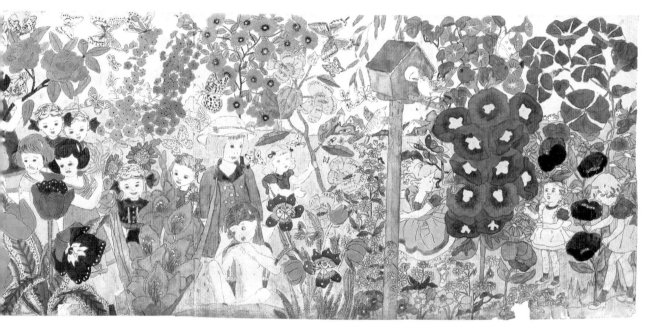

1861 Abraham Lincoln becomes
16th President of the United States

1872 Metropolitan Museum of Art
opens in New York

1885–1889 August Rodin sculpts
The Burghers of Calais

1909 Founding of the Knave of
Diamonds group of artists
in Moscow

1925 F. Scott
Fitzgera
publish
The Gre

1845 1850 1855 1860 1865 1870 1875 1880 1885 1890 1895 1900 1905 1910 1915 1920 1925 1930

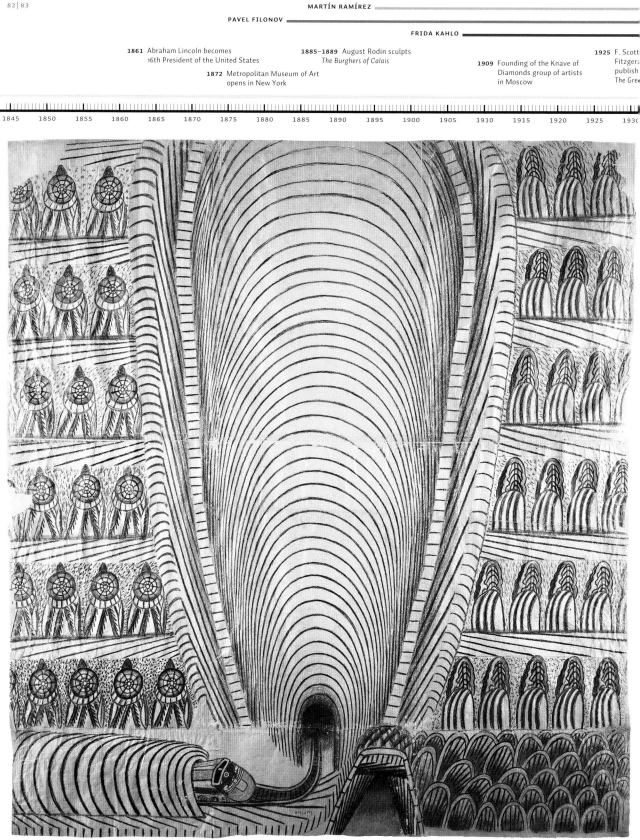

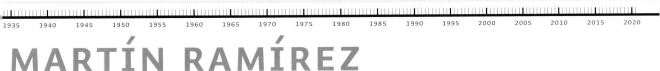

1938 The *Hindenburg* Zeppelin, the largest air vehicle ever built, goes up in flames as it docks at Lakehurst, New Jersey

1958 First Agnes Martin solo exhibition in New York

1974 Watergate scandal ends with resignation of U.S. President Richard Nixon

1991 Breakup of the USSR

2004–2010 Construction of Burj Chalifa in Dubai

1935 1940 1945 1950 1955 1960 1965 1970 1975 1980 1985 1990 1995 2000 2005 2010 2015 2020

MARTÍN RAMÍREZ

Out of work and far from home, Martín Ramírez was detained for vagrancy by the San Joaquin County police in California in 1931. He was transferred to the state psychiatric hospital, diagnosed with incurable schizophrenia, and institutionalized for life. Unable or unwilling to communicate, Ramírez turned to drawing, revealing a world that transcended his confinement.

Ramírez left his village in Jalisco, Mexico, in 1925 to seek work in California. Like many men of his generation, he hoped that his stay would be brief—just long enough to pay off some standing debts and augment his family's income. For the next few years, Ramírez traveled throughout California, working in the mines and on the railroads and sending part of his wages home to his wife and four children. But after the onset of the Great Depression, his contact with his family ceased. In 1931, when the San Joaquin County police branded him a vagrant and took him into custody, he appeared irrational and confused, so they committed him to the Stockton State Hospital. Over the next decade, aside from repeated and brief escapes, Ramírez proved to be a cooperative but uncommunicative patient. In 1946 he was transferred to the DeWitt State Hospital in Auburn, California, where he lived until his death.

The circumstances that prompted Ramírez to start drawing are not known, but by 1935 the staff at Stockton observed that he drew with increasing regularity and intensity. He used any materials that were on hand: paper bags, scavenged notes and memos, and paper rolls made to cover examination tables. He drew with crayons, but also made pigments out of juice and shoe polish, applying them with a matchstick. He used a tongue depressor as a straight edge and collaged images torn from discarded magazines on to his drawings with paste that he made out of bread and saliva.

The staff at Stockton seemed to appreciate his work; they sent some of his drawings to his family in Mexico when he was transferred to DeWitt. But in 1948 Tarmo Pasto, a visiting professor from Sacramento State College who was studying the links between art and psychology, identified Ramírez as an original talent rather than just a patient obsessed with drawing. Pasto requested that Ramírez be released from daily chores to concentrate on his art. He brought him art supplies,

which Ramírez incorporated into his ad hoc practice, and arranged to exhibit Ramírez's work in a group show at the M. H. de Young Memorial Museum in 1954.

For nearly thirty years Ramírez explored a limited number of motifs. In some he recalls his homeland: an image of the Madonna similar to the type favored in Mexican churches and on holy cards, and proud *jinetes* (horsemen) brandishing guns and flags with bands of bullets crossing their chests. In others, he portrays the modern world on the move: trains barreling through tunnels and cars speeding along highways. These separate worlds sometimes converge, when he depicts animals that placidly graze near the train tracks and *jinetes* who ride their horses right into the station. His line is taut but effortless, and his repetition of parallel curves, set up in elaborate patterns to indicate roads, hills, and soaring towers, enlivens his designs with unified energy. He was deliberate about his imagery. On a visit to DeWitt, artist Wayne Thiebaud watched as Ramírez consulted drawings—"little prototypes"—that he kept in his jacket as he arranged the characters of his composition as if he were blocking the members of "a repertory company" on a stage.

But the narrative he composed remains elusive, fraught with the contradictions of a life experienced between contradictions: the traditional and the modern, Mexico and the United States, freedom and confinement, and lived reality and the artist's imagination.

1895 Born on January 30 in Rincón de Velázquez, Jalisco, Tepatitlán, Mexico
1918 Marries María Santa Ana Navarro Velázquez
1925 Departs for the United States
1925–1930 Works temporary jobs in mines and on railroads in California
1931 Committed by San Joaquin County police to the Stockton State Hospital
1932–1944 Makes repeated escapes from the state hospital
AROUND 1935 Turns an intense attention to drawing
1946 Transferred to the DeWitt State Hospital in Auburn, California
1948 Visited by Professor Tarmo Pasto, who takes an interest in his treatment
1952 Has a solo exhibition of his art, organized by Pasto, on the campus of the University of California, Berkeley
1963 Dies on February 17 in the DeWitt State Hospital

FURTHER READING
Brooke Davis Anderson (ed.), *Martín Ramírez*, Seattle 2007
Brooke Davis Anderson (ed.), *Martín Ramírez: The Last Works*, New York 2008

left page
Martín Ramírez, *Untitled (Super Chief)*, 1954, crayon and pencil on pieced paper, 139,7 x 129,5 cm, Collection American Folk Art Museum, New York, Promised gift of Lois and Richard Rosenthal

1861 American Civil War breaks out

1881 First electric tram in Berlin

1901 Construction of the Ward W. Willitts House in Highland Park, Illinois, to plans by Frank Lloyd Wright

1920–1921 Alexander Rodchenko d free-floating *Spatial Constructi*

| 1850 | 1855 | 1860 | 1865 | 1870 | 1875 | 1880 | 1885 | 1890 | 1895 | 1900 | 1905 | 1910 | 1915 | 1920 | 1925 | 1930 | 1935 |

1941 Premiere of Orson Welles's film
Citizen Kane

1959 Allan Kaprow organizes the first Happening
at the Reuben Gallery in New York

1983 Pope John Paul II.
rehabilitates Galileo Galilei

1977 First skulptur.projekte
in Münster

1992–1995 Bosnian War

2007 Damien Hirst presents
For the Love of God skull

| 1940 | 1945 | 1950 | 1955 | 1960 | 1965 | 1970 | 1975 | 1980 | 1985 | 1990 | 1995 | 2000 | 2005 | 2010 | 2015 | 2020 | 2025 |

ALEXANDER CALDER

On a visit to Piet Mondrian's Parisian studio in 1930, Alexander Calder became captivated with some color cardboard rectangles tacked on a white wall. Mondrian used them to arrange his geometric compositions, but they gave Calder an idea for his own work. He imagined them suspended and oscillating—a sculpture set into motion.

Throughout his youth Calder resisted becoming an artist, even though his father and grandfather were renowned sculptors and his mother was a successful portrait painter. Instead Calder chose to study mechanical engineering and received his degree in 1919 from the Stevens Institute of Technology in Hoboken, New Jersey. For a few years he moved from job to job. In 1922 he sailed from New York City to San Francisco via the Panama Canal, working as a fireman in a boiler room. One morning at dawn, off the Guatemalan coast, he was stunned to see the simultaneous appearance of a blood-red sun and a cold-silver moon on opposite horizons. The visual spectacle of the natural world made him yearn to paint, and a few months after his boat docked, he moved to New York City and enrolled at the Art Students League.

To earn his way, Calder became a press artist for the *National Police Gazette*. A two-week assignment covering the Ringling Brothers and Barnum & Bailey Circus inspired him to make figures—acrobats, tightrope walkers, animals—out of found materials and wire. In 1926 he packed his figures up to move to Paris, where he became a sensation with his performances of the "*Cirque Calder*." Seated amid his little troop, Calder would manipulate the figures manually. He charmed the avant-garde art world circle, including Joan Miró, Marcel Duchamp, and Jean Cocteau. Calder made portraits of his new friends—as well as Parisian celebrities such as Josephine Baker—out of twisted wire. They looked like outline drawings made in the air, and in 1928 his wire sculptures were featured in his first solo exhibition, at the Weyhe Gallery in New York City.

Calder's 1930 visit to Mondrian's studio "shocked" him into abstraction. He cut shapes out of wood and suspended them on wires. To answer his own question, "Why must art be static?" he powered the forms into motion with a motor. When Duchamp saw these new sculptures in Calder's studio in 1931, he named them "mobiles," a French double

entendre suggesting both "motion" and "motive." Calder quickly refined his form, eliminating the motor and achieving his desired oscillation solely by the currents of the wind. For the rest of his career, he tested the limits of balance and scale in the suspended forms of his mobiles.

Calder also explored the abstract potential of still form; Jean Arp dubbed his motionless sculptures "stabiles." Calder bolted sheets of cut and curved metal to make standing stabiles such as *Devil Fish* (1937), and the innovation allowed him to increase his scale. *Mercury Fountain*, featured in the Spanish Pavilion at the 1937 World's Fair in Paris, won him international acclaim, and after World War II, public commissions dominated his career.

Calder never stopped experimenting in form. In *La Spirale* (1958), installed at the UNESCO Headquarters in Paris, he mounted a mobile form on a stabile base. He designed wire jewelry, as well as sets and costumes for ballet and theater. His largest stabile, *El Sol Rojo*, a 67-foot (20-meter) black work bearing a bright-red sun, was commissioned by Mexico City for the 1968 Olympics. And at the end of his career he created *Flying Colors*, a distinctive abstract pattern in primary colors designed to adorn Braniff International Airlines' DC-8 fleet. Whether working large or small, Calder held to the singular belief that forms must be conceived as "spaces carved out within surrounding space."

left page
Alexander Calder, *Josephine Baker IV*, 1928, iron wire, 100 x 84 x 21 cm, Musée national d'art moderne, Centre Georges Pompidou, Paris

above
André Kertész, Alexander Calder with his circus, 1929

following double page
left
Alexander Calder, *Red Petals*, 1942, wire, sheet metal, and paint, 259 x 91 cm, The Arts Club of Chicago

right
Alexander Calder, *Four Leaves and Three Petals*, 1939, sheet metal, wire, and paint, 205 x 174 x 135 cm, Musée national d'art moderne, Centre Georges Pompidou, Paris

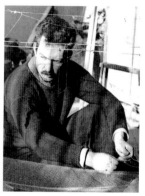

1898 Born on July 22 in Lawnton, Pennsylvania
1919 Receives a degree in mechanical engineering from the Stevens Institute of Technology in Hoboken, New Jersey
1923–1925 Studies painting at the Art Students League in New York City
1924 Begins work as a press artist for the *National Police Gazette*
1926 Sails to Europe; gives the first performance of his *Cirque Calder* in Paris
1928 Has a solo exhibition of wire sculptures at the Weyhe Gallery in New York City
1931 Creates kinetic sculptures called "mobiles" by Marcel Duchamp
1933 Purchases a farmhouse in Roxbury, Connecticut
1937 Designs *Mercury Fountain* for the Spanish Pavilion at the World's Fair in Paris
1958 Has *La Spirale* installed for UNESCO in Paris
1967 Designs *El Sol Rojo* for the 1968 Olympics to be held in Mexico City
1973 Commissioned to create designs for Braniff International Airlines' DC-8 fleet
1976 Dies on November 11 in New York City

FURTHER READING
Carmen Giménez, A. S. C. Rower, and F. Calvo Serraller, *Calder: Gravity and Grace*, London 2004
Marla Prather, *Alexander Calder: 1898–1976*, Washington, DC, 1998

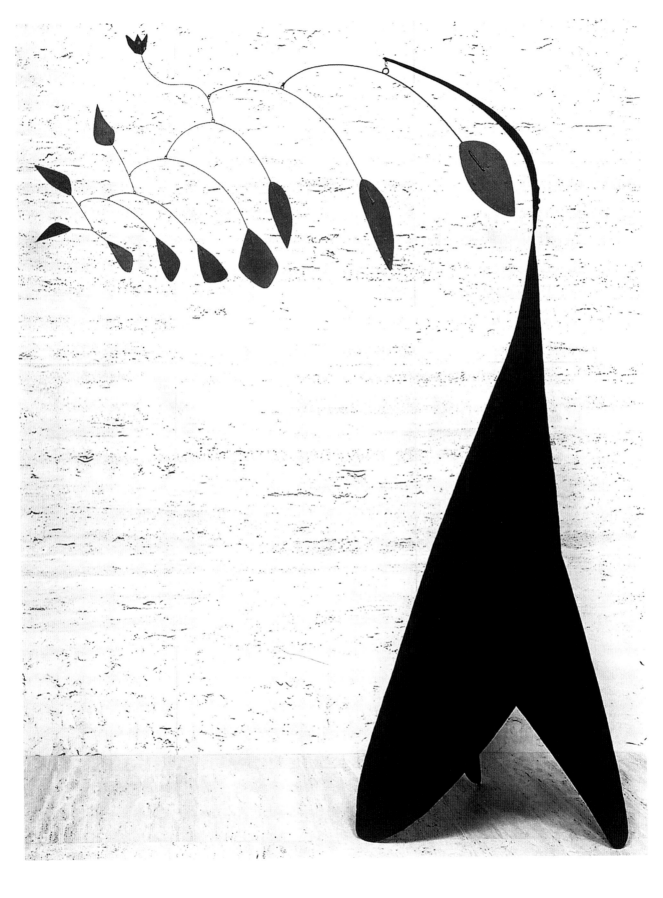

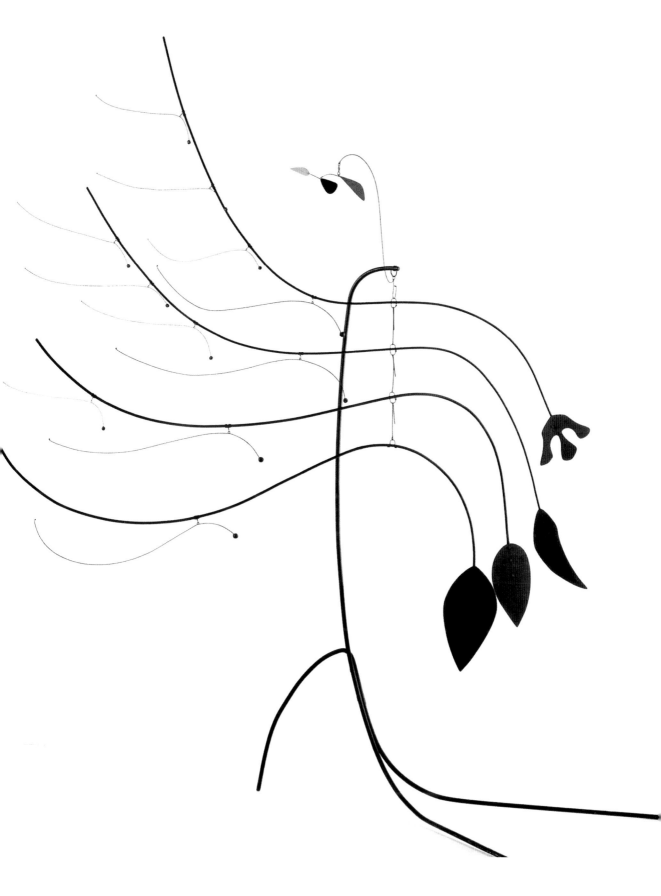

1861 Women get the vote in Australia **1900** Boxer Rising in China **1920–1930** Harlem Renaissance

1885 Mark Twain publishes
The Adventures of Huckleberry Finn

| 1850 | 1855 | 1860 | 1865 | 1870 | 1875 | 1880 | 1885 | 1890 | 1895 | 1900 | 1905 | 1910 | 1915 | 1920 | 1925 | 1930 | 1935 |

Alice Neel, *Nancy and the Rubber Plant*,
1975, oil on canvas, 203.2 x 91.4 cm,
Private Collection

1945 Marilyn Monroe discovered as photo model

1959 Cuban Revolution

1969 Stonewall Riots in Christopher Street in New York

1977–1980 Cindy Sherman's *Untitled Film Stills*

1995 Founding of the World Trade Organization (WTO)

2006 The highest price to date for a work of art, $140 million, paid for Jackson Pollock's *No. 5 of 1948*

1940 1945 1950 1955 1960 1965 1970 1975 1980 1985 1990 1995 2000 2005 2010 2015 2020 2025

ALICE NEEL

Alice Neel painted landscapes, still lifes, and urban scenes, but portraiture defined her aims as an artist. For over six decades, "using people as evidence," Neel chronicled her times in insightful likenesses of family, friends, and art world colleagues that are unparalleled for their candor and intimate point of view.

In her art—as well as her life—Neel followed her own path. She chose to train at the Philadelphia School of Design for Women (now the Moore College of Art and Design) rather than the more prestigious Pennsylvania Academy of the Fine Arts because she "didn't want to be taught Impressionism." Neel preferred the more passionate examples of Goya, Munch, and the German Expressionists. She followed her husband, Carlos Enríquez, to Havana, but their older daughter died, the marriage failed, and she lost custody of their second daughter. Her personal life was turbulent: one lover destroyed her work and another left shortly after the birth of their son. Neel had another son, and she eventually raised her two boys, Richard and Hartley, on her own. But it was the life of her times—rather than her biography—that filled her repertoire of subjects. Whether painting political demonstrations, the neighborhood boys in Spanish Harlem, or whimsical scenes of herself with lovers, Neel reveled in what she called "the human comedy."

During her decade-long involvement with federal art programs, Neel was amused to hear herself described as "the woman who paints like a man," but she defined artistic expression as a matter of individuality rather than gender. After the Federal Art Project ended in 1943, Neel had to take public assistance so that she could continue to paint while she raised her sons. For more than a decade, she kept a low profile, rarely exhibiting and attracting little critical notice. By the end of the 1950s, still painting friends and family, Neel widened her circle of sitters to include prominent figures in the cutting-edge art world: she painted Andy Warhol, Robert Smithson, and Allen Ginsberg, as well as influential collectors and curators. Some critics have regarded this as a strategy to advance her career, but Neel's increased confidence, as well as her heightened recognition, reflects the rising regard for women's contribution to the arts. Always committed to progressive politics, Neel supported civil rights and the women's movement; in the 1970s, she gave lectures on feminism in art and painted portraits of Bella Abzug and Kate Millett.

Sitting for Neel was an experience. She preferred to choose her sitters, approaching them on the street or at a social event. Rather than rent a separate studio, Neel worked in her apartment, and her sitters recall that she often served them tea and cookies—or even lunch—before the session began. On rare occasions, Neel would suggest that they wore a particular hat or piece of jewelry; generally she painted them in their street clothes, but she always tried to get them to pose nude. She set up her easel in her living room, told her sitters to sit on a certain chair or to lounge on the sofa, and would then talk with them—often telling sexy stories—before she began to paint. This was a crucial step: Neel believed that as they relaxed, their posture and gestures would reveal their character—"what the world has done to them and their retaliation."

But it was her own candor and her insatiable fascination with the human condition that gave Neel's art its revelatory strength. Near the end of her life, Neel painted a self-portrait (1980), in which she is nude in a pretty, striped chair, holding a brush and a paint rag. She had never flattered her sitters, and here she studied her lived-in body—as well as her mild, grandmotherly face—with the same unblinking gaze.

1900 Born on January 28 in Merion Square, Pennsylvania
1918–1921 Works as a secretary for the Army Air Corps
1921–1923 Attends the Philadelphia School of Design for Women
1926–1927 Lives in Havana
1930 Suffers a nervous breakdown
1932 Moves to Greenwich Village in New York City
1933 Enrolls in the Public Works of Art Project
1935 Enrolls in the Works Progress Administration's Federal Art Project
1938 Moves to Spanish Harlem
1943 Goes on public assistance after Congress terminates the Federal Art Project
1959 Appears in the film *Pull My Daisy* with Allen Ginsberg and Jack Kerouac
1970 Her portrait of feminist Kate Millett is featured on the cover of *Time* magazine
1974 Has a retrospective at the Whitney Museum of American Art
1984 Makes the first of several appearances on the *Tonight Show*; dies on October 13 in New York City

FURTHER READING
Patricia Hills, *Alice Neel*, New York 1983
Ann Temkin, Susan Rosenberg, and Richard Flood, *Alice Neel*, New York 2000
A film about Neel is *Alice Neel*, dir. Andrew Neel, 2008

Samuel Brody, Alice Neel, photograph

1879 First electric street
lighting in London

1893–1894 Construction of the Hôtel
Tassel in Brussels to plans by
Viktor Horta

1911 Vasily Kandinsky publishes
Über das Geistige in der Kunst
("On the Spiritual in Art")

1930 Edward Weston
photographs a slice
half artichoke

1863 Édouard Manet paints *Olympia*

| 1855 | 1860 | 1865 | 1870 | 1875 | 1880 | 1885 | 1890 | 1895 | 1900 | 1905 | 1910 | 1915 | 1920 | 1925 | 1930 | 1935 | 1940 |

Mark Rothko, *No. 10*, 1950, oil on canvas,
229.2 x 146.4 cm, The Museum of Modern Art,
New York

1945 Iron Curtain divides Europe
into East and West

1958 Yves Klein puts on the
"Le Vide" exhibition in Paris

1970 Robert Smithson creates the
Spiral Jetty at Rozel Point, Utah

1998 Founding of the global anti-
globalization network Attac

2004 Murder of Dutch film director
Theo van Gogh

| 1945 | 1950 | 1955 | 1960 | 1965 | 1970 | 1975 | 1980 | 1985 | 1990 | 1995 | 2000 | 2005 | 2010 | 2015 | 2020 | 2025 | 2030 |

MARK ROTHKO

Mark Rothko sought to eliminate "all obstacles between the painter and the idea, and between the idea and the observer." He stripped his work of representational suggestion and gestural expression to bridge the gulf between the artist, his work, and the viewer solely through immersive planes of color.

At seventeen, the Russian-born Rothko left Portland, Oregon, to attend Yale University on a scholarship. He dropped out after two years to move to New York City and attend classes at the Art Students League. There he sought out the company of like-minded aspiring artists with progressive political views and, influenced by Social Realism, he concentrated on painting figures in urban environments. In 1935 he joined nine other artists—many from similar immigrant backgrounds—to form the Ten, an exhibiting group that lasted five years. Rothko's realist approach waned in favor of a fascination with Surrealism. He explored universal themes drawn from mythology and philosophy, using organic shapes that became increasingly abstract. By 1947 he relinquished recognizable figuration and covered his canvases with spreading blots of high-keyed color. Rather than a break, though, his "multiforms" revealed the result of decades of purposeful elimination in his pursuit of the essential elements of painting.

Rothko pushed his reduction further in 1949, stacking colored rectangles that flow edge to edge on a lightly brushed, colored ground. His palette included sun-struck oranges, yellows, and reds as well as nocturnal shades of violet and blue. In the absence of line and suggestive shapes, the presence of paint on canvas gained evocative power. Rothko varied the height of his color blocks. In some paintings he divided the blocks with a stroked band of color or drew a box within a block in a similar but more saturated hue. He put down layers that ranged in density from thin, atmospheric staining to nearly impenetrable opacity. Rothko also increased the size of his canvases; he maintained that his expansive scale derived from a desire to be "human and intimate," explaining, "However you paint the larger picture, you are in it." Critics hailed Rothko's stunning departure as Abstract Expressionism, but he resisted labels. And his work was neither gestural nor spontaneously expressive, marking a strong contrast to that of de Kooning and Pollock. But he shared their intense level of engagement—in his own deliberative manner—and like them, he believed that content derived from the inherent character of painting rather than from external meanings suggested by form.

By the late 1950s, Rothko had adopted a richer, darker range of hues and developed specific standards for the exhibition of his work. He wanted his paintings to be seen on their own, unframed, hung low to the ground and in "close quarters" to situate the observer "within the picture" and to create "the ideal relationship" between the viewer and the paintings. Mural commissions promised the level of control that Rothko sought. He was approached in 1958 by the designers of New York City's Seagram Building to paint a colossal set of canvases for the Four Seasons restaurant, but when he dined there, he cancelled the contract, claiming that he had understood that his paintings would be visible from a worker's canteen. He went on to produce fourteen canvases, commissioned by John and Dominique de Menil, for a new interdenominational chapel on the campus of the University of St. Thomas in Houston (1964–1967). The dark surfaces—black nuanced with violet—surround the viewer in wordless, timeless, and transcendent space. In the Rothko Chapel, dedicated to the artist after his suicide, it is the emotive power of painted color alone—divested of form or programmed meaning—that transports the observer to a state of deeply felt and highly private reflection.

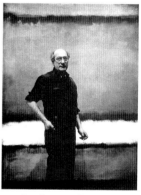

1903 Born Marcus Rothkowitz on September 25 in Dvinsk, Russia (now Daugavpils, Latvia)
1913 Immigrates to the United States with his mother and sister; they join his father and two older brothers in Portland, Oregon
1921–1923 Attends Yale University; moves to New York City
1929 Begins teaching art part-time to children at the Brooklyn Jewish Center
1935–1940 Belongs to the Ten, an independent group of painters
1938 Becomes an American citizen
1958 Becomes contracted to paint murals for the Four Seasons restaurant in the Seagram Building in New York City
1959 Cancels the commission and returns the money
1964–1967 Paints murals for a chapel planned for the University of St. Thomas in Houston
1969 Receives an honorary doctorate from Yale University
1970 Commits suicide on February 25 in New York City
1971 The Rothko Chapel is dedicated in Houston

FURTHER READING
Achim Borchardt-Hume and Briony Fer, *Rothko: The Late Series*, London 2008
Jeffrey S. Weiss and John Gage, *Mark Rothko*, Washington, DC, 1998
A film about Rothko is *Rothko's Rooms*, dir. David Thompson, 2000

Mark Rothko photographed in front of No. 7, 1961

1889 Founding of Worpswede
artists' colony

1915–1923 Marcel Duchamp's
Large Glass

1936 Premiere of
Charlie Chap
film *Modern T*

1872 Creation of the first U.S. national
park (Yellowstone National Park)

1903–1940 Construction of the German-
sponsored Baghdad Railway

| 1855 | 1860 | 1865 | 1870 | 1875 | 1880 | 1885 | 1890 | 1895 | 1900 | 1905 | 1910 | 1915 | 1920 | 1925 | 1930 | 1935 | 1940 |

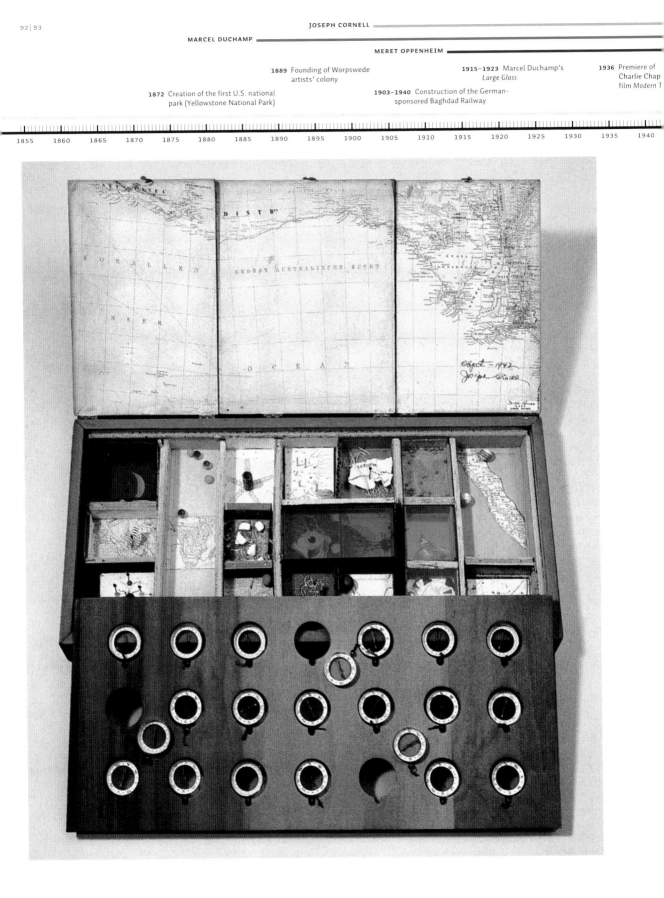

1969 Woodstock Festival in New York state

1955 "The Familiy of Man" exhibition at the
Museum of Modern Art in New York

1999 Kosovo War

1983 Production of the first
commercial mobile phone

2008 Kosovo declares independence
from Serbia

| 1945 | 1950 | 1955 | 1960 | 1965 | 1970 | 1975 | 1980 | 1985 | 1990 | 1995 | 2000 | 2005 | 2010 | 2015 | 2020 | 2025 | 2030 |

JOSEPH CORNELL

Joseph Cornell saved newspaper clippings and art reproductions. He collected odd and whimsical objects. He organized his miscellany into dossiers according to what interested him: the ballet, the opera, films, toys, and the penny arcade. He called them his "explorations" and used them to created his miniature worlds of wonder.

While working as a textile salesman for the William Whitman Company in the 1920s, Cornell haunted the bookstalls, secondhand stores, and Asian import shops of lower Manhattan. Deeply passionate about art, music, and all types of theater, he picked up used books, old programs, reviews, and reproductions and took them back to his home in Queens, where he sorted them into binders and boxes. His eccentric archive fed a rich imaginative life—he was diffident in social situations—and he began to keep detailed journals and to write letters to a wide range of correspondents, both actual and fictive. In November 1931, the same year he lost his job at Whitman's, Cornell wandered into Julien Levy's newly opened art gallery. There he saw the works of European Surrealist artists for the first time. Shortly after, he began to clip images out of prints, which he then reassembled on cardboard in odd yet evocative juxtapositions.

Cornell showed his collages to Levy, and in 1932 Levy included Cornell's work in "Surréalisme," the first survey of Surrealist art held in New York City. He also asked Cornell to design the cover of the catalogue and later introduced him to Man Ray, André Breton, Lee Miller, Dorothea Tanning, and Max Ernst. Cornell often credited Ernst's collage novel, *La Femme 100 têtes* (1929), as one inspiration for his own distinctive mode of assemblage: the shadow box. Cornell began to make his boxes sometime in the early 1930s. At first he used boxes from secondhand shops, but by 1936 he was making his own boxes and altering the ones that he found, polishing and weathering the wood to suggest sumptuous materials or signs of age.

Within his "poetic theaters," Cornell arranged select objects from his "explorations." For one of his idols, nineteenth-century dancer and femme fatale Cléo de Mérode (1940), Cornell combined clippings, references to Egypt, and little things that evoked beauty and glamour: pearl beads, sequins, glass crystals, and plastic rose petals. Cornell transformed these dime-store tributes into rare and precious objects through the grace of his wit and the sincerity of his endeavor. He collaged images into his boxes, altering them in surprising ways. He turned a Renaissance Medici prince into a slot machine, doilies into stage curtains, random snips of text into prose poems, and colorful parrots into shooting-gallery targets. With the artistry of a stage manager, as well as the interpretive concerns of a curator, he turned his objects and ephemera into entrancing yet entirely enigmatic scenes.

Fascinated by the cinema—he made tributes to movie queens including Hedy Lamarr and Lauren Bacall—Cornell made his own films by splicing together found footage into fantastic montages. For *Rose Hobart* (1936), Cornell selected thirteen minutes of the Hollywood actress's appearance in the film *East of Borneo* (1931), tinted the stock blue, and set it to Brazilian music. Over the years Cornell continued to experiment with collage and assemblage, as well as film, and he kept up his habits of wandering, foraging, and adding to his dossiers, which he described as "the core of a labyrinth, a clearinghouse for dreams and visions." Cornell claimed that his work was the "natural outcome of love for the city," and he used New York City's trinkets and castoffs to create a new and magical reality.

1903 Born on December 24 in Nyack, New York
1917–1921 Enrolls in Phillips Academy in Andover, Massachusetts
1919 Moves with his family to Bayside, Queens
1921–1931 Works for the William Whitman Company, a textile manufacturer in New York City
1925 Joins the Christian Science Church
1926 Begins to assemble newspaper clippings in binders
1929 Moves with his family into a house on Utopia Parkway, in the Flushing neighborhood of Queens, New York
1931 Begins his association with Julien Levy's New York City gallery
1933 Writes the film scenario *Monsieur Phot*
1934–1940 Works as a textile designer for the Traphagen Commercial Textile Studio in New York City
1936 Makes his first collage film, *Rose Hobart*
1940 Begins to work as a freelance designer for popular magazines, including *Mademoiselle*, *Vogue*, and *Good Housekeeping*
1972 Dies on December 29 in Flushing

FURTHER READING
Charles Simic, *Dime-Store Alchemy: The Art of Joseph Cornell*, New York 2007
Diane Waldman, *Joseph Cornell: Master of Dreams*, New York 2002
A DVD that includes Cornell's films is *The Magical Worlds of Joseph Cornell*, Washington, DC, 2004

left page
Joseph Cornell, *Object (Roses des Vents)*, 1942–1953, box construction, 6.4 x 54 x 26.7 cm, The Museum of Modern Art, New York

above
Joseph Cornell and one of his boxes, c. 1940

1866 Civil Rights Act gives citizenship
to Americans of all races

1882 Robert Koch isolates
tuberculosis bacillus

1897 Opening of the Tate Gallery
in London

1913–1927 Marcel Proust publishes
A la Recherche du Temps Perdu

| 1855 | 1860 | 1865 | 1870 | 1875 | 1880 | 1885 | 1890 | 1895 | 1900 | 1905 | 1910 | 1915 | 1920 | 1925 | 1930 | 1935 | 1940 |

Willem de Kooning,
Woman I, 1950–1952, oil on
canvas, 192.7 x 147.3 cm,
The Museum of Modern
Art, New York

1952 First performance of John Cage's 4′33″

1979 Margaret Thatcher becomes Prime Minister in Great Britain

Nazis stage "Degenerate Art" exhibition in Munich

1965 Joseph Beuys's "action" *Wie man einem toten Hasen die Bilder erklärt* ("How to Explain Pictures to a Dead Hare")

1995 Srebrenica massacre

2007–2010 Burj Chalifa (828 m; 2,716 ft) is the tallest building in the world

1945 1950 1955 1960 1965 1970 1975 1980 1985 1990 1995 2000 2005 2010 2015 2020 2025 2030

WILLEM DE KOONING

Willem de Kooning applied paint to his canvas with elemental intensity. He worked his pigment, piling, streaking, and scraping in a direct engagement with his medium. Although known for his tactile surfaces, he was guided by a desire to make images, believing that they were more significant than "the beauty of the paint."

After years of training at the Rotterdam Academy of Fine Arts and Techniques, de Kooning worked as a commercial artist. At the age of twenty-two, he immigrated—without papers—to the United States. Speaking little English, he found work in Hoboken, New Jersey, as a housepainter, but within a year he moved to New York City, where friendship with artists Stuart Davis and Arshile Gorky encouraged him to explore Modernist ideas in his painting.

De Kooning signed up with the easel division of the Works Progress Administration's Federal Art Project in 1935, but eventually had to quit to hide his illegal status. In 1936 he decided to work at his painting full-time, concentrating on the human figure. He painted "quiet men" with bodily contours smoothed into volumes. He shattered the background planes—and even the limbs—of "wild women" and painted in bright, high-contrast colors as he reinterpreted Cubist fracture. Over the next decade, he pushed his forms to abstraction, and in 1948, at his first solo exhibition, his large-scale, black-and-white canvases, painted with house enamel, exposed the essential gesture of his painting in vigorous brushstrokes and organic forms. These breakthrough works stunned critics, who positioned de Kooning at the center of the new movement that they called Abstract Expressionism.

In the early 1950s, De Kooning treated his surface like a field for tactile experimentation. He piled on the paint, forming a sculptural impasto. He scraped and scratched the paint layers and drew with grease pencil on areas coated with shellac. The visual accretion evoked the aesthetic of a ruined wall, marked with graffiti, or the exposed ground of an archaeological dig. Although de Kooning conveyed his ideas through form and gesture, he never thought of himself as a nonobjective artist. His content originated in his personal response to something: a natural form, a place, or—as in his most controversial series—the bodies of women. From 1950 to 1955, he painted large, heavy-breasted women whose massive physiques and grimacing faces seemed trapped in the densely covered surface of his canvas. The works have continued to ignite debate: some critics see an Amazonian power in these female figures, while others are repelled by what they regard as a blunt projection of misogyny. De Kooning acknowledged the heightened emotionalism of the *Women* series, admitting that at times women's behavior irritated him and that he was painting that irritation. But he also believed that the paintings reflected the elemental physicality of his art.

After the *Women* series, de Kooning moved away from dense surface accretion to broader, more painterly planes of saturated color. The *Highway* paintings (1957–1958) were inspired by his fondness for road trips, the rich hues of gold and brown evoke the blur seen from a car speeding along the highway. In 1963 he moved to the Springs, in East Hampton, New York, and his palette reflected the pale beach grass, steel-gray ocean, and sandy shores surrounding his new home. Late in his career he opened his surface even further, covering his canvases with graceful calligraphic lines and washes of glowing color. But, no matter how de Kooning handled his surface, he saw himself as a "maker of images" whose expressive assertion of hand and brush was the true content of his painting.

Willem de Kooning, 1953

1904 Born on April 24 in Rotterdam, the Netherlands
1916–1924 Attends night classes in the fine arts at the Rotterdam Academy of Fine Arts and Techniques
1926 Immigrates to the United States; settles in Hoboken, New Jersey
1927 Moves to New York City
1935–1936 Joins the mural division of the Works Progress Administration's Federal Art Project; lack of citizenship forces him to quit
1943 Marries painter and critic Elaine Fried
1948 Has his first solo exhibition at the Charles Egan Gallery in New York City
1953 Exhibits "Paintings on the Theme of the Woman" at the Sidney Janis Gallery in New York City; the Museum of Modern Art acquires *Woman I*
1962 Becomes an American citizen
1968 Takes his first return trip to the Netherlands
1969 Makes his first experiments in sculpture
1974 Sells *Woman V* for $850,000, marking the highest price paid for the work of a living artist to date
1997 Dies on March 19 in East Hampton

FURTHER READING
Edvard Lieber, *Willem de Kooning: Reflections in the Studio*, New York 2000
Marla Prather, David Sylvester, and Richard Shiff, *Willem de Kooning: Paintings*, Washington, DC, 1994

1870 Telegraph cable links London and Calcutta

1891 Opening of Carnegie Hall in New York

1903 First Tour de France

1925 "Neue Sachlichkeit" exhibition at the Kunsthalle in Mannheim

| 1855 | 1860 | 1865 | 1870 | 1875 | 1880 | 1885 | 1890 | 1895 | 1900 | 1905 | 1910 | 1915 | 1920 | 1925 | 1930 | 1935 | 1940 |

Paul Cadmus, *Night in Bologna*, 1957–1958, egg tempera on pressed wood panel, 26.7 x 89.5 cm, National Museum of American Art, Smithsonian Institution, Washington, D.C.

1955 Rosa Louise Parks triggers
Montgomery bus boycott

1983 Scientists discover the Human
Immunodefiency Virus (HIV)

2008 Escalation of the conflict between
Russia and Georgia in the Caucasus

German Wehrmacht invades Poland
on September 1

1969 Stonewall Riots in Christopher
Street in New York

1994 Nelson Mandela becomes first
black President of South Africa

1945 1950 1955 1960 1965 1970 1975 1980 1985 1990 1995 2000 2005 2010 2015 2020 2025 2030

PAUL CADMUS

Paul Cadmus ignited a national scandal when his Works Progress Administration (WPA) mural of sailors carousing on leave drew censure from the U.S. Navy. Throughout his long career, Cadmus courted controversy with iconoclastic subjects made all the more irreverent by his impeccable command of centuries-old artistic techniques.

Cadmus's parents—both working artists—encouraged his potential in the arts. By the age of ten he had published a prize-winning sketch in the *New York Herald Tribune*, and at fifteen he enrolled at the National Academy of Design in New York City, where he developed his ability to draw the human figure in life class and also learned printmaking. In 1927 he launched a career as a commercial artist. For the next four years, Cadmus designed sketches and layouts for a New York City advertising agency; he resigned to take an extended trip abroad with his companion at the time, Jared French. They rented bicycles to tour Europe but soon settled in Majorca, where Cadmus produced paintings in which he seamlessly merged contemporary content with a traditional aesthetic. His large, magnificently proportioned figures filled shallow frieze-like spaces with the dynamically choreographed action that he described as the "point and counterpoint of the forms."

Upon his return to the United States in 1933, Cadmus joined the WPA's Public Works of Art Project (PWAP). His first mural was *The Fleet's In!* (1934), a depiction of sailors on a spree. The work offended Assistant Secretary of the Navy Henry Latrobe Roosevelt, who demanded that it be expelled from a PWAP exhibition at the Corcoran Gallery of Art in Washington, D.C. This set off a hot debate about censorship in the press; most factions pilloried Cadmus's satire as the "disreputable" expression of a "sordid, depraved imagination," but the firestorm established Cadmus—now twenty-nine—as an *enfant terrible*. Other official commissions drew public ire: a four-part mural of suburban life for the Long Island Post Office (1936) was rejected as unsuitable, and a scene of Pocahontas saving Captain Smith for the Parcel Post Building (1938) in Richmond, Virginia, was deemed indecent. Cadmus insisted that he did not seek controversy—he regarded himself as a satirist rather than a social critic. But when he stripped away the gloss of decorum from iconic themes such as servicemen, history, and middle-class manners, American life appeared as crude and carnivalesque as the crowd scenes of Bosch and Bruegel. Notoriety brought him notice, and when a 1937 solo exhibition in New York City drew record-breaking crowds, he was profiled in *Life* and other national magazines.

Throughout his career, Cadmus boldly portrayed the male body as an object of desire. He hid neither his homosexuality—he was barred from military service in World War II—nor the homoerotic charge of male beauty in his art. He also experimented with longstanding techniques, eventually adopting the demanding medium of egg tempera on wooden panel, which was well suited to his deft touch. In the decades after the war, Cadmus moved away from social satire to more evocative narratives that he described as Magic Realism; his hyperrealistic style appeared antithetical to the shift toward Abstract Expressionism in the mainstream art world. But Cadmus had his own artistic vision, and when asked whether he was a contemporary painter, he answered with whimsy: "If I'm alive today, I'm a contemporary artist."

Cadmus remained a working artist to the end of his life, and he culminated his career with an extended series of figure drawings in pencil and crayon on tinted paper starting in the mid-1960s. In them, he expressed a lyric sensibility unmatched in his previous work, and these magnificent, complexly posed male figures celebrate the beauty of human form. In these late works, the artist paid tribute to the artists whom he most admired—Luca Signorelli, Andrea Mantegna, and Michelangelo—breathing new life into old traditions and celebrating the ideal of human beauty as the ultimate motive for artistic expression.

1904 Born on December 17 in New York City
1914 Wins a children's drawing contest
1919–1926 Studies at the National Academy of Design in New York City
1928–1931 Works for a New York City advertising agency
1931–1933 Travels in Europe
1933 Joins the Works Progress Administration's Public Works of Art Project (PWAP)
1934 *The Fleet's In!* is censored at a show of PWAP art at the Corcoran Gallery of Art in Washington, D.C.
1937 Has an important solo exhibition in New York City
1938 Designs costumes for the ballet *Filling Station* by Virgil Thomson
1940 Adopts the technique of painting in egg tempera
1965 Begins an extended series of the male nude based on his life partner, Jon Andersson
1999 Dies on December 12 in Weston, Connecticut

FURTHER READING
Philip Eliasoph, *Paul Cadmus: Yesterday & Today*, Oxford, OH, 1981
Lincoln Kirstein, *Paul Cadmus*, New York 1984
A film about Cadmus is *Paul Cadmus: Enfant Terrible at Eighty*, dir. David Sutherland, 1984

Paul Cadmus, *Self Portrait* (detail), 1948, egg tempera on brown paper, 23.5 x 19.37 cm

1890–1892 Paul Cézanne paints
The Card Players

1914–1918 World War I

1874 First Impressionist exhibition
in Paris

1909 Marinetti publishes the
Futurist Manifesto

1860 1865 1870 1875 1880 1885 1890 1895 1900 1905 1910 1915 1920 1925 1930 1935 1940 1945

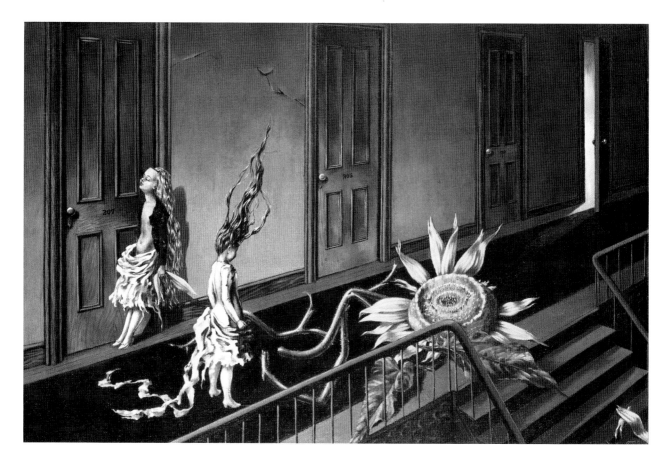

Dorothea Tanning, *Eine Kleine Nacht-
musik (A Little Night Music)*, 1943, oil on
canvas, 50.3 x 32 cm, Private Collection

948 Founding of the COBRA group
of artists in Paris

1974 James Turrell begins work on his celestial
observatory at the Roden Crater, Arizona

2001– Afghanistan War

1961 John F. Kennedy becomes
35th President of the United States

1987 Stockmarket crash on October 19
triggers new global financial crisis

2007 Assassination of Pakistani
politician Benazir Bhutto

1950 1955 1960 1965 1970 1975 1980 1985 1990 1995 2000 2005 2010 2015 2020 2025 2030 2035

DOROTHEA TANNING

Dorothea Tanning's imagery conjures up a world of restless dreams. Doors open onto endless corridors, flowers grow with propulsive force, and adolescent girls stand transfixed as their hair floats above them. Her Surrealist vision suggests that mysterious forces are hidden just below the surface of all that is familiar.

Tanning's father promised to support her desire to go to art school if she first completed college, but she left Knox College, in Galesburg, Illinois, to enroll at the Chicago Academy of Art in 1930. Three weeks of classes convinced her that she would learn more on her own, and after three years she moved from Chicago to New York City. In 1936, at the Museum of Modern Art, Tanning viewed the exhibition "Fantastic Art, Dada, Surrealism," and the experience opened her mind to the "limitless expanse of POSSIBILITY." She saved her money for three years for a trip to Paris, but when she arrived in 1939, she encountered a bleak city, stripped of its glamour and on the brink of war. Tanning's stay was cut short and her return trip to New York City was harrowing. She found work drawing fashion illustrations for Macy's and also continued to paint.

In 1941 gallery owner Julien Levy offered to represent her. Through him, Tanning met artists at the forefront of European Surrealism—André Breton, Marcel Duchamp, and Max Ernst—who had immigrated to the United States seeking refuge from the war. Her self-portrait *Birthday* (1942) expressed her embrace of the Surrealist vision. In this work, dressed in bizarre garb made of an old Elizabethan jacket and a skirt trimmed with thorny roots, she opens a door to a bewildering setting of other doors, all bathed in silver light. Tanning rapidly developed a distinctive vocabulary of ambiguous symbols: hybrid creatures with wings, massive sunflowers, and comely girls whose preternatural sexuality subverts their innocent appearance. With a technique as precise as that of a Northern Renaissance master, she created a convincing world of mystery and allusion, as beautiful as it was disconcerting.

Tanning and Ernst married in 1946 and moved to Arizona to build a house. For a decade, they split their time between Sedona, Arizona, and Paris, and Tanning's art continued to evolve, true to her own

conviction that "an artist is the sum of his risks." She transformed her paintings by playing with scale, and she investigated potential chromatic relationships ranging from subtle harmonies to jarring juxtapositions. In the 1950s her art became more abstract and energetic; although increasingly nonrepresentational, the forms remained organic, and the energy that fueled them expressed an unnerving erotic dimension. At the same time Tanning designed costumes and sets for ballets produced by George Balanchine. She also illustrated books and appeared in several films. In 1969 she began to make soft sculpture, sewn out of tweed and velvet and stuffed with sawdust, tennis balls, and birdshot. Her installation *Hôtel du Pavot, Chambre 202* (1973), an ensemble of pink-and-brown anthropomorphic forms sprawled in a shabby hotel room, culminated her explorations in three dimensions.

Although Tanning has continued to draw and paint, in recent years she has focused on writing. She has published novels, and her poetry has appeared in the *Partisan Review*, the *Paris Review*, and the *New Republic*. In an effort to create "a little order out of chaos," she wrote the first of her two memoirs in 1986, but the prose is as heady—and as evocative—as her painting. When asked in a recent interview to share the insights that she had gained through a long career with aspiring artists, she expressed what had been her guiding principle from the beginning: "Keep your eye on your inner world."

1910 Born on August 25 in Galesburg, Illinois
1930 Briefly enrolls at the Chicago Academy of Art
1935 Moves to New York City
1936 Sees the exhibition "Fantastic Art, Dada, Surrealism" at the Museum of Modern Art
1939 Takes her first trip to Paris
1940–1941 Works as a commercial artist for Macy's
1941 Offered gallery representation by Julien Levy
1946 Designs sets for the ballet *The Night Shadow*; marries Max Ernst; they build a house in Sedona, Arizona
1949–1957 Splits her residency between Sedona and France
1957 Ernst fails to obtain citizenship; they move to Paris
1969–1974 Tanning makes cloth sculptures
1976 Max Ernst dies
1977 Tanning publishes *Abyss*, her first novel
1981 Settles in New York City
1986 Publishes *Birthday*, her first memoir
2001 Publishes *Between Lives*, her second memoir

FURTHER READING
Jean Christophe Bailly and Robert C. Morgan, *Dorothea Tanning*, New York 1995
Dorothea Tanning, *Between Lives: An Artist and Her World*, New York 2001
Dorothea Tanning, *Birthday*, Santa Monica 1986

Ashkan Sahihi, Dorothea Tanning

LOUISE BOURGEOIS ━━━━━━━━━━━━━━━━━━━━━━━━

HENRY MOORE ━━━━━━━━━━━━━━━━━━━━━━━━━━━━━━━━━━━━

JEAN TINGUELY ━━━━━━━━━━━━

1877–1880 Auguste Rodin sculpts
the *Age of Iron*

1897 Founding of the Vienna Secession

1923 Sigmund Freud publishes
the *Ego and the Id*

1914 Marcel Duchamp produces his
first readymade, the *Bottle Rack*

1938 Reichskristall
heralds Nazi
Jewish pogro[m]

| 1860 | 1865 | 1870 | 1875 | 1880 | 1885 | 1890 | 1895 | 1900 | 1905 | 1910 | 1915 | 1920 | 1925 | 1930 | 1935 | 1940 | 1945 |

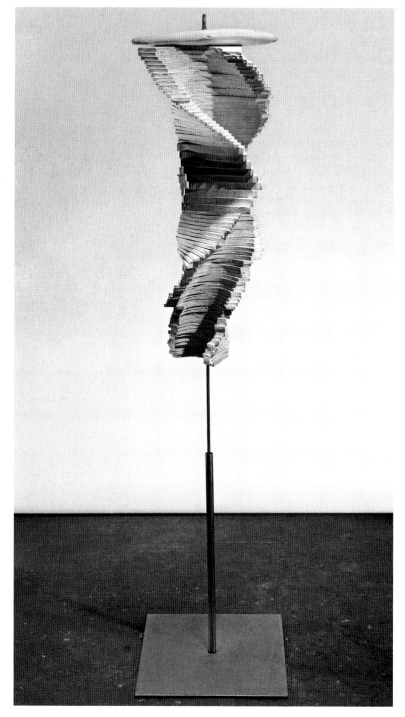

Louise Bourgeois, *Spiral Woman* 1951-2,
1951–1952, painted wood and stainless steel,
127 x 30.5 x 30.5 cm, The Metropolitan
Museum of Modern Art, New York

1954 First commercial atomic power station
commissioned at Obninsk near Moscow

1968 Premiere of Stanley
Kubrick's film 2001

1996 First mammal cloned
(Dolly the Sheep)

1986 Jeff Koons produces his *Rabbit*

2005 Hurricane Katrina causes
flooding of New Orleans

| 1950 | 1955 | 1960 | 1965 | 1970 | 1975 | 1980 | 1985 | 1990 | 1995 | 2000 | 2005 | 2010 | 2015 | 2020 | 2025 | 2030 | 2035 |

LOUISE BOURGEOIS

In a surprising tribute to her mother, Louise Bourgeois explored the motif of the spider in various media, including a colossal steel and marble sculpture that she entitled Maman *(1999). The spider, she notes, will repair any damage that is done to her web: "She doesn't get mad. She weaves and repairs it."*

Looking back at her youth in France, Bourgeois reflected that she "came from a family of repairers." Her childhood home contained a studio for tapestry repair, and by the time that she was twelve, she helped with the family business. As a young woman, Bourgeois studied math and philosophy at the Sorbonne in Paris, before changing her focus to art at the École des Beaux-Arts in 1936. She also studied drawing and sculpting with prominent artists such as Fernand Léger, posed for the photographer Brassaï, sent her work to group exhibitions, and opened a gallery that specialized in the works of Modernists. In 1938 she met American art historian Robert Goldwater; after a few months they married and moved to New York City.

Bourgeois continued her pursuit of the arts in her new home, enrolling in the Art Students League and sending some of her prints to an exhibition at the Brooklyn Museum. In her husband's circle, she encountered the leaders of the New York City art world, including critic Clement Greenberg and collector Peggy Guggenheim, as well as aspiring artists with challenging ideas, such as Willem de Kooning, Mark Rothko, and Franz Kline. In the early 1940s, Bourgeois's chronic insomnia prompted her to employ her drawing as therapy, and she created the motif of the *Femme Maison*: a nude female figure with a house engulfing her head and shoulders. She rendered the image in drawing, painting, and sculpture, initiating her career-long practice of exploring an idea in a variety of media to expose her intense and deeply personal revelations. She also began a series of tall, standing sculptures that she called *Personages* to represent the people in her life, especially those whom she had left in France. Rather than literal or symbolic portraits, Bourgeois's *Personages* evoke a human presence through formal elements: a stele of painted bronze, a sword-like shape of wood, or a tower of wooden blocks stacked on a stainless-steel spine.

Fascinated by the potential of malleable material, Bourgeois experimented with bronze, plaster, latex, and stuffed fabric, and she never flinched from the erotic potential of modeled form. She tackled unnerving content—sexuality, entrapment—and her strong identity as a woman informed her interpretations. Although she disliked labels, insisting that there was no feminist aesthetic, Bourgeois recognized the importance of her perspective: "My feminism expresses itself in an intense interest in what women do." In 1974 she confronted her own painful memories of her father's infidelities in *Destruction of the Father*, a cave-like room littered with bones.

By the 1990s the expansion of scale into real space dominated Bourgeois's work, as seen in her series of *Cells*. The placement of domestic furnishings—a bed, a floor lamp, hand-embroidered fabrics—transformed her installations into a deeply personal architecture of memory. Much of her later work commemorates the spirit of her mother, a model of female strength, patience, and resolve whom Bourgeois likens to a benevolent and industrious spider, perpetually weaving and tending her web. Bourgeois summed up her own resilience in a soaring installation commissioned by the Tate Modern in London for the opening of its Turbine Hall: *I Do, I Undo, I Redo* (1999–2000), an ensemble of three soaring steel towers surrounded by spiral staircases. As visitors climbed and descended each in turn, their movements reflected Bourgeois's belief that a woman's art, like her life, is an evolving process of creation, unraveling, and recreation.

1911 Born on December 25 in Paris
1920S Helps her parents restore tapestries
1933–1938 Studies art in Paris
1936 After studying at the Sorbonne, she switches her focus to art at the École des Beaux-Arts
1938 Marries Robert Goldwater and moves to New York City
1941 Begins making *Personages*, life-size wooden sculptures
1945 Has her first solo show in New York City
1955 Becomes an American citizen
1960 Starts to experiment with malleable materials
1977 Receives an honorary doctorate in fine arts from Yale University
1982 Publishes the autobiographical article "Child Abuse" in *Artforum*
1999 Commissioned to create an inaugural installation for the Turbine Hall in the Tate Modern in London
2001 Displays *Maman*, a 30-foot (9-meter) bronze spider, in Rockefeller Plaza, New York City

FURTHER READING
Eva Keller and Regula Malin (eds.), *Louise Bourgeois: Emotions Abstracted, Works 1941–2000*, Zürich 2004
Frances Morris (ed.), *Louise Bourgeois*, New York 2008

Louise Bourgeois in her studio, 1988

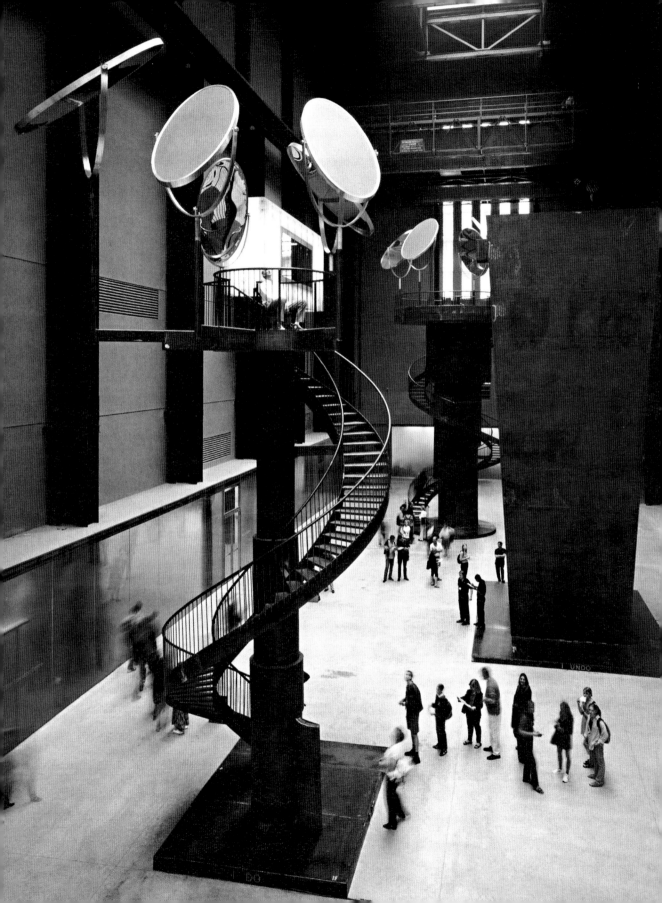

1880 First electric elevator in Mannheim

1911–1913 Introduction of montages and collages

1895 First Venice Biennale

1926 Max Ernst paints *The Virgin Chastises the Infant Jesus*

| 1860 | 1865 | 1870 | 1875 | 1880 | 1885 | 1890 | 1895 | 1900 | 1905 | 1910 | 1915 | 1920 | 1925 | 1930 | 1935 | 1940 | 1945 |

Romare Bearden, *Of the Blues: Wrapping It Up at the Lafayette*, 1974, collage of various papers with fabric, paint, ink, and surface abrasion on fiberboard, 121.9 x 91.4 cm, The Cleveland Museum of Art

1959 Miles Davis publishes *Kind of Blue* album **1972–1974** North tower of the World Trade Center is the highest building in the world

1998 Michel Houellebecq publishes *Elementary Particles*

1989 Portable Game Boy consoles launched

2005 Publication of Mohammed cartoons in Danish newspaper *Jyllands-Posten* triggers Islamic riots

...tomic bombs dropped on Hiroshima and Nagasaki

| 1950 | 1955 | 1960 | 1965 | 1970 | 1975 | 1980 | 1985 | 1990 | 1995 | 2000 | 2005 | 2010 | 2015 | 2020 | 2025 | 2030 | 2035 |

ROMARE BEARDEN

Through the art of collage, Romare Bearden reconfigured the world. He clipped images from magazines and art reproductions, gathered bits of foil and fabric, and assembled them in dense juxtapositions. These fragmented images fuse into a new dynamic whole, uniting diverse impressions of memory, observation, and experience.

Bearden's mother, Bessye, was a correspondent for the *Chicago Defender*, an influential African American newspaper, and in her home she hosted the luminaries of the Harlem Renaissance, including Langston Hughes, Fats Waller, and Paul Robeson. Throughout his youth, Bearden felt the dual pull of art and activism. While earning a degree in education, he published political cartoons, and after graduation, while he worked as a caseworker for the New York City Department of Social Services, he studied at the Harlem Artists Guild and at the Art Students League. He had a strong sense of his own racial identity, and in his 1934 essay, "The Negro Artist in Modern Art," he urged his contemporaries toward subjects that reflected their lives. But Bearden embraced all forms of art as potential influence, ranging from French Modernism and contemporary Social Realism to European masterworks and traditional art from Africa.

Bearden joined the U.S. Army in 1942, and after his discharge in 1945, he sought new directions in his art. He went to Paris on the G.I. Bill in 1950, and when he returned, he launched a long investigation of color by copying black-and-white prints of famous paintings in his own hues. Through this regimen he learned to make his pigments "walk like free men" in tracks across the canvas, and by the middle of the decade, his forms became more abstract. But Bearden never fully abandoned figuration, nor was he yet able to devote himself fully to art. He resumed his career as a social services caseworker and augmented his income with a successful stint as a songwriter.

In July 1963 Bearden helped found Spiral, a group of African American artists devoted to the advocacy of civil rights. For a collaborative project, Bearden suggested that they create a collage from magazine clippings, but his colleagues weren't interested. Undeterred, Bearden carried out the work on his own, combining "visual notions" cut from journals and newspapers into dense compositions. He

compared his method to that of a jazz musician improvising on a motif. He played with his medium, applying fabric swatches and foil papers, as well as paint strokes and ink, to make "montage paintings," and he enlarged small collages on a Photostat machine to make a series he called *Projections* (1964). His new work won immediate acclaim; prominent publications such as *Fortune* (1968) and the *New York Times Magazine* (1969) commissioned covers from Bearden, and he was finally able to retire from social work. He challenged the conventional limited scale of his medium, designing a mural in collage for the city hall in Berkeley, California (1974). Although Bearden did not work exclusively in collage—he designed sets and costumes for theater and returned to painting in his later years—it remained his signature mode of expression.

Bearden's themes illuminated the broad scope of African American experience. He depicted life in the rural South, as well as in the urban North, and the trains that transported the waves of the Great Migration. His ideas drew on personal memory, as well as generations-old folk beliefs. His rhythmic aesthetic echoed that of jazz, while his fragmentation recalled sources as diverse as Cubist fracture and handmade quilts. By unifying pictorial fragments, Bearden sought a counterpoise between the individual and the universal; he saw collage as the means to filter diverse ideas through his personal consciousness and create an art that transcended the divisions of nationality and race.

1911 Born on September 2 in Charlotte, North Carolina
1914 Moves with his family to Harlem, New York City
1934 Publishes the essay "The Negro Artist in Modern Art"
1936–1937 Studies with George Grosz at the Art Students League in New York City
1938 Begins working for the New York City Department of Social Services as a caseworker
1940 Rents a studio in Harlem
1942–1945 Serves in the U.S. Army in the 372nd Infantry Regiment
1950 Goes to Paris on the G.I. Bill
1951 Launches a career as a songwriter
1963 Forms the Spiral group; begins to create collages
1964 Appointed Art Director of the Harlem Cultural Council
1969 Publishes *The Painter's Mind* with co-author Carl Holty
1973–1974 Designs a collage mural for the city of Berkeley, California
1977 Designs sets and costumes for the Alvin Ailey American Dance Theater's *Ancestral Voices*
1987 Receives the National Medal of Arts
1988 Dies on March 12 in New York City

FURTHER READING
Ruth E. Fine, *The Art of Romare Bearden*, Washington, DC, 2003
Richard J. Powell, *Conjuring Bearden*, Durham, NC, 2006
A film about Bearden is *The Art of Romare Bearden*, dir. Carroll Moore, 2005

Romare Bearden in front of the Hispanic Society of America, New York, 1958, Estate of Romare Bearden

JACKSON POLLOCK

JOAN MIRÓ

ARNULF RAINER

1884 George Seurat paints
Bathers at Asnières

1913 The Armory Show in New York introduces European
avant-garde art to the American art scene

1870–1871 Franco–Prussian War

1902 Cuba gains independence
from Spain

1929 Wall Street crash on October 25
triggers global financial crisis

1860	1865	1870	1875	1880	1885	1890	1895	1900	1905	1910	1915	1920	1925	1930	1935	1940	1945	

Jackson Pollock, *Autumn Rhythm No. 30*,
1950, oil on canvas, 270.51 x 538.48 cm,
The Metropolitan Museum of Art,
New York

J.S. Congress approves
the Marshall Plan

1969 Michel Foucault publishes
What Is an Author?

1959 Allan Kaprow stages the first Happening
at the Reuben Gallery in New York

1990–1991 First Gulf War

2006 The highest price to date for a work of art,
$140 million, paid for Jackson Pollock's *No. 5 of 1948*

| 1950 | 1955 | 1960 | 1965 | 1970 | 1975 | 1980 | 1985 | 1990 | 1995 | 2000 | 2005 | 2010 | 2015 | 2020 | 2025 | 2030 | 2035 |

JACKSON POLLOCK

Jackson Pollock moved his canvas from the easel to the studio floor to gain complete access to the painting's surface. He threw his whole body into the act of painting, lunging in from all four sides to drip trails of paint that tracked his athletic movements in tangles of color.

After repeated expulsions from the Manual Arts High School in Los Angeles, California, eighteen-year-old Jackson Pollock dropped out and moved to New York City. He enrolled at the Art Students League and studied with Thomas Hart Benton. Although he would reject Benton's naturalism, he embraced his epic vision and remained close to his teacher throughout the 1930s. Pollock's ambitions were also shaped by the great Mexican muralists, Rivera, Orozco, and Siqueiros, who were all working in New York, but it was the influence of Picasso's pulsating forms that pushed his work toward a vital and organic abstraction.

In 1943 Peggy Guggenheim reluctantly included Pollock's work in an exhibition of young artists at her cutting-edge gallery, Art of This Century. After visiting his studio, she offered him a regular stipend to support his painting and commissioned a mural for the foyer of her Manhattan townhouse. Faced with the opportunity to work on a grand scale, Pollock froze; he delayed work until the commission was due, and then completed the 8-by-20-foot (2.5-by-6-meter) mural in one explosive painting session. Although fully abstract, the shapes in *Mural* expressed a figural vitality in broad, slashing brushstrokes that recorded every sweep and thrust of Pollock's arm. Critic Clement Greenberg hailed Pollock as the "most powerful painter in contemporary America," and over the next four years Guggenheim showcased his work in four solo exhibitions.

Pollock moved to an old farmhouse in the Springs, in East Hampton, New York, in 1945 and converted a small barn on the property into a studio. Within two years, in a deliberate rejection of what he called "the usual painter's tools," he was working on the floor. He first marked his canvas with figural forms, and then, dripping paint from a stiff brush or a stick or pouring it right from the can, he began to work around the canvas, putting the full force of his body behind the flowing movements of his arm. The resulting image was a tangle of supple skeins of paint that tracked the physical act of painting. He used unorthodox materials—industrial enamel, sand, gravel, and plumber's aluminum paint—and as he worked, his cigarettes and the contents of his pockets spilled out and adhered to the tacky surface. Between 1947 and 1952, Pollock produced a magisterial series of monumental works that were unparalleled in scale, bold expression, and raw vitality.

Broad news coverage, including a 1949 profile in *Life* magazine that posed the question "Is This the Greatest American Painter?" rocketed Pollock to international attention. In 1950 Hans Namuth documented him painting in a series of photographs and a film that recast his art as performance. The aggressive physicality of Pollock's method prompted critic Harold Rosenberg to dub it "Action Painting," putting as much importance on the gesture that made the stroke as on the stroke itself. Pollock buckled under his new celebrity: he succumbed to alcoholism and volcanic bursts of temper, and by 1954 he had all but stopped painting. He died in a car crash two years later. Pollock's life has taken on a mythic quality; like James Dean and Marlon Brando, he embodied a reckless, hypermasculine spirit that was seen as distinctly American in the postwar era. But, more importantly, his bold act of taking the canvas off the easel and the brush off the canvas redefined the concept of painting.

1912 Born on January 28 in Cody, Wyoming; later that year, he moves with his family to California
1930 Follows his brother to New York City
1930–1932 Studies art with Thomas Hart Benton at the Art Students League
1935 Joins the mural division of the Works Progress Administration's Federal Art Project
1939 Sees Picasso's *Guernica* at the Valentine Gallery in New York City
1943 Commissioned by Peggy Guggenheim to create a mural for her Manhattan townhouse
1945 Marries painter Lee Krasner; he moves with her to the Springs, in East Hampton, New York
1947–1948 Begins to paint off the easel, with his canvas on the floor
1949 Featured in *Life* magazine
1950 Documented in the act of painting by photographer Hans Namuth
1954–1956 With rare exceptions, he stops painting
1956 Dies on August 11 in a car crash on Springs-Fireplace Road, in East Hampton

FURTHER READING
Jeremy Lewison, *Interpreting Pollock*, London 1999
Kirk Varnedoe, with Pepe Karmel, *Jackson Pollock*, New York 1998
A film about Pollock is *Jackson Pollock: Love and Death on Long Island*, dir. Teresa Griffiths, 1999

Jackson Pollock, photograph c. 1955/56

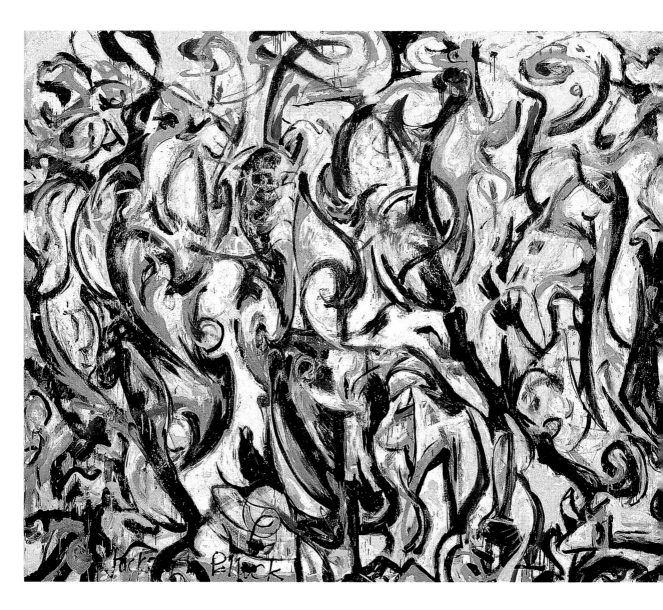

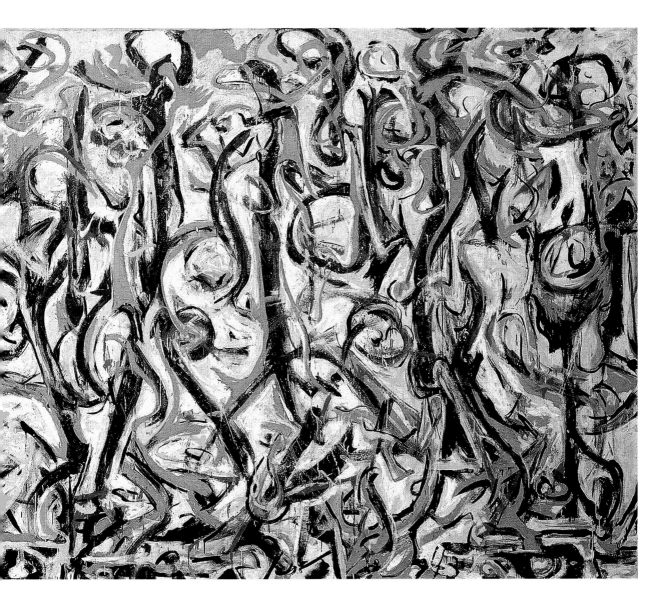

Jackson Pollock, *Mural*, 1943–1944 (dated 1943), oil on canvas, 243.2 x 603.2 cm, The University of Iowa Museum of Art, Iowa City, gift of Peggy Guggenheim

1891 Paul Gauguin's first trip to Tahiti

1920–1930 Harlem Renaissance

1949 Fou
of N

1880 First issue of *Science* periodical

1908 Henri Matisse paints
Harmony in Red

1938 Hahn and Strassman
discover fission

1865 1870 1875 1880 1885 1890 1895 1900 1905 1910 1915 1920 1925 1930 1935 1940 1945 1950

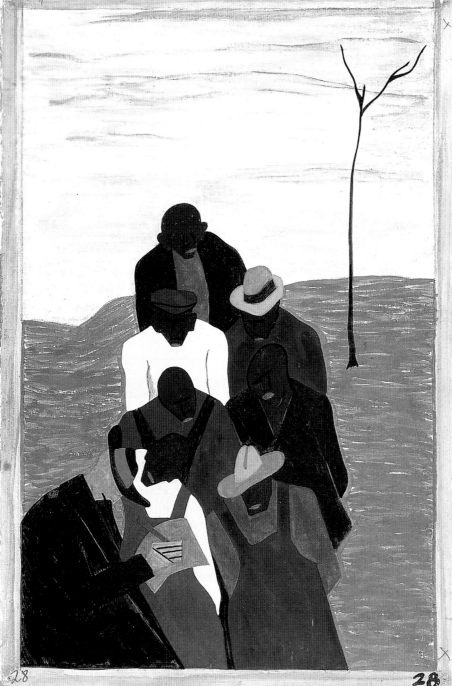

Jacob Lawrence, *The Migration Series/28.*
The labor agent who had been sent South by
Northern industry was a very familiar person
in the Negro counties. 1941

1963 Martin Luther King's
"I Have a Dream" speech

1967 Racial unrest in many U.S. cities

1991 World Wide Web (www) released
for general use

2009 Barack Obama becomes
44th President of the United States

| 1955 | 1960 | 1965 | 1970 | 1975 | 1980 | 1985 | 1990 | 1995 | 2000 | 2005 | 2010 | 2015 | 2020 | 2025 | 2030 | 2035 | 2040 |

JACOB LAWRENCE

In his series paintings, Jacob Lawrence merged the aesthetic daring of a modern artist with the soulful spirit of a traditional storyteller. Whether he commemorated the extraordinary trials of cultural heroes or the daily experience of his Harlem neighbors, Lawrence created a compelling chronicle of African American life.

Lawrence's interest in art was sparked when he attended an after-school program at the Utopia Children's House in Harlem. His teacher was the young muralist Charles Alston, who mentored the teenaged Lawrence and introduced him to the vibrant local art scene. Eager to expand his vision, Lawrence made regular trips to Manhattan's Metropolitan Museum of Art and Museum of Modern Art, but the richness of his Harlem neighborhood—the families, the churches, the shops, and the street life—shaped his artistic identity. Through Alston's training, which emphasized building composition through geometric structure, Lawrence also developed a bold, Modernist style based on strong color, the relationship of shapes, and the cohesive power of pattern.

He conceived the idea of painting in series after seeing a production of W. E. B. Du Bois's play *Haiti* in 1936. Lawrence charted the saga of Toussaint L'Ouverture, founder of the Haitian Republic, in forty-one distinct yet visually linked panels (1937–1938), fueling the timeless craft of storytelling with the energy of modern art. In the following years, Lawrence painted series narratives on the lives of others who had fought to free the enslaved American populace, including Frederick Douglass, Harriet Tubman, and John Brown. In 1941 he completed his largest series: the sixty panels of *The Migration of the Negro*. Born and raised in the North, Lawrence remembered relatives who spoke of "another family coming up" as the black labor force moved from the segregated South to the northern industrial cities. His stark yet eloquent imagery captured every detail: the cruelty and poverty that propelled the migration, the train journey north, and the harsh reality of a new life restricted by discrimination and limited opportunities. Rather than a tragic tale, Lawrence presented the migration as the common man's epic; he regarded sacrifice as part of the human condition rather than the measure of exemplary lives.

Through art, Lawrence served his nation. He worked for the Works Progress Administration and, during World War II, he joined the U.S. Coast Guard as a member of the first racially integrated crew on the USS *Sea Cloud*. He captured his memories in the series *War* (1947). The small scale and durable material of his paintings—usually hard board panels—facilitated traveling exhibitions, and Lawrence's reputation grew. He traveled to Africa in the 1960s. As a teacher he held a number of positions that culminated with a full professorship at the University of Washington in Seattle in 1971. He took an active role in the civil rights movement; his paintings reflect that struggle. But the small things in his community also continued to fascinate him, as he created new series portraying a hospital stay, games, libraries, and the building trades.

In his later career he continued to experiment with different media, collaborating with a master lithographer to produce screen prints, completing his first mural in 1979, and producing illustrations for a new edition of John Hersey's novel *Hiroshima* in 1983. He drew upon his boyhood memories of the Abyssinian Baptist Church in Harlem for a commission to illustrate the book of Genesis (1990), turning the words of the charismatic preachers into vivid imagery glimpsed just outside the church windows. Though his media changed, Lawrence's style was consistent. He described his standards as "universality, clarity, and strength." And he held to his mission of telling his community's story, stating, "I don't see how a history of the United States can be written honestly without including the Negro."

1917 Born on September 7 in Atlantic City, New Jersey
1930 Settles with his family in Harlem, New York City
1937–1938 Paints the *Toussaint L'Ouverture* series
1938–1940 Paints the *Harriet Tubman* and *Frederick Douglass* series
1939–1940 Employed by the Works Progress Administration's Federal Art Project
1940–1941 Paints *The Migration of the Negro* series
1943–1945 Serves in the U.S. Coast Guard
1962 Makes his first visit to Nigeria; makes his first print with a master lithographer
1966–1969 Teaches at the New School for Social Research, in New York City
1970 Moves to Seattle, Washington, to accept a full professorship at the University of Washington
1979 Completes his first commissioned mural, *Games*, for the Kingdome Stadium in Seattle
1983 Retires from teaching
1990 Awarded the National Medal of Arts
2000 Dies on June 9 in Seattle

Jacob Lawrence, c. 1941, National Archives, Harmon Foundation Collection

FURTHER READING
David C. Driskell and Patricia Hills, *Jacob Lawrence: Moving Forward, Paintings, 1936–1999*, New York 2008
Peter T. Nesbett and Michelle DuBois, *Over the Line: The Art and Life of Jacob Lawrence*, Seattle 2000

RICHARD DIEBENKORN

OTTO DIX

HORST ANTES

1883–1885 Construction of the
first skyscraper in Chicago

1902 Alfred Stieglitz founds the
Photo-Secession in New York

1922–1953 Joseph Stalin rules
Soviet Empire

1942 Edward Hopper
paints *Nighthawks*

| 1870 | 1875 | 1880 | 1885 | 1890 | 1895 | 1900 | 1905 | 1910 | 1915 | 1920 | 1925 | 1930 | 1935 | 1940 | 1945 | 1950 | 1955 |

1963 The "New Figuration" exhibition
in Florence

7 Albert Camus awarded the
Nobel Prize for Literature

1988 The "Freeze" exhibition in London is
breakthrough for the Young British Artists

1977 First *Star Wars* film by George Lucas

1998 Construction begins on the International
Space Station (ISS)

2004 Catastrophic floods in Asia

| 1960 | 1965 | 1970 | 1975 | 1980 | 1985 | 1990 | 1995 | 2000 | 2005 | 2010 | 2015 | 2020 | 2025 | 2030 | 2035 | 2040 | 2045 |

RICHARD DIEBENKORN

Richard Diebenkorn composed his paintings in response to his surroundings, from the sun-bleached deserts of New Mexico to the luminous convergence of land and water on the southern California coast. Whether abstract or figurative, Diebenkorn's art conveys a sense of place, not through motif, but through the distinctive interplay of colors on a painted surface.

From early childhood, Diebenkorn wanted to be an artist, but, following his father's desire that he pursue a practical profession, he enrolled in the general curriculum at Stanford University in 1940. Three years later he enlisted in the Marine Officers Training Corps, which allowed cadets to continue their studies. Diebenkorn signed up for art classes, and when he was transferred to the Officers Candidate School in Quantico, Virginia, he spent his free time in Washington, D.C., visiting art collections. He was fascinated by the way modern artists handled light. In Edward Hopper's work he discovered that light and shade could be "saturated with mood," and Henri Matisse's evocative rooms revealed to him that interior and exterior illumination could mingle on a single surface. The war ended before Diebenkorn was deployed, and in 1946 he returned to the San Francisco Bay Area to finish his studies at the California School of Fine Arts (CSFA; now the San Francisco Art Institute).

In 1947, when Diebenkorn joined the faculty at CSFA, the innovative ideas of the New York School had ignited interest in the Bay Area. Clyfford Still was on the faculty, and Mark Rothko had a brief residence over the summer of 1947 and 1948. Diebenkorn explored the potential of nonrepresentational art, working his canvas edge to edge in fields of color, and by the time he moved to Albuquerque to pursue a master's degree at the University of New Mexico, his mode was fully abstract. The drastic change of surroundings had an immediate impact on the way he painted. He drained his palette of vivid hues in response to the arid, sun-bleached landscape and reduced his forms to echo the broad vistas of the desert. He frequently flew back to the Bay Area; the view from the low-flying airplane transformed his ideas about topography. His *Albuquerque* series (1950–1952) strengthened his trust in painting direct impressions of the landscape and taught him to conceive space through aerial perspective.

By 1953, with his return to the CSFA, Diebenkorn drew national acclaim for the serene and painterly aesthetic that he brought to Abstract Expressionism. But by 1956, questioning his own "desire to explode the picture," he turned to figuration: studio still life and the human body. With like-minded painters, including David Park and Elmer Bischoff, Diebenkorn became part of the Bay Area Figurative Movement, a loose association of California-based artists recognized by critics for presenting an alternative to New York-based abstractionism. For a decade, Diebenkorn positioned solitary figures in quiet spaces; stripped of motion and narrative, they anchor the richly brushed planes of his architectonic compositions. He left the Bay Area in 1966 to take a position at the University of California, Los Angeles. He rented a studio in the Ocean Park neighborhood of Santa Monica, and the new setting once again changed his art.

The *Ocean Park* series, begun in 1967, occupied Diebenkorn for the next twenty-five years. His grand, vertical paintings—planes of sumptuously brushed color divided into blocks by delicate lines—reflected his impressions of the broad sky over the open waters and the brilliant haze of light that shimmered on every surface. Although he resisted labels, Diebenkorn openly acknowledged that while he did not paint landscape, he possessed the temperament of a landscape painter, delighting in the "moments of hope" that a "new scene" brought to his work.

1922 Born on April 22 in Portland, Oregon
1924 Moves with his family to San Francisco, California
1940–1943 Studies at Stanford University in Palo Alto, California
1943–1945 Serves in the U.S. Marine Officers Training Corps
1946 Resumes his studies at the California School of Fine Arts (CSFA; now the San Francisco Art Institute)
1947 Joins the faculty of the CSFA
1951 Receives his master of fine arts degree from the University of New Mexico, Albuquerque
1953 Returns to the Bay Area
1964 Travels to the Soviet Union sponsored by the U.S. State Department Cultural Exchange Program
1966 Moves to southern California and sets up a studio in the Ocean Park neighborhood in Santa Monica
1967 Begins his *Ocean Park* series
1978 Represents the United States at the thirty-eighth Venice Biennale
1993 Dies on March 30 in Berkeley, California

FURTHER READING
Jane Livingston, John Elderfield, and Ruth Fine, *The Art of Richard Diebenkorn*, New York 1997
Jane Livingston and Barnaby Conrad, *Richard Diebenkorn: Figurative Works on Paper*, San Francisco 2003
Gerald Nordland, Mark Lavatelli, and Charles Strong, *Richard Diebenkorn in New Mexico*, Santa Fe 2007

left page
Richard Diebenkorn, *Ocean Park No. 54*, 1972, oil on canvas, 254 x 205.7 cm, San Francisco Museum of Modern Art

above
Richard Diebenkorn, 1986

1887–1889 Construction of the
Eiffel Tower in Paris

1915 Kasimir Malevich paints
the *Black Square*

1931 Founding of the Whitney Museum
of American Art in New York

1898 Spanish–American War

1947 UN proposes partition
of Palestine

1875	1880	1885	1890	1895	1900	1905	1910	1915	1920	1925	1930	1935	1940	1945	1950	1955	1960

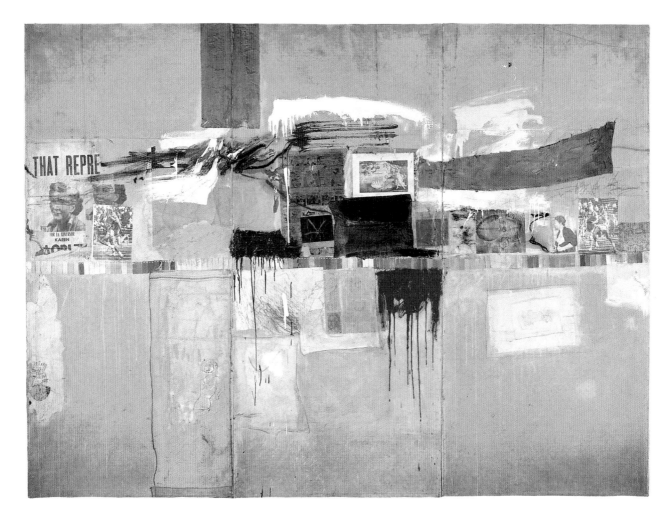

Robert Rauschenberg, *Rebus*, 1955,
oil, graphite, and collage on canvas,
243.8 x 332.7 cm, Private Collection

1992 "Projects 34: Felix Gonzalez-Torres" exhibition in
the form of billboards in 24 locations in New York

...ement Greenberg publishes
...ssay on Modernist painting **1979–1989** Soviet–Afghan War **2000** The dotcom bubble bursts

2007–2009 Global credit crunch

| 1965 | 1970 | 1975 | 1980 | 1985 | 1990 | 1995 | 2000 | 2005 | 2010 | 2015 | 2020 | 2025 | 2030 | 2035 | 2040 | 2045 | 2050 |

ROBERT RAUSCHENBERG

Robert Rauschenberg's desire to add three-dimensionality to painting prompted him to move his canvas off the wall and into the center of the room. This gave him additional spaces—sides, back, and even underneath—on which to paint. Rather than sculpture, he thought of his work as a "free-standing picture," and he called it a "combine."

Although he liked to draw cartoons as a child, there was nothing in Rauschenberg's hometown of Port Arthur, Texas, to expand his interest in art. During his naval service, during which he worked in a psychiatric hospital, he sketched in his free time, and after his discharge in 1945 he used funds from the G. I. Bill to attend the Kansas City Art Institute in Missouri and to travel to Paris for study at the Académie Julian. When he returned to the United States in 1948, Rauschenberg enrolled in the rigorous Bauhaus-based program at Black Mountain College, near Asheville, North Carolina; by the fall of 1949 he moved to New York City, where the explosive example of Abstract Expressionism jolted him into rethinking the potential of the painted surface.

As Rauschenberg experimented with abstraction in series of monochromatic paintings, he focused on the manipulation of surface texture. He explored tonal variants in his *White* series (1951) and painted on a "lively ground" of crumbled newspaper in his *Black series* (1951–1952). Rauschenberg admired the work of Jackson Pollock and Willem de Kooning, but his emphasis on tone and texture rather than gesture moved his work in a different direction from Abstract Expressionism. In works such as *Automobile Tire Print* (1953), made by driving a car over twenty sheets of paper, and *Erased De Kooning Drawing* (1953), in which he rubbed off most of the artist's original markings, leaving only faint traces, he openly challenged the high seriousness and deflated the grandeur of the iconic work of the New York School.

In 1953 he met Jasper Johns, and they worked together dressing windows for Tiffany and the Bonwit Teller department store. Like Johns, Rauschenberg began to introduce real-world objects into his painting, using postcards, signs, newspapers, and prints. He recalled how his mother, a dressmaker, would lay paper pattern pieces on fabric, and said, "That's where I learned collage."

For his assemblages he salvaged metal and other refuse that he found in the streets. By 1955 his paintings became fully three-dimensional, prompting him to take them off the walls so that every surface played an integral part of the work. He defied all conventional thinking about art material in his "combines," using his own pillow and quilt for *Bed* (1955), a taxidermy rooster for *Odalisk* (1955–1958), and a stuffed goat, embellished with dabs of paint and wearing a tire around its middle, in *Monogram* (1955–1959). His work, fueled in part by humor and high spirits, pushed the boundaries of what was accepted as "art" and laid the foundation for Pop art in the United States.

Rauschenberg valued collaboration. He shared a studio with Johns and worked in close association with composer John Cage and choreographer Merce Cunningham. He toured with Cunningham's dance troupe for a decade (1954–1964), designing sets, costumes, and, after 1961, lighting. Rauschenberg also staged ballets (1963–1967) and designed sets and costumes for other companies, including those run by Paul Taylor and Trisha Brown. Throughout his career, he tried out new materials, using card-board and painting on satin and silk. With the support of the National Gallery of Art, he launched the Rauschenberg Overseas Cultural Interchange (1984–1990) a worldwide tour of his work that included venues in Cuba, the Soviet Union, and Tibet. He left one work at each site, reflecting his conviction that thinking differently about art would inspire different ways to think about life.

1925 Born on October 22 in Port Arthur, Texas
1943–1945 Serves as a neuropsychiatric technician in the U.S. Navy
1947 Studies at the Académie Julian in Paris
1948–1949 Studies at Black Mountain College, near Asheville, North Carolina
1952–1953 Travels to Europe and North Africa with Cy Twombly
1953 First designs costumes for the Merce Cunningham Dance Company; meets Jasper Johns in New York City
1964 Becomes the first American to win the Grand Prize at the Venice Biennale
1970 Moves to Captiva Island, Florida
1976 Becomes the first artist featured on the cover of *Time* magazine
1984 Wins a Grammy Award for his cover design for Talking Heads' 1983 album, *Speaking in Tongues*
1984–1990 Helps organize the Rauschenberg Overseas Cultural Interchange, which stages exhibitions in twelve countries
2008 Dies on May 12 on Captiva Island

FURTHER READING
Sam Hunter, *Robert Rauschenberg: Works, Writings and Interviews*, Barcelona 2006
Mary Lynn Kotz, *Rauschenberg, Art and Life*, New York 1990
A film about Rauschenberg is *Robert Rauschenberg: Man at Work*, dir. Chris Granlund, 1997

Robert Petersen, Robert Rauschenberg, 1978

1900 Sigmund Freud publishes
The Interpretation of Dreams

1919–1933 Prohibition in the United States

1955 First "docι
exhibition
Kassel

1886 Erection of the Statue of Liberty
in the Port of New York

1910 The first film studios
set up in Hollywood

1942 Peggy Guggenheim opens the "Art of
This Century Gallery" in New York

| 1875 | 1880 | 1885 | 1890 | 1895 | 1900 | 1905 | 1910 | 1915 | 1920 | 1925 | 1930 | 1935 | 1940 | 1945 | 1950 | 1955 | 1960 |

Nancy Spero, *Black and Red III (panels I,
III, IV)*, 1994, handprinted and printed
collage on paper, 22 panels, 50 x 5395 cm
overall installation, Malmö Konsthall,
Sweden

1964–1973 Vietnam War

1993 Bill Clinton becomes
42nd President of the United States

1979 Saddam Hussein becomes
President of Iraq

2003 U.S. invasion of Iraq

1965 1970 1975 1980 1985 1990 1995 2000 2005 2010 2015 2020 2025 2030 2035 2040 2045 2050

NANCY SPERO

At mid-career, Nancy Spero decided only to feature images of women in her art. Over the following decades she built a repertory of characters—goddesses, athletes, and entertainers, as well as anonymous women from the everyday world— not to revise history, but rather to present it from a woman's perspective.

In 1964 Spero and her family returned to New York City after a five-year stay in Paris. She had met her husband, the painter Leon Golub, while they were students at the School of the Art Institute of Chicago, and although she continued to paint after they married and had children, his career overshadowed hers. The insight that she had been "hiding behind the nuclear family," coupled with the escalation of the Vietnam War, gave Spero the impetus to rethink her art. For more than a decade, she had worked in oil like her husband, using dark, rich tones and rubbing the surface; now, pursuing greater clarity, she switched to watercolor. Always a figurative painter, Spero had focused on relationships—lovers, mothers and children— but her new work was political. In *The War Series* (1966–1970), Spero declared her stance against war with disturbing images of exploding bombs, severed heads, and hovering helicopters.

She joined Artists and Writers Protest Against the War in Vietnam (1964–1972) and the Art Workers' Coalition (1968–1969), but, frustrated by the male domination that she encountered, she turned to women's groups, such as Women Artists in Revolution (WAR) and the Ad-Hoc Committee of Women Artists. In 1972 she co-founded A. I. R. (Artists in Residence) Gallery, which was dedicated to the support and exhibition of women's art. By this time Spero was experimenting with collage, cut paper, and writing fragments, producing her first scroll, the *Codex Artaud* (1971–1972). Spero extracted passages from the work of Antonin Artaud and embellished them with cut-paper images of disembodied heads, phallic tongues, and androgynous figures. Her purpose was confrontational—"I was literally sticking my tongue out at the world," she said—but her discovery that Artaud was "canonized" for his "otherness" while women were silenced for their suffering moved her to a momentous decision. After 1974 she would only depict women.

Over the decades Spero built a vast cast repertory—over 500 characters—that she compared to members of a "stock company"; the characters "act together" but continuously change roles. Some are "stars": ancient goddesses, Olympic athletes, Marlene Dietrich. Others are anonymous women from every walk of life. Spero arranged them as if in a random procession. They leap over barriers and tumble like acrobats. Others look on amused. Her figures always begin small, a quality that she saw as a "retort" to the ambitious scale of "most male New York artists," but in later work, she had her little figures enlarged, to be screened on walls, printed on cut aluminum, and incorporated into murals.

Spero also had her figures turned into rubber stamps so that she could repeat them, and in 1994, while installing the scroll *Black and the Red III* (1994) in a gallery at the Malmö Konsthall in Sweden, Spero began to stamp figures on the wall between her paper sheets. After that ephemeral images became a part of her work; after the exhibition they disappeared behind a fresh coat of paint. Spero compared the viewer's experience to seeing a theater production that lives on in memory rather than in physical form. But she also created enduring monuments for public spaces, such as the ceramic and glass mural featuring opera singers, acrobats, and dancers for the Lincoln Center subway station in New York City (2004). In Spero's work, moving or still, transient or permanent, women make their presence known.

1926 Born on August 24 in Cleveland, Ohio
1949 Earns a bachelor of fine arts degree from the School of the Art Institute of Chicago
1951 Marries Leon Golub
1959–1964 Lives in Paris
1966–1970 Creates her *War Series*
1968–1969 Is a member of the Art Workers' Coalition
1969 Joins Women Artists in Revolution (WAR)
1971–1972 Creates the *Codex Artaud*
1972 Co-founds the A. I. R. Gallery
1974 Decides to focus on female imagery
1988 Hand-prints imagery directly onto walls
2004 Designs the ceramic and glass mural *Artemis, Acrobats, Divas, and Dancers* for the 66th Street–Lincoln Center subway station in New York City
2007 Creates her first sculpture installation
2009 Dies on October 18 in New York City

FURTHER READING
Jon Bird, Jo Anna Isaak, and Sylvère Lotringer, *Nancy Spero*, London 1996
Hans-Ulrich Obrist, *Nancy Spero*, Cologne 2008

Nancy Spero at the festival hall Dresden-Hellerau, 1998

1894 First public film screening
in New York

1907 Picasso paints
Les Demoiselles d'Avignon

1923 First issue of *Time* magazine

1940 McDonald's founded

1949 Mao sets up People's
Republic of China

1963 Assassin
of Presid
John F. K

1880 1885 1890 1895 1900 1905 1910 1915 1920 1925 1930 1935 1940 1945 1950 1955 1960 1965

Andy Warhol, *Self-Portrait*, 1967, acrylic on
canvas with silkscreen, 182.9 x 182.9 cm,
Saatchi Collection, London

1973 First commercial PC

1989 Massacre of peaceful protestors
in Tiananmen Square, Beijing

1995 Tracey Emin's *Everyone I Ever Slept With*

2005 Founding of YouTube

1970 1975 1980 1985 1990 1995 2000 2005 2010 2015 2020 2025 2030 2035 2040 2045 2050 2055

ANDY WARHOL

Andy Warhol's absurd quips, delivered with deadpan naiveté, often disguised shrewd insights. He claimed to like "boring things": popular products, movie stars, and the endlessly repeating news cycle. These were his icons, and in his art they represented the common culture of a postwar, affluent America.

In 1949 Andy Warhola moved from Pittsburgh, Pennsylvania, to New York City to find work as a commercial artist. He shortened his surname to Warhol and quickly found success designing stylish and witty advertisements. Warhol's deft drawing simulated the lines of printing, and he soon began to replicate the images that he found in newspapers and the backs of comic books. His repertoire—ads for nose-jobs, dance lessons, trusses, and wigs—reflected the new trend of Pop art, a provocative movement that obliterated the boundary between fine art and popular culture. He created a sensation when he exhibited his paintings of Campbell's soup cans in 1962. Asked to explain his subject, he stated the obvious: everyone liked soup.

Warhol's iconography reflected his interests. An avid reader of the tabloids, he copied grainy photographs of ghastly car crashes and bizarre accidents. He also experimented with various printing techniques, such as stencils, photo strips, and rubber stamps, eventually adopting the industrial process of photo silkscreen to create an easily recognized and infinitely repeatable image. The 1962 suicide of Marilyn Monroe inspired him to merge the power of mass media with the traditions of commemorative portraiture. Warhol used an old film still to create an iconic image, which he screened in grids over variously painted backgrounds. The visual effect evoked an endless loop, played over and over until the subject was drained of meaning. In thrall to the combination of tragedy and fame, he created other series featuring Liz Taylor (1963), who had suffered through a near-fatal surgery, and Jacqueline Kennedy (1964) before and after her husband's assassination in Dallas.

By using mechanized reproduction techniques—as well as an army of assistants—Warhol widened the distance between the artist and the created object. In emulation of mass production, he deliberately sought a neutral aesthetic, devoid of the artist's unique touch. He called his studio "the Factory" and taunted his critics by declaring, "I want to be a machine." By the middle of the 1960s, Warhol embraced cinema. Visitors to the Factory sat for "screen tests," he filmed the Empire State Building (1964), and he made "Superstars" out of his favorite assistants. Warhol also transformed the role of artist into impresario, staging happenings, launching the band the Velvet Underground, and founding *Interview* magazine in 1969. He simultaneously appropriated and mocked the trappings of popular fame. His puckish prediction that "In the future everybody will be world famous for fifteen minutes" expressed a little-acknowledged aspect of the contemporary American dream.

Warhol had more than his fifteen minutes. In 1968, when he was shot by Valerie Solanis, a self-styled member of SCUM (Society for Cutting Up Men), he became the subject of tabloid news. During the 1970s his celebrity subjects—Liza Minnelli, Rudolf Nureyev, Mick Jagger—were also his dance club companions. Still, Warhol remained in awe of fame, positioning himself on the margins, an odd, nervous figure in an ill-fitting silver wig always carrying a tape recorder. He kept changing with the times, producing television programs and music videos and endorsing products. He also resumed painting and entered into collaboration with several young artists, including Keith Haring and Jean-Michel Basquiat (1984–1985). Although Warhol dumbfounded some critics and angered others, he possessed an uncanny ability to shape his art to the shifting waves of popular culture. Equal parts chronicler, common consumer, and trickster, Warhol captured an image of American interests that was as egalitarian as it was artificial.

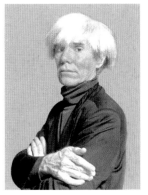

1928 Born on August 6 in Pittsburgh, Pennsylvania

1945–1949 Studies design at the Carnegie Institute of Technology (now Carnegie Mellon University)

1949 Moves to New York City to work as a commercial artist

1957 Wins the annual Art Directors Club award for his I. Miller & Sons shoe advertisements

1960 Begins to create paintings based on advertisements and comic strips

1962 Begins to use the photo silkscreen technique

1963 Opens the "the Factory" and begins to film "Screen Tests" and other films

1968 Shot by Valerie Solanas

1969 Founds *Interview* magazine

1974 Begins to assemble "Time Capsules"

1976 Begins to dictate his diaries to Pat Hackett; they are later published in 1989

1980 Publishes POPism with Pat Hackett

1985–1987 Hosts *Andy Warhol's Fifteen Minutes* on MTV

1987 Has gall bladder surgery; dies in New York City on February 22

FURTHER READING
Douglas Fogle, *Andy Warhol/Supernova: Stars, Death, and Disasters 1962–1964*, Minneapolis 2005
Kynaston McShine, *Andy Warhol: A Retrospective*, New York 1989
A film about Warhol is *Andy Warhol*, dir. Ric Burns, 2006

Andy Warhol, photograph

below
Andy Warhol, *Sixteen Jackies*, 1964, synthetic
polymer and silkscreen inks on canvas,
overall: 203.2 x 162.6 cm, Walker Art Center,
Minneapolis

right page
Andy Warhol, *Lavender Disaster*, 1963, acrylic
on canvas with silkscreen, 269.2 x 208 cm,
The Menil Collection, Houston

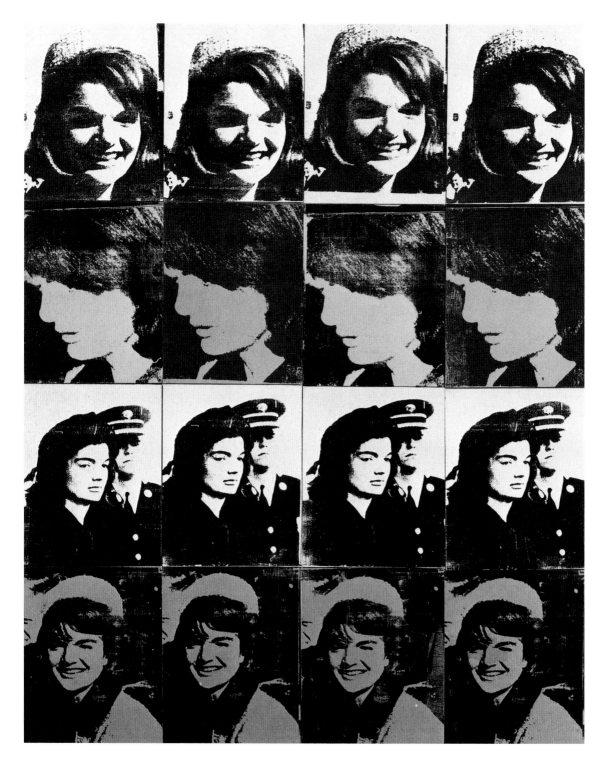

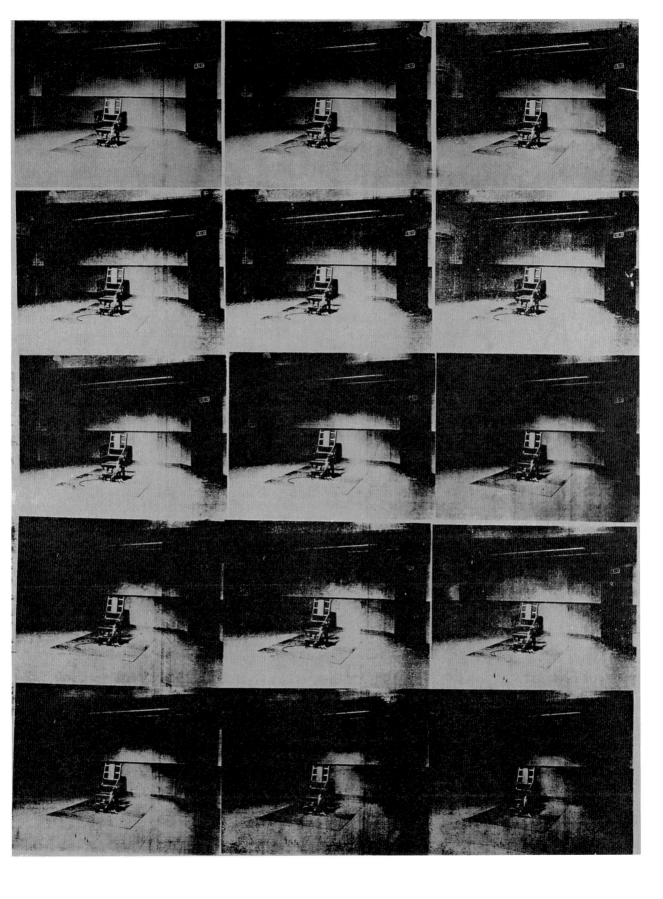

1907 Constantin Brâncuşi's *The Kiss*

1895 Oscar Wilde publishes
The Importance of Being Ernest

1928 Alexander Fleming discovers penicillin

1961 Found
Amnes
Interna

1918 U.S. President Wilson presents
his 14-point program

1944 Allies land in Normandy

| 1880 | 1885 | 1890 | 1895 | 1900 | 1905 | 1910 | 1915 | 1920 | 1925 | 1930 | 1935 | 1940 | 1945 | 1950 | 1955 | 1960 | 1965 |

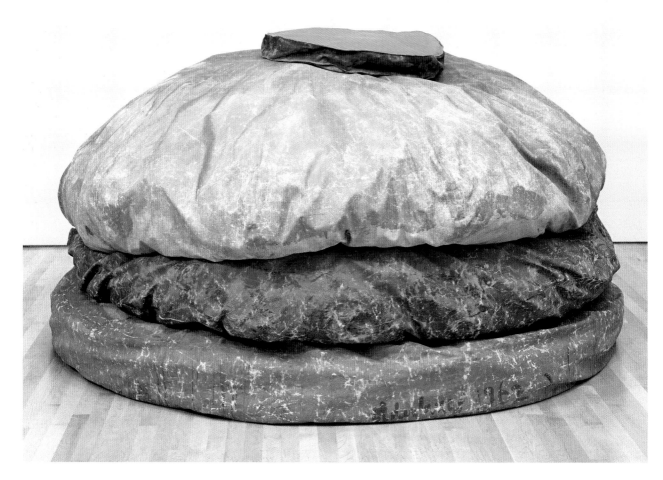

Claes Oldenburg, *Floor Burger*, 1962,
acrylic on canvas filled with foam rubber
and cardboard boxes, 132.1 x 213.4 cm,
Art Gallery of Ontario, Toronto

CLAES OLDENBURG

Floor Cone (1962) sprawls across a gallery floor like a beanbag. Batcolumn *(1977), inspired by a baseball bat, stands 96 feet (29 meters) high.* Spoonbridge and Cherry *(1985–1988) features a 50-foot- (15-meter-) long spoon. With wit, daring, and superb engineering, Claes Oldenburg transforms mundane objects into monuments.*

Oldenburg's father served as an official in the Swedish consulate, and due to his various postings, the family lived in several different countries during the artist's childhood. In 1936 the Oldenburg family settled in Chicago, where Oldenburg attended the exclusive Latin School. After he earned a bachelor of arts degree from Yale University, Oldenburg returned to Chicago, and while working as an apprentice reporter at the City News Bureau, he attended the School of the Art Institute to study figure painting. In 1956, two years after completing his art training, he moved to New York City.

Abstract Expressionism dominated the New York City art scene, but Oldenburg took greater interest in the city's character. He liked its rough edges: cluttered storefronts, trash in the alley, graffiti-marked walls. He met other artists—Red Grooms, Jim Dine, Allan Kaprow—who shared his desire to tear down the barrier between street life and art. Oldenburg turned from figure painting to plaster sculpture with a thickly painted surface, and he took part in Happenings, a spontaneous mode of interactive performance art pioneered by Kaprow. In 1961 Oldenburg rented a rundown storefront in the Lower East Side, where he installed painted plaster and muslin sculptures of everyday merchandise such as cakes and underwear. Everything in *The Store* was for sale. That same year, he released "I Am for an Art," a statement that positioned the mundane as the core of his expression—for example, "I am for an art that grows up not knowing it is art at all."

Oldenburg first made soft sculptures out of sewn canvas stuffed with kapok to use in Happenings, but he quickly saw their potential as independent exhibition objects. His banal motifs—a hamburger sandwich, an ice-cream cone, a commode—as well as his use of exaggerated scale, bright colors, and baggy contours lampooned the seriousness of artistic pretension. Soft sculpture positioned Oldenburg at the forefront of American Pop art.

In 1965 he began to consider issues of scale in an open-ended series of drawings he called *Monuments*. Using crayon, watercolor, and collaged images clipped from magazines and postcards, Oldenburg imagined huge, site-specific sculptures that featured baked potatoes, peeled bananas, and lipstick tubes. He puckishly explained, "I feel my purpose is to say something about my times." By the end of the decade, he began to fabricate his forms on a grand scale in steel, and he received his first major public commission in 1974: the 45-foot- (14-meter-) tall *Clothespin* that was later installed in downtown Philadelphia's Center Square Plaza.

Oldenburg's selection of motifs may seem whimsical, but he takes the surrounding site, as well as personal associations, into consideration. The design process for *Batcolumn* (1977), commissioned for the plaza in front of the new Social Security Administration Center (now the Harold Washington Social Security Center) in Chicago, included a collage of the city's famous skyscrapers turned upside down to demonstrate their resemblance to a bat balanced on its handle. The colossal proportions and imposing grace of *Spoonbridge and Cherry* (1985–1988), in Minneapolis, transcend the idea's origins in an old novelty item that Oldenburg kept in his studio: a trick spoon resting in a puddle of latex chocolate. He knows that scale can transform and "intensify" the most mundane object, and he compares his role as a sculptor to that of a still-life painter who uses "the city as a tablecloth."

1929 Born on January 28 in Stockholm, Sweden
1936 Moves with his family to Chicago, Illinois
1946–1950 Attends Yale University in New Haven, Connecticut
1952–1954 Attends the School of the Art Institute of Chicago
1953 Becomes an American citizen
1956 Moves to New York City
1961 Opens *The Store* on the Lower East Side of Manhattan
1962 Makes his first large soft sculptures in canvas
1967 Exhibits *Giant Soft Fan* in the U.S. Pavilion at Expo '67 in Montreal
1975–1984 Collaborates with Frank Gehry on the Main Street Project in Venice, California
1977 Marries Coosje van Bruggen, who works as his collaborator
1995 Has a retrospective exhibition of his work at the Guggenheim Museum in New York City
2009 Van Bruggen dies

FURTHER READING
Kristine Bell, Greg Lulay, and Alexandra Whitney, *Claes Oldenburg: Early Work*, New York 2005
Claes Oldenburg and Coosje van Bruggen, *Large Scale Projects*, New York 1980

Angelika Platen, Claes Oldenburg 1972

1894 Premiere of Claude Debussy's symphonic
tone poem *Prélude à l'Après-Midi d'un Faune*

1920–1921 Alexander Rodchenko designs
free-floating *Spatial Constructions*

1945 Iron Curtain divides Europe
into East and West

1910 Los Angeles County Museum
of Art opens

1927 Charles Lindbergh flies nonstop
across the Atlantic

1953 Merce Cunningham found
his own dance company

| 1880 | 1885 | 1890 | 1895 | 1900 | 1905 | 1910 | 1915 | 1920 | 1925 | 1930 | 1935 | 1940 | 1945 | 1950 | 1955 | 1960 | 1965 |

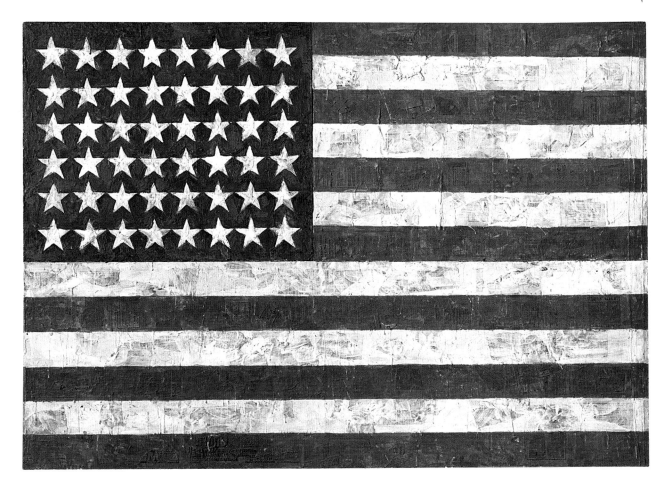

Jasper Johns, *Flag*, 1954/55, encaustic,
oil, and collage on fabric mounted on
plywood (three panels), 107.3 x 154 cm,
The Museum of Modern Art, New York

1968 Assassination of Martin Luther King **1994** End of apartheid in South Africa

1982 Production of the first **2001** Terrorist attacks in the United
commercial CD player States on September 11

| 1970 | 1975 | 1980 | 1985 | 1990 | 1995 | 2000 | 2005 | 2010 | 2015 | 2020 | 2025 | 2030 | 2035 | 2040 | 2045 | 2050 | 2055 |

JASPER JOHNS

Jasper Johns paints ordinary objects such as targets, maps, words, and flags—"things the mind already knows." He limits his palette to primary and secondary hues, sometimes mixing them to produce subtle tones of gray. Within these constraints, he focuses on the true subject of his art: the unlimited potential of the painted surface.

In 1954 Johns destroyed most of the works in his studio. He had come to New York City five years earlier to pursue a long-held dream of becoming an artist but, due in part to a two-year hiatus for his army service, he had struggled to find his own mode of expression in an art world dominated by the painters of the New York School. Yet suddenly, surrounded by like-minded friends—dancer Merce Cunningham, musician John Cage, and artist Robert Rauschenberg—he revised his vision, rejecting the gestural emotions of Abstract Expressionism for a purposeful application of paint to canvas, rooted in control. For his subject, he selected the American flag. Rather than presenting it as an emblem with iconic importance, Johns treated it as a neutral motif, so familiar that as an image it warranted little notice.

What Johns cared about was the application of paint on the canvas: "What had gone before in a picture, and what was done after." Working with encaustic—pigment embedded in molten wax—extended his control. With oil paint, layers blended and colors smeared, but as soon as the wax in the encaustic cooled, he had a stable, inviolate mark on his canvas. The characteristic opacity of encaustic emphasized each stroke: his painted surface acquired a subtle range of textures that contributed as much to his image-making as his choice of colors. He invented upon his motif with variations. He painted a flag in shades of white (1955), and he stacked three flags, placing the smallest on top and the largest on the bottom (1958). Johns also expanded his repertoire of imagery, working with targets, maps, and stenciled words and numbers. He selected his motifs for their banality; rather than new meaning, Johns sought to give them a concrete presence as painted forms. Executed with consummate skill, Johns's motifs are easy to recognize, but his deliberate handling and transformed context endow the most accessible image with a provocative ambiguity.

Johns experimented with his media. He developed an oil-painting technique that simulated the surface of encaustic. He collaged newsprint onto his canvas and then obscured it beneath layers of paint. Like Rauschenberg, he incorporated found objects into his paintings, but his purposeful placement of them—as in *Target with Four Faces* (1955), with each bland plaster face neatly inserted into a frieze—contrasts with his friend's accumulative aesthetic. Johns also cast commonplace objects, such as a coffee can filled with paintbrushes, in bronze and then simulated the original surface in painted oil. His use of words ranges from evocative association, such as stenciling the name of the poet "Tennyson" across the bottom of an imposing gray canvas (1958), to the ironic scrawls labeling adjacent objects that are secured to his canvas.

Johns's work constantly evolves. He has expanded his vocabulary with new forms and markings, such as cross-hatching and harlequin patterning. During the 1980s his work reached its height of complexity, as he loaded his canvases with imagery and objects that had personal significance. But in 1997 he once again stripped back his aesthetic, initiating a series of stark gray paintings inspired by the catenary curve, the downward arc formed by a string that is suspended from two secure points. Although Johns considers himself "a very literal artist," his work reveals that he is a master of understated eloquence and nuanced suggestion.

1930 Born on May 15 in Augusta, Georgia
1947–1948 Attends the University of South Carolina in Columbia, South Carolina
1949 Moves to New York City
1951–1953 Serves in the U.S. Army
1954 Meets Robert Rauschenberg, John Cage, and Merce Cunningham; begins his first flag painting
1955 Paints his first target picture
1958 Has his first solo show, held at the Leo Castelli Gallery in New York City
1961 Buys a house in Edisto Island, South Carolina
1966 His Edisto Island house and studio are destroyed by fire
1967–1978 Becomes the artistic adviser to the Merce Cunningham Dance Company
1972 Introduces the cross-hatching motif to his work
1988 Awarded the Golden Lion at the 43rd Venice Biennale
1990 Receives the National Medal of Arts
2006 The sale of his *False Start* (1959) brings the highest price for the work of a living artist

FURTHER READING
Barbara Hess, *Jasper Johns: "The Business of the Eye,"* Cologne 2007
James Rondeau and Douglas Druick, *Jasper Johns: Gray,* Chicago 2007
A film about Johns is *Jasper Johns: Take an Object: A Portrait: 1972–1990,* dir. Hans Namuth and Judith Wechsler, 1990

Jasper Johns in 1955 at his studio on Pearl Street, in New York City

above
Jasper Johns, *White Flag*, 1955, encaustic,
oil, newsprint, and charcoal on canvas
(three panels), 198.9 x 306.7 cm, The
Metropolitan Museum of Art, New York

right page
Jasper Johns, *Ventriloquist*, 1983,
encaustic on canvas, 190.5 x 127 cm,
The Museum of Fine Arts, Houston

FRANK STELLA

VICTOR VASARELY

BLINKY PALERMO

1897 Founding of the
Viennese Secession

1911 Roald Amundsen is first person to
reach the geographical South Pole

1915 Kazimir Malevich paints
the *Black Square*

1932 The "International Style"
exhibition at the Museum of
Modern Art, New York,
introduces the American public
to recent European architecture

1949 David Ben Gurion
becomes first
Prime Minister
of Israel

1960 Clement Greenberg
publishes his essay
Modernist Painting

1885 1890 1895 1900 1905 1910 1915 1920 1925 1930 1935 1940 1945 1950 1955 1960 1965 1970

Frank Stella, *Getty Tomb* (first version),
1959, enamel on canvas, 215.27 x 245.1 cm,
Private Collection

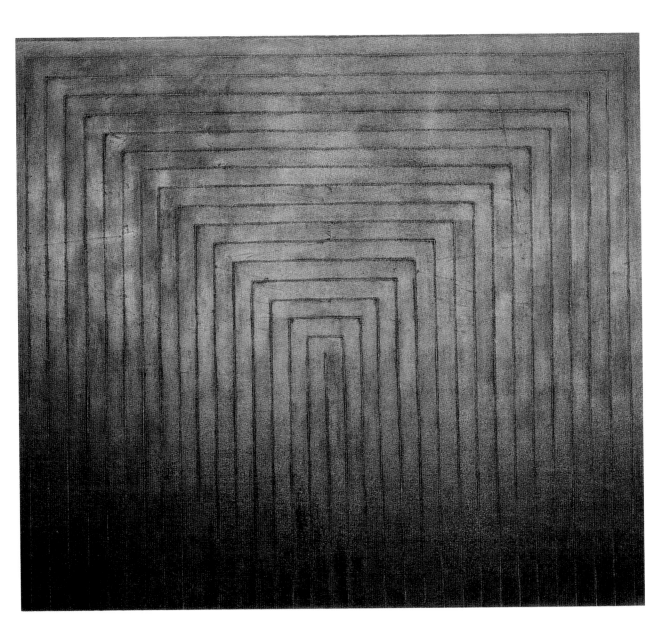

1991 Breakup of Yugoslavia triggers Balkan conflicts **2004** Islamic terrorist attacks in Madrid on March 11 kill 191 people

973 First oil crisis

1998 Founding of the International Court of Justice in The Hague

1975 1980 1985 1990 1995 2000 2005 2010 2015 2020 2025 2030 2035 2040 2045 2050 2055 2060

FRANK STELLA

Frank Stella created a series of Black Paintings *(1958–1960) that featured ink-black stripes, the width of his paintbrush, separated by thin lines of exposed canvas. By repeating his monochrome bands in regular, parallel intervals, Stella found the visual means to force "illusionistic space out of the painting."*

In his youth Stella liked to draw with pastels, but had little interest in honing his representational skills. When he enrolled at the Phillips Academy in Andover, Massachusetts (1950–1954), he found his direction in a studio program that focused on abstract art. At Princeton University he took part in informal painting sessions—studio art was not part of the curriculum—that were overseen by art historian William Seitz, one of the first scholars to write a doctorial thesis on Abstract Expressionism. Stella responded to the inherent physicality of the work of the New York School, to the "the openness of gesture, the directness of attack."

After graduating from Princeton in 1958 with a degree in history, Stella moved to New York City. Seeing the work of Jasper Johns made him question the emotional content of Abstract Expressionism, and, in Johns's example of repetition and a monochrome palette, Stella discovered the means to approach painting as a pictorial field with its own integrity. Later that year, using enamel paint, he began to cover his field with concentric stripes. He worked inward from the perimeter of the plane, painting stripes the width of his paintbrush and leaving a thin line of raw canvas between them. The *Black Paintings* (1958–1960) achieved the holistic expression that he sought. The repetition completely flattened the surface and purged any suggestion of illusionistic space. Through the *Black Paintings* Stella revealed the nuanced potential of a Minimalist aesthetic.

Stella experimented with other types of paint, such as industrial metallic aluminum (1960) and copper (1960–1961). For his *Benjamin Moore Paintings* (1961), he used primary and secondary colors of the high-quality brand of house paint, joking, "I tried to keep the paint as good as it was in the can." He began to make shaped canvases, in further pursuit of the painting as object. First, he notched the corners of his *Aluminum Paintings*, making his parallel stripes conform to the introduction of the

angle. He used L-shapes for the *Copper Paintings*, treating the right angle as his field or joining two or more together to create a cross- or T-shaped canvas. By 1965, inspired by geometric instruments, Stella began to create complex, interlocking shapes, as seen in his *Irregular Polygon* series (1966–1967) and the *Protractor* series (1967–1971). Over the course of the decade, his scale expanded and his hues brightened to radiance. The stripes gave way to planes of color in geometric shapes defined by the persistent presence of the exposed canvas line.

In 1967 Stella made his first prints at the Gemini G. E. L. Studio in Los Angeles, carrying forward the deductive formal analysis that he pursued in his painting. Over the decades, he has continued to experiment and innovate. He introduced surface relief in his *Polish Village* series (1971–1973), using planes of wood, metal, and paper. He has continued to expand his scale, and with the assistance of the engineering consultant Earl Childress, he has taken on architectural projects, explaining, "buildings are nothing more than outsize sculpture." Through all the changes in his work, Stella remains a staunch and articulate advocate of the primacy of formal expression in art. Playing on a catchphrase from the 1970s, he likes to explain that the integrity of his art solely depends upon what is actually there: "What you see is what you see."

1936 Born on May 12 in Malden, Massachusetts
1954–1958 Attends Princeton University, in Princeton, New Jersey
1958 Moves to New York City; begins the *Black Paintings*
1959–1960 Featured in "Sixteen Americans" at the Museum of Modern Art in New York City
1960 Makes first shaped canvases
1961 Marries art critic Barbara Rose
1964 Included in the "Post-Painterly Abstraction" exhibition at the Los Angeles County Museum of Art
1967 Designs sets and costumes for Merce Cunningham's dance project *Scramble*
1970 Becomes the youngest artist to receive a retrospective exhibition at the Museum of Modern Art
1983 Named Charles Eliot Norton Professor at Harvard University in Cambridge, Massachusetts
1992 Designs murals, dome paintings, and reliefs for the Princess of Wales Theater in Toronto, Ontario
2001 Receives the Gold Medal of the National Arts Club in New York City

FURTHER READING
Lawrence Rubin, *Frank Stella: Paintings 1958 to 1965: A Catalogue Raisonné*, New York 1986
Frank Stella, *Working Space*, Cambridge, MA, 1986

Frank Stella, photograph, Private Collection

ROBERT SMITHSON ══════════════════════════════════

JANNIS KOUNELLIS ══════════════════════════

ANDY GOLDSWORTHY ══════════════

1905 Founding of *Die Brücke* group
of artists in Dresden

1929 First public TV
pictures broadcast

1945 Kingdom of Yugoslavia recreated
as a communist federal state

1964–1973 Vietnam War

1919 German colonies in Africa shared
among Great Britain and France

1954 J. R. R. Tolkien publishes
Lord of the Rings

1971 Foundin
Greenpe

| 1890 | 1895 | 1900 | 1905 | 1910 | 1915 | 1920 | 1925 | 1930 | 1935 | 1940 | 1945 | 1950 | 1955 | 1960 | 1965 | 1970 | 1975 |

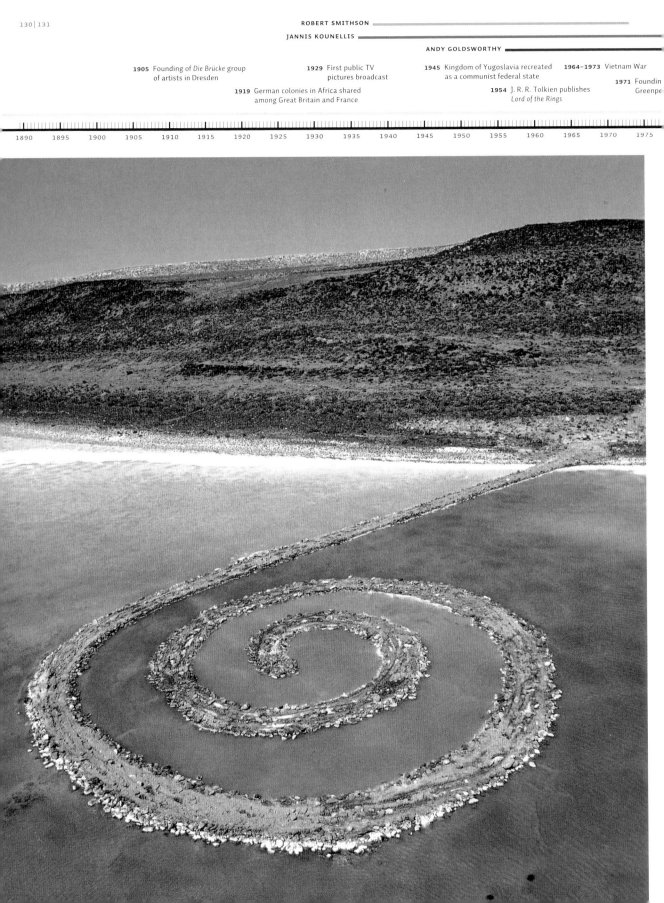

ROBERT SMITHSON

As Robert Smithson drove through the salt flats that spread out from the Great Salt Lake in Utah, he was drawn to a site with jigsaw cracks in its mud-encrusted surface. He hauled rocks and earth from the lake's edge to the flats to create Spiral Jetty, a massive earthwork built in and of the earth, rather than upon it.

Smithson liked to draw as a child, but his real passion was natural science. He collected shells and fossils, and he documented them in his drawings. Bored with high school, he began to attend classes at the Art Students League in New York City as a teenager. In 1956 he joined the U.S. Army, but only served for six months. After an extended road trip through the West Coast in 1957, he returned to the East Coast, settled in New York City, and embraced the art scene with the conviction that once he understood Modernism, he could "make my own moves."

In 1961 Smithson traveled to Europe. He was intrigued by the interior spaces of the Roman Baroque churches, as well as the Byzantine aesthetic of late medieval Sienese painting. The drawings and collages he made upon his return assimilated these new influences with his repertoire of natural motifs. But in 1963 Smithson stopped painting, entering what he described as a "groping, investigating period." He focused on the structure of materials, rather than their expressive potential. He studied the process of crystallization and the practice of mapping. He gained a reputation for writing insightful art theory and criticism, publishing his essays in prominent journals, including *Artforum* and *Arts Magazine*.

Guided by his enduring interest in the natural world, Smithson began to consider natural materials, and he made stripped-down, Minimalist sculptures using found objects such as rocks and shells as well as glass sheets, wooden containers, and mirrors. He documented outdoor installations, such as his *Chalk-Mirror Displacement* (1969), with photographs that he then exhibited in galleries. He recognized a dialectic between these two modes of installation; he termed them *site*, referring to a specific outdoor geographical location, and *non-site*, meaning an interior space, such as a gallery, where objects from sites could be displayed. In the non-site, the object—be it a rock or shell or pile of soil—

carried elements of the site, while the site itself was subject to constant environmental change.

In the late 1960s, Smithson began to explore the potential of "entropic landscapes"—fringe sites such as old quarries, backwater sandbanks, and burned-out fields—as potential locations for earthworks: monumental, site-specific landforms created out of the land itself. His search for the *Spiral Jetty* (1970) site was prompted by his interest in the ruddy tone of salt-flat waters infested with saline-tolerant algae, but he chose his location for the cracked and crusted mud flats that suggested to him "matter collapsing into the lake mirrored in the shape of a spiral." Smithson secured a twenty-year lease on the land, hired a contractor and earth-moving equipment, and oversaw the construction of a 1,500-foot- (460-meter-) long, counterclockwise coil mounded out of earth and black basalt rock hauled from the shore of the nearby Great Salt Lake. In 1970 Smithson made a film of the site, and three years later he died in a plane crash while searching for new sites in the vicinity of Amarillo, Texas. By the end of the decade, the *Spiral Jetty* site had disappeared under rising waters; Smithson had built his earthwork near the end of a prolonged drought. It remained submerged until the dry spell of 2004. Visible only for a year, the basalt had acquired a white, saline crust and the waters had become pale pink.

1938 Born on January 2 in Passaic, New Jersey
1953–1955 Takes classes at the Art Students League in New York City
1956 Joins the U.S. Army for six months
1957 Hitchhikes around the United States; moves to New York City
1961 Travels to Europe
1963 Gives up painting
1964 Begins to write art criticism
1968 Discusses the idea of "land art" in "A Sedimentation of the Mind," published in *Artforum*
1969 Begins making earthworks
1970 Begins construction of *Spiral Jetty*; makes the film *Spiral Jetty*
1973 Dies on July 20 in Amarillo, Texas
2004 After more than two decades submerged underwater, *Spiral Jetty* reemerges

FURTHER READING
Lynne Cooke and Karen Kelly (eds.), *Robert Smithson: Spiral Jetty: True Fictions, False Realities*, Berkeley 2005
Jack D. Flam (ed.), *Robert Smithson: The Collected Writings*, Berkeley 1996
Spiral Jetty, dir. Robert Smithson, 1970 (released on DVD in 2000)

left page
Robert Smithson, *Spiral Jetty*, 1970, Rozel Points, Utah

Gianfranco Gorgoni, Smithson in his studio, New York City, 1970

1906 Henri Matisse paints *The Joy of Life*

1919 Founding of the Bauhaus in Weimar

1933 Franklin D. Roosevelt becomes 32nd President of the United States

1955 First "documenta" exhibition in Kassel

1966 "Primary Structures" exhibition at the Jew Museum in New Yor

1945 Liberation of the remaining inmates of Auschwitz concentration camp on January 27

1890　1895　1900　1905　1910　1915　1920　1925　1930　1935　1940　1945　1950　1955　1960　1965　1970　1975

1991 Breakup of Yugoslavia **2007–2009** Global credit crunch
triggers Balkan conflicts

77 First *skulptur.projekte* in Münster **2002** United States sets up controversial
detention facility in Guantánamo Bay

| 1980 | 1985 | 1990 | 1995 | 2000 | 2005 | 2010 | 2015 | 2020 | 2025 | 2030 | 2035 | 2040 | 2045 | 2050 | 2055 | 2060 | 2065 |

RICHARD SERRA

Richard Serra transforms steel into a pliable medium. His colossal planes torque and bend; they soar in seeming defiance of the metal's physical properties. He uses his steel to describe volumes in space, for just as steel is Serra's medium, space is his content.

Serra recalls that when he was a boy, his father took him to the Marine Shipyard in San Francisco. The launch of a ship—at once massive yet weightless—fascinated him, and he dreamed of it for years. Drawing, too, was important in his childhood, but he studied English literature in college and worked in steel mills during the summers to pay his tuition. He turned to the arts for his graduate degree at Yale University, where he studied drawing and painting. In 1964 he traveled to Europe, and his interest shifted to sculpture. For a month he made daily visits to Constantin Brancusi's studio in Paris, and then, in Florence, he marveled at how Donatello incorporated the sinuous power of drawing into bronze sculpture.

In 1966 Serra moved to New York City, where he met sculptors Robert Smithson and Donald Judd, who were actively challenging the traditional definition of the medium. Serra began to experiment with the potential of materials by working in rubber and lead. He compiled a long list of verbs to detail the possibilities: "to roll, to crease, to fold, to store, to bend." His interest focused not on the material itself, but rather on the act of manipulating it. In 1968 he began to make his lead-splash pieces, for which he flung ladles of molten lead against a wall. Rather than performance or the creation of an object, he saw his work as a process in which the end result was the material accumulation as evidence of a series of actions. It is this emphasis—on the actions that produce a piece rather than the piece itself—through which Serra differentiates his "process" work from Minimalism. Like the Minimalists, Serra stripped his work of all extrinsic content and embellishment, but in his desire to take the focus off the object he wanted to "make the viewer the subject." Toward this end he began to conceive site-specific works that would reshape the surrounding space and alter the viewer's movements in and around the forms that he created.

Early in the 1970s, Serra began to work in steel, designing grand-scale, subtly curved planes that cut through the volume of outdoor locations, such as *Titled Arc* (1981), a work commissioned by the U.S. General Services Administration for the Federal Plaza in New York City. Some local workers complained that the placement of *Tilted Arc* obstructed their access through the plaza; in 1985, at a public hearing held to resolve the matter, Serra refused to have the sculpture moved, maintaining that site specificity was integral to the work. The jury voted to remove the sculpture, and after a failed appeal, *Titled Arc* was cut into three pieces and hauled to a scrapyard in 1989.

The conflict strengthened Serra's convictions, and in the ensuing years his works have become even more ambitious in scale and daring. For *Weights and Measures* (1987), he balanced three massive square slabs of steel onto two delicate corner points. In *Snake* (1994–1997) three parallel planes undulate as if in slithering motion. And his soaring *Charlie Brown* (2000), named after the comic character invented by Charles Schultz, appears to be made of pliant bands rather than rigid steel planes. Although known for his unprecedented ability to craft steel into spare, elegant, and astonishing shapes, Serra insists that his real medium is space; the steel only serves to heighten the viewer's understanding of the site that surrounds it.

1939 Born on November 2 in San Francisco, California
1955–1957 Works in steel mills during the summers
1961 Earns a degree in English literature from the University of California
1964 Earns his bachelor and master of fine art degrees from Yale University
1964–1966 Travels to Paris and Italy on Yale's Traveling Fellowship and a Fulbright scholarship
1967–1968 Compiles his "verb list"
1968 Makes his first film, *Hand Catching Lead*
1969 Has his first solo show at the Leo Castelli Warehouse in New York City; appears in a performance of Steve Reich's *Pendulum Music* at the Whitney Museum of American Art
1981 Has his work *Titled Arc* installed in the Federal Plaza in New York City
1989 *Titled Arc* is removed and scrapped
2002 Appears in Matthew Barney's *Cremaster 3* film as "the architect"

FURTHER READING
Carmen Giménez (ed.), *Richard Serra: The Matter of Time*, Bilbao 2005
Sherrill Jordan (ed.), *Public Art, Public Controversy: The Tilted Arc on Trial*, New York 1987
Kynaston McShine, Lynne Cooke, Benjamin H. D. Buchloh, and John Rajchman, *Richard Serra: Sculpture: Forty Years*, New York 2007

left page
Richard Serra, *The Matter of Time*, 1994–2005, steel, Guggenheim Museum, Bilbao

above
Dieter Schwerdtle, photograph of Richard Serra in Kassel, 1982, Turin, Private Collection

1903 Kraft Foods is founded
in Chicago

1912 The *Titanic* sinks in the
North Atlantic

1920 First public radio broadcast

1936 Premiere of Charlie Chaplin's
film *Modern Times*

1949 David Ben Gurion becomes
first Prime Minister of Israel

1962 Andy Warhol paints
Campbell's Soup Cans

1890　1895　1900　1905　1910　1915　1920　1925　1930　1935　1940　1945　1950　1955　1960　1965　1970　1975

Ed Paschke, *Violencia*, 1980, oil on canvas,
188 x 245.1 cm, Whitney Museum of
American Art, New York, gift of Sherry
and Alan Koppel in memory of Miriam
and Herbert Koppel

ED PASCHKE

Ed Paschke filled his studio with magazine clippings, posters, and advertisements. The street outside his studio—in a rough Chicago neighborhood—pulsed with activity. Out of these raw materials, Paschke fashioned the provocative and often lurid figures that he painted with exquisite precision and in hues as electrified as neon light.

The mass media imagery of Paschke's childhood—comic books, cartoons, and flamboyant television wrestlers—ignited his interest in art. By the time he entered the School of the Art Institute of Chicago in 1957, he was, in his own words, a skillful "mimic," able to reproduce anything that he saw. But the formalist emphasis of the curriculum forced him to adopt a kind of "schizophrenic" practice, absorbing the principles of abstract art in class, while continuing to hone his representational technique on his own. He also drew influence from the museum's changing exhibitions, featuring the work of artists ranging from Georges Seurat to Jasper Johns and Robert Rauschenberg. But the popular image was his touchstone; classmate Karl Wirsum recalled that in 1961, Paschke brought *Life* magazine covers to class and reconfigured the images on his canvas.

After graduation Paschke worked in commercial illustration; *Playboy* magazine gave him three commissions, with twenty-five more over the next decades. In 1962 he was drafted into the U.S. Army, where he used his skills to delineate maps and illustrate firearms manuals. After his discharge in 1964, Paschke returned to commercial work, but he also experimented in film. In 1967 he turned his full energy to his painting, and the following year he returned to the School of the Art Institute to pursue a graduate degree. He developed a meticulous, hyperreal style that re-situated well-known images—the photograph of Lee Harvey Oswald holding a rifle, or a smiling Marilyn Monroe—into new and jarring contexts. *Purple Ritual* (1967), his Oswald painting, appeared in the inaugural exhibition of Chicago's Museum of Contemporary Art. Paschke's command of representational form allied him with the Chicago Imagists, an open circle of local painters whose use of figuration, humor, and popular culture was in contrast to the rigorous formalist aesthetic associated with New York City.

Paschke exhibited his work at Chicago's cutting-edge Hyde Park Art Center with a group called the Nonplussed Some. But his raw imagery—wrestlers, strippers, and transvestites—separated his work from the naïf aesthetic of his Imagist contemporaries. The "in-your-face," confrontational attitude of his early work was deliberate; Paschke's desire to provoke and challenge responded to the turmoil of the times. But as his content evolved away from menacing, sensational figures to more enigmatic masked forms over the next decades, his precise technique prevailed. As a painter Paschke was a traditionalist, building his figures up on the canvas from a monochromatic underpainting to his taut, blindingly bright surface with layers of colored glaze.

Throughout his career Paschke embraced the influence of mass media. In the 1980s he mirrored the visual effects of a video screen on his canvas by using subtle gradations in tone to evoke electrostatic pulsations. He depicted iconic figures—George Washington, Mona Lisa, Elvis—in an open series that he jokingly described as the "Most Famous Faces in the History of Civilization." In 1997, collaborating with Ellen Sandor, founder of the (art)n Laboratory, he created computer-generated projections of his hand-painted images to produce PHSColograms, haunting phantoms that appear to exist in three dimensions and seem to shift positions from different viewpoints. But changes in his media and motif did not alter his refined approach or his enduring fascination with popular culture. To Paschke, modern life a was an ongoing spectacle, and his role was to observe it, filter it, and make his art from the "raw material" of his times.

1939 Born on June 22 in Chicago, Illinois
1948 Moves with his family to a farm in Lyndon Station, Wisconsin
1950 Returns with his family to Chicago
1957–1961 Studies at the School of the Art Institute of Chicago
1962–1964 Serves in the U.S. Army
1965 Takes his first trip to Europe
1968 Plays the role of the "leading man" in Red Grooms's film *Tappy Toes*
1973–1976 Teaches at the School of the Art Institute of Chicago
1977 Joins the Department of Art Theory and Practice at Northwestern University, in Evanston, Illinois
1997 Begins to collaborate with Ellen Sandor to create PHSColograms
2000 Receives a Guggenheim Fellowship
2004 Dies on November 25 in Chicago
2005 A section of Monroe Street adjacent to the Art Institute of Chicago is named "Honorary Ed Paschke Way"

FURTHER READING
Neal Benezra, Carol Schreiber, Dennis Adrian, and John Yau, *Ed Paschke*, New York 1990
Michael Dunbar and Marc Paschke, *Ed Paschke: Electronicon*, Jacksonville, IL, 2007

Ed Paschke in his studio, 1989

1915–1917 Genocide of Armenians
in the Ottoman Empire

1940 Frank Sinatra achieves his breakthrough
with *I'll Never Smile Again*

1962 Cuban Missile Crisis

1901 Swedish King confers first Nobel
Prize awards in Stockholm

1927 Premiere of *The Jazz Singer*,
the first "talkie"

1949 Founding of the Council of Europe
based in Strasbourg

| 1890 | 1895 | 1900 | 1905 | 1910 | 1915 | 1920 | 1925 | 1930 | 1935 | 1940 | 1945 | 1950 | 1955 | 1960 | 1965 | 1970 | 1975 |

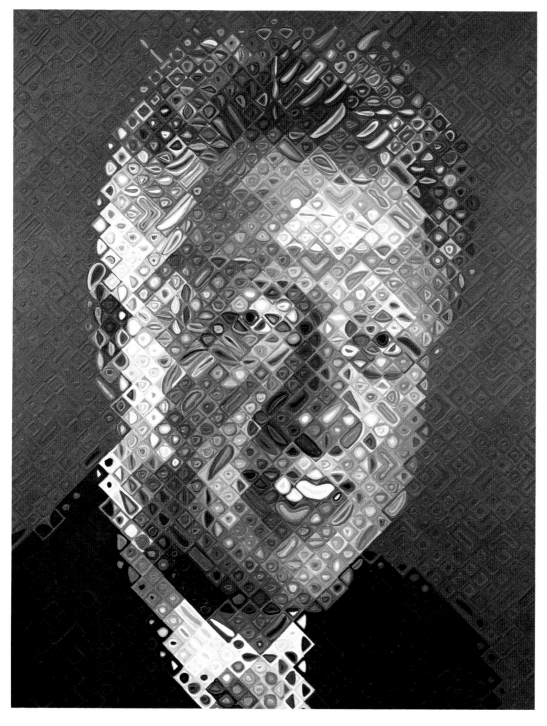

Chuck Close, *Bill Clinton*,
2006, oil on canvas,
275.6 x 213.4 cm, Private
Collection, New York

1990 German reunification
Pol Pot takes power in Cambodia **1999** First e-book reader on the market
 2006 Iraqi tribunal sentences
 Saddam Hussein to death

1980 1985 1990 1995 2000 2005 2010 2015 2020 2025 2030 2035 2040 2045 2050 2055 2060 2065

CHUCK CLOSE

For more than four decades, Chuck Close has painted portraits. His format—grand scale, face front, neutral expression—rarely varies. But by shifting the traditional rationale behind portrait painting from capturing a likeness to pictorial investigation, Close has completely redefined one of the most conventional subjects in the history of art.

When Close was five years old, his father made him an easel and gave him a set of oil paints that he ordered from the Sears, Roebuck catalogue. At eight, Close began to study anatomy, still life, and life drawing with a private tutor. He majored in art throughout college, but a visit to New York City to see contemporary art made him aware of the limits of being "a kid from Seattle used to black and white reproductions." He completed his studies at Yale University, earning a master of fine arts degree in 1964; he spent the following year at Vienna's Akademie der Bildenden Künste on a Fulbright grant.

As a painter, Close began to work with photography in 1966, taking black-and-white pictures of a young woman to use in a study for a reclining nude. A year later he pieced together fragments of several of those photographs to create an image that he then enlarged on a grid as the under drawing for the 21-foot- (6.4-meter-) long painting, *Big Nude*. He next took a close-up head shot of himself and transferred it to a canvas nearly 9 feet (2.7 meters) high. *Big Self-Portrait* (1968) set the template for the work that would occupy him for decades: a colossal mode of portrait painting that incorporated likeness as one feature in a meticulous visual analysis.

Close used an airbrush—an industrial painting tool—to blow bursts of monochrome pigment on the surface of *Big Self-Portrait*. The result was seamless, lacking the identifying touch of the artist's hand, but Close was after what he described as the quality of "all-overness" rather than anonymity. His concentration on surface effect rather than rendered image united his aims with those of painters such as Jasper Johns and Frank Stella. After painting seven more black-and-white works in a series he referred to as "Heads" (1968–1970), he shifted to color, simulating the color separation process of commercial printing. Like his friend Richard Serra, Close was interested in process, but

he was also intrigued by the apparent dichotomies of making portraits that were simultaneously "impersonal and personal" and "minimal and maximal," "employing unbelievable handwork" without the display of "virtuoso brushmanship."

Over the years, Close has continued to reinvent his method. In 1978 he began to make "fingerprint drawings" by dipping his thumb or forefinger into pigment and varying the pressure to control tonality. He has experimented with printmaking and photography, reviving the neglected techniques of mezzotint (1972) and daguerreotype (1991), and in 1979 he began to use a large-scale Polaroid camera (20 by 24 inches; 51 by 61 centimeters) to make photographs intended to stand as independent works of art rather than serve as painting studies. Wheelchair-bound since 1988, when a collapsed spinal artery left him partially paralyzed, Close now paints with his brush strapped to his wrist. He continues to make portraits—mostly of his friends and rarely on commission—and his approach continues to evolve. His current paintings are composed of tile-like fields of color, each containing elliptical or ovoid forms that have the richness of minutely rendered abstractions. Seen from a distance, these small units merge into the sitter's likeness, but up close they maintain their distinctive visual identity, illustrating Close's belief that in painting, "the object ... is not just to make a picture but to lay bare what a picture is made of."

above
Chuck Close, *Self-Portrait/Diptych*, 2005, two color Polaroid photographs mounted on aluminium, 261.6 x 203.2 cm, Private Collection, New York

following double page
left
Chuck Close, *Linda/Pastel*, 1977, pastel on watercolor-washed paper, sheet: 76.2 x 57.2 cm, Collection of Doris and Donald Fisher, San Francisco

right
Chuck Close, *Leslie/Watercolor*, 1972–1973, watercolor on paper mounted on canvas, 184.2 x 144.8 cm, Private Collection, Rutherford, California

1940 Born on July 5 in Monroe, Washington
1946 Receives his first set of oil paints
1961 Takes his first visit to New York City
1964 Receives a master of fine arts degree from Yale University
1966 Starts working with photographs
1968–1970 Creates his "Heads" series in black and white
1970 Begins to experiment with color
1972 Publishes his first mezzotints
1978 Makes his fingerprint drawings
1979 Begins to use a Polaroid large-format camera
1980 Returns to oil painting with a brush
1988 Left with incomplete quadriplegia as a result of a collapsed spinal artery
1997 Receives an honorary doctorate from the Rhode Island School of Design
1999 Begins to produce daguerreotypes
2000 Awarded the National Medal of Arts in Washington, D.C.
2004–2009 Uses his daguerreotype and Polaroid photographs to create tapestry designs

FURTHER READING
Christopher Finch, *Chuck Close: Work*, Munich 2007
Robert Storr, Kirk Varnedoe, and Deborah Wye, *Chuck Close*, New York 1998
A film about Close is *Chuck Close: A Portrait in Progress*, dir. Marion Cajori, 1998

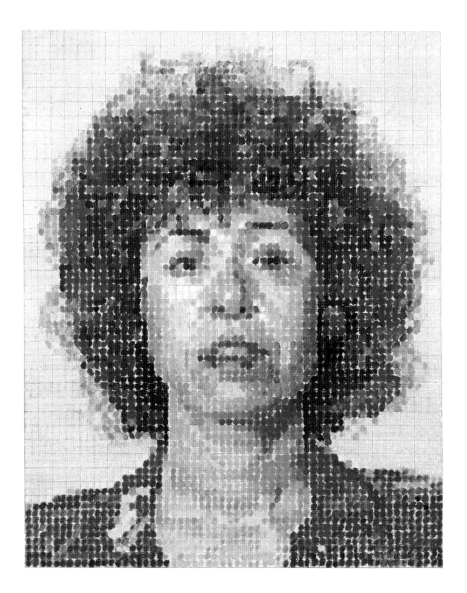

1917 Premier of Apollinaire's play
The Breasts of Tiresias

1949 Simone de Beauvoir publishes
The Other Sex

1971 Wom
the v
Swit.

1902 Cuba gains independence from Spain

1935 Nazis pass Nuremberg Race Laws

1959 China annexes Tibet

1890 1895 1900 1905 1910 1915 1920 1925 1930 1935 1940 1945 1950 1955 1960 1965 1970 1975

Elizabeth Murray, *Beginner*, 1976,
oil on canvas, 287 x 289.6 cm, Saatchi
Collection, London

1982 Production of the first
commercial CD player

1999 Columbine Highschool massacre

1990–1991 First Gulf War

2007 Apple launches iPhone

1980　1985　1990　1995　2000　2005　2010　2015　2020　2025　2030　2035　2040　2045　2050　2055　2060　2065

ELIZABETH MURRAY

Elizabeth Murray's shaped canvases dissolve the barrier between a two-dimensional surface and a three-dimensional object. With forms that curve or crash against one another like lightening bolts, and surfaces that are thickly brushed, vividly colored, and suggestively figurative, Murray pumped new energy into the formal possibilities of American painting.

Murray loved cartoons as a child, and, as a young adult, she enrolled at the School of the Art Institute of Chicago to train for a career in commercial art. To reach her classrooms, Murray walked through the museum galleries, and this daily exposure to the great works of the past convinced her to pursue her own vision as a painter. She obtained a master's degree in fine arts at Mills College in Oakland, California, in 1964 and then went on to teach at Rosary Hill College in Buffalo, New York. Influenced by Claes Oldenburg's droll take on familiar objects, Murray bought a sewing machine and began to make overscaled, stuffed sculptures of armchairs and trousers. But her 1967 move to New York City reignited her engagement with painting.

During this period, contemporary artists' prevailing interest in rigorous Minimalism had pushed painting to a secondary status. Murray observed, "Painting was out, hip people weren't involved in painting." When painting did prevail, its material elements were reduced to smooth planes of color undisturbed by brushstrokes and figuration. Murray chafed at this restrictive view, and in 1971 she stopped making dimensional objects and turned her full attention to exploring painting's key components: line, surface, and color. For the next five years, she worked on thickly brushed grounds, making various types of marks. She began with figures adapted from paintings by Paul Cézanne that she had admired as a student, but quickly moved to examining the potential of line. She covered her surface with grids, ladders, fan forms, waves, and Möbius bands, allowing her lines to express the restless energy of her investigations. The intensity of her color heightened and "subject matter became less important, paint more important." By 1976 she introduced new figural forms into her canvases, including one composed of two ballooning commas with a pointed, beak-like projection that she described as "Tweetie Bird," a cartoon character from her childhood.

In 1977 in her first solo exhibition at the Paula Cooper Gallery in New York City, Murray presented nine shaped canvases. With their jagged or curved edges, her new paintings challenged the integrity of the painting plane, but her experiment was in its initial stages, and critic Roberta Smith likened them to "nervous teenagers." Just three years later, inspired by a stack of old canvases on her studio floor, Murray shattered the plane, splitting her canvases into fragments, lapping one over the other, and allowing the stretchers to warp the flat surface and make it jut out from the wall. With the confidence of this new discovery, she also enlarged the scale of her works and fully released her passion for high-keyed color.

Murray fragmented forms, inflated them, and set them in motion with propulsive energy. Her teasing titles—*Just in Time, Yikes, Do the Dance*—act like mocking captions and recall her enthusiasm for cartoons. Through surface, color, and form, Murray boldly declared her exuberance for her medium, rooted in a discovery from her student days. As she admired a small still life by Cézanne, she realized it was not the bowl of apples that intrigued her, but rather "the joy of looking at a painting."

1940 Born on September 6 in Chicago
1958–1962 Attends the School of the
　　　　Art Institute of Chicago
1962–1964 Earns her master's degree
　　　　in fine arts from Mills College, in
　　　　Oakland, California
1965–1967 Teaches at Rosary Hill
　　　　College in Buffalo, New York
1967 Moves to New York City
1971 Stops working in three dimensions
　　　to concentrate on painting
1976 Exhibits her first shaped canvases
1978–1980 Teaches at Yale University
1984 Receives the American Academy
　　　and Institute of Arts and Letters
　　　Award
1995 Curates "Artist's Choice—
　　　Elizabeth Murray: Modern
　　　Women" from the collection of
　　　the Museum of Modern Art in
　　　New York City
1999 Receives a John D. and Catherine
　　　T. MacArthur Foundation Award
2005 Has a forty-year retrospective of
　　　her work at the Museum of
　　　Modern Art
2007 Dies on August 12 in Washington
　　　County, New York

FURTHER READING
Sue Graze, Kathy Halbreich, Roberta
Smith, and Clifford S. Ackley, *Elizabeth
Murray: Paintings and Drawings*, New
York 1987
Robert Storr, *Elizabeth Murray*, New
York 2005

Elizabeth Murray, *Can You Hear Me?* 1984, oil on 4 canvases,
269.2 x 403.9 x 30.5 cm, Collection Dallas Museum of Art,
Foundation for the Arts Collection, anonymous gift

above
Elizabeth Murray at the Whitney Gala,
2004

1915–1917 Genocide of Armenians
in the Ottoman Empire

1943 Premiere of Michael
Curtiz's film *Casablanca*

1968 Viennese Action
perform *Art and
Revolution*

1903–1940 Construction of the German-
sponsored Baghdad Railway

1930 Edward Weston photographs
a sliced half artichoke

1957 Albert Camus awarded
Nobel Prize for literature

| 1890 | 1895 | 1900 | 1905 | 1910 | 1915 | 1920 | 1925 | 1930 | 1935 | 1940 | 1945 | 1950 | 1955 | 1960 | 1965 | 1970 | 1975 |

Cindy Sherman, *Untitled*, 1983, color photograph,
89.5 x 54 cm, courtesy of the Artist and Metro
Pictures

1991 The World Wide Web (www) **2004** The Abu Ghraib torture
is released for general use scandal breaks

1982 Michael Jackson releases **1998** Founding of the Napster online
his *Thriller* album music sharing service

| 1980 | 1985 | 1990 | 1995 | 2000 | 2005 | 2010 | 2015 | 2020 | 2025 | 2030 | 2035 | 2040 | 2045 | 2050 | 2055 | 2060 | 2065 |

CINDY SHERMAN

Cindy Sherman poses in her own photographs, submerging her identity under wigs, makeup, costumes, and prostheses. With her body as the medium and the camera as her means, she creates characters. She neither names them nor spells out their stories, but we know who they are at first glance.

Growing up in suburban Long Island, New York, Sherman enjoyed playing dress-up with discarded clothing and makeup. By the time she enrolled at the State University College at Buffalo to study painting, she was scouring thrift shops for vintage garments, accessories, and wigs. Her "characters" began to emerge as a result of all the "detritus" that she collected; at first she simply dressed up to go out with friends, but in 1975, thinking, "Why waste it?" she began to photograph herself in character. Having switched her major to photography and film, she created little narratives, featuring herself as an animated paper doll or as a repertory of characters in photographed tableaux. She always played all the roles.

After graduation she moved to New York City, and in 1977, inspired by the evocative photographs used to promote Hollywood movies, Sherman began to shoot her *Untitled Film Stills* (1977–1980). Rather than imitate a known actress or reprise a recognized role, Sherman created a cast of types: a bewildered ingénue on the streets of Manhattan, a seductive librarian, a femme fatale in a cocktail dress. She refused to title the photographs, not wanting to "spoil the ambiguity," and her impersonations featured uncertain gestures, tamped down emotions, and neutral facial expressions. But the types were so familiar from movies and mass media that viewers took part in the role-play and easily invented the absent details. The final series featured sixty-nine black-and-white prints; she shot most of them herself using a shutter-release cable.

In 1980 Sherman began to shoot in color, and to avoid working on location, as she did for many of the *Film Stills*, she simulated elaborate backgrounds in her studio, posing before rear screen projections. Commissioned in 1981 by *Artforum*, she created a series that she initially called *Horizontals*, in which she shot herself from above, while crouching or reclining on the ground. Sherman appropriated the format of a two-page magazine spread, leading to

the series' title, *Centerfolds* (1981). Fearing that readers might interpret the prone characters as victims, editor Ingrid Sischy rejected the prints. Sherman deliberately tackled disturbing content and grotesque imagery in *Fairy Tales* (1985) and *Disasters* (1986–1989). As these series played out, Sherman began to replace her own image with dismembered dolls, mangled mannequins, and prosthetic body parts, to the point that she removed herself completely and approached the work as still life.

Sherman returned to posing for the *History Portraits* (1989–1990). With elaborate costumes and makeup, she created characters that resembled iconic portraits by renowned European artists. Once again, she sought to simulate rather than imitate; her references to specific paintings are suggestive rather than explicit. She created a group of contemporary, middle-aged characters for the *Hollywood/Hampton Types* (2000–2002), envisioning them as "failed or fallen actors" at a casting call. Since 2008 Sherman has used a digital camera, which allows her to make fine adjustments to her characters as she shoots. Green-screen technology has led her to use more elaborate and evocative backgrounds, and a recent series, shot in 2008 and printed on a colossal scale, presents expensively dressed older women in settings that indicate substance and privilege. The dual role as artist/model that first intrigued her remains crucial to Sherman's practice; as she has said, "I am the one who's always available and I know what I want."

1954 Born on January 19 in Glen Ridge, New Jersey
1972–1976 Studies art at the State University College at Buffalo
1975 Begins to photograph herself in character
1977 Moves to New York City; begins her *Untitled Film Stills* series
1979 Exhibits *Untitled Film Stills* at Metro Pictures in New York City
1980 Starts to work in color with rear screen projection
1981 Commissioned to create work for *Artforum*, which then refuses to publish the *Centerfolds*
1988 Commissioned by Artes Magnus to design porcelain for Limoges
1989–1990 Creates her *History Portraits* series
1995 Awarded the John D. and Catherine T. MacArthur Foundation Award
1997 Directs and cowrites the comedy-horror film *Office Killer*
2000–2002 Creates the *Hollywood/Hampton Types* series
2005 Receives the Guild Hall Academy of the Arts Lifetime Achievement Award for Visual Arts
2008 Works with digital photography

FURTHER READING
Amada Cruz, Elizabeth A. T. Smith, and Amelia Jones, *Cindy Sherman: Retrospective*, New York 1997
David Frankel (ed.), *Cindy Sherman: The Complete Untitled Film Stills*, New York 2003

Cindy Sherman, undated

1919–1933 Prohibition in the United States

1905 Constitutional revolution in Iran

1949 Premiere of Arthur Miller's
play *Death of a Salesman*

1973 First
commerci
PC

1936–1939 Spanish Civil War

1963 James Brown's breakthr
Live at the Apollo album

1890　1895　1900　1905　1910　1915　1920　1925　1930　1935　1940　1945　1950　1955　1960　1965　1970　1975

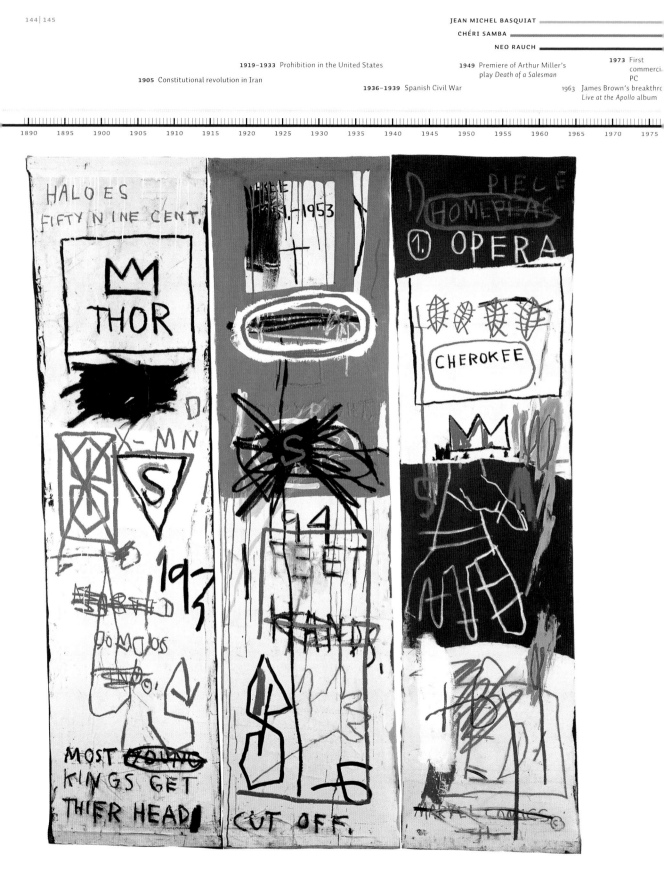

1985 Mikhail Gorbachev comes to
power in the Soviet Union

2003 Darfur conflict erupts in the Sudan

2009 Barack Obama is awarded the
Nobel Peace Prize

1994 Genocide of the Tutsis in Rwanda

| 1980 | 1985 | 1990 | 1995 | 2000 | 2005 | 2010 | 2015 | 2020 | 2025 | 2030 | 2035 | 2040 | 2045 | 2050 | 2055 | 2060 | 2065 |

JEAN-MICHEL BASQUIAT

Jean-Michel Basquiat's paintings are filled with ciphers, symbols, and scrawled cryptic texts. His images are roughly painted in thick, slapped-on strokes on an uneven ground of smeared, streaked color. He transferred his aesthetic directly from the street to the galleries in his meteoric rise from teenage tagger to international art star.

Basquiat's childhood was unsettled by his parents' divorce in 1968. His father repeatedly moved the family around the boroughs of New York City, and, for a brief time, to Puerto Rico. Back in Brooklyn in 1976, Basquiat enrolled in New York City's experimental City-as-School program, which offered internships and experience as an alternative to the confinement of the classroom. His classmate Al Diaz was already an adept graffiti artist, and together they invented a character named SAMO (an acronym for "Same Old Shit"), and used spray paint to scrawl faux philosophical proclamations— "SAMO is everything, everything is SAMO"—on walls throughout SoHo and the East Village.

In December 1978 writer Philip Faflick published a feature on SAMO in the *Village Voice*, along with a photograph of Basquiat and Diaz. Shortly after the last tag appeared, stating "SAMO is dead." By this time Basquiat had dropped out of school, broken with Diaz, and struck out on his own. He made postcards and T-shirts that merged found imagery with graffiti motifs, and he became a recognized figure among the independent musicians and filmmakers, as well as the artists, of the East Village club scene. His drawings—full of invention and energy—caught the attention of alternative gallery owners, and in 1980 his work was featured in the "Times Square Show." He gained national notice when the show was reviewed in *Art in America*.

Poet and critic René Ricard positioned Basquiat in the forefront of a new art for a new generation in the article "The Radiant Child," published in *Artforum* in December 1981. Ricard explained that Basquiat's aggressive, slapdash approach to painting was the "logical extension of what you could do with a city wall." He acknowledged the role that hype and Basquiat's image—his good looks, his punk attitude—played in his seemingly instant recognition, but dismissed it all as part of the packaging. The art—which translated the vernacular authenticity of graffiti into work that

deserved to be displayed, discussed, and collected—was the real issue. In the next two years, Basquiat's production was as prolific as his meteoric rise. He increased his scale, giving himself as much room on a canvas as on a wall. His figuration retained the naiveté of an untrained hand, but his choice of motifs—merging high-art references, iconic African Africans, and social critique—revealed the sophistication of his under-lying concepts. In 1982 Basquiat met Andy Warhol; within two years they began to collaborate. They painted and exhibited together, bringing Basquiat to the height of his fame and revitalizing Warhol's late career.

Basquiat was devastated by Warhol's death in 1987. His anguish accelerated his growing desire for isolation, and his drug use—he had experimented since his club days—spiraled out of control. After several attempts to detoxify his system, he died of an overdose of narcotics in August 1988. In the years that followed his death, the stunning arc of his career has taken on mythic proportions, often to the point that interest in his life story has obscured insight into his art. But his raw imagery remains provocative, and whether factual or fictionalized, his rapid rise to fame embodies the spirit of the New York City art world in the 1980s, when the subversive energy and the confrontational aesthetics of the street dealt the final blow to the barrier between fine art and popular culture.

1960 Born on December 22 in Brooklyn, New York
1967 Creates a children's book with a classmate from St. Ann's School
1968 His parents separate and eventually divorce
1974 Moves with his father to Mira Mar, Puerto Rico
1976 Returns with his family to Brooklyn
1977 Begins his "SAMO" collaboration with Al Diaz
1978 Leaves home
1979 Ends his SAMO collaboration
1980 Has his work featured in the "Times Square Show"
1981 Has his work reviewed by René Ricard in *Artforum*
1983 Commissioned by gallerist Bruce Bischofberger to create collaborative work with Andy Warhol and Francesco Clemente
1985 Featured on the cover of the *New York Times Magazine*
1987 Devastated by Warhol's death
1988 Dies on August 12 in New York City
1996 Release of the film *Basquiat*, directed by Julian Schnabel
2000 Release of *Downtown 81*, originally filmed in 1981 and featuring Basquiat

left page
Jean Michel Basquiat, *Charles the First*, 1982, acrylic and oil paintstick on canvas, three panels, 198.1 x 158.1 cm, Estate of Jean-Michel Basquiat, New York, courtesy Robert Miller Gallery, New York

above
Lizzie Himmel, Basquiat in Great Jones Street studio, New York, 1985

FURTHER READING
Rudy Chiappini (ed.), *Jean-Michel Basquiat*, Milan 2005
Leonhard Emmerling, *Jean-Michel Basquiat: 1960–1988*, Cologne 2003

NAM JUNE PAIK

CHRIS CUNNINGHAM

1917 United States enters World War I **1940** McDonald's founded

1905 Russian Revolution

1930 Mahatma Gandhi leads salt march **1950–1953** Korean War
in protest against British salt tax

1968 Premiere of
Stanley Kubrick
film *2001*

1890 1895 1900 1905 1910 1915 1920 1925 1930 1935 1940 1945 1950 1955 1960 1965 1970 1975

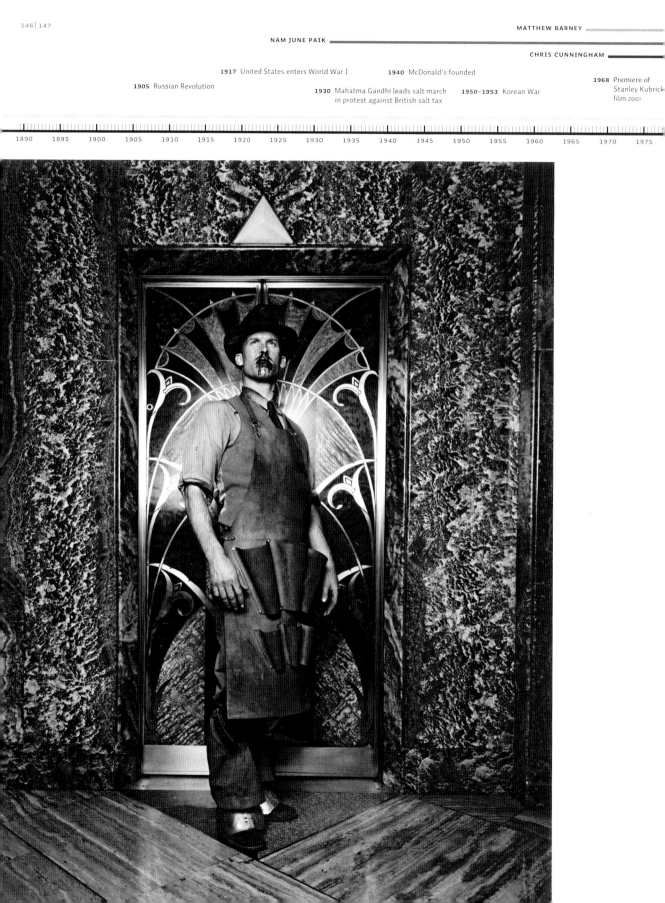

7–1980 Cindy Sherman's
Untitled Film Stills

1999 Kosovo War

1987–1993 First Intifada
in Palestine

2004 Murder of Dutch film director
Theo van Gogh

| 1980 | 1985 | 1990 | 1995 | 2000 | 2005 | 2010 | 2015 | 2020 | 2025 | 2030 | 2035 | 2040 | 2045 | 2050 | 2055 | 2060 | 2065 |

MATTHEW BARNEY

Just as an athlete pushes his strength and endurance to it limits to increase his power, so Matthew Barney embeds resistance in his artistic process. He allows his creative capacity to function like a body in training, building its potential by rising to each new challenge.

As a student artist at Yale, Barney transformed his studio into a gymnastic laboratory. He tethered his legs with elastic cords, working against this self-imposed resistance to climb a ramp and add marks to a drawing on the wall above him before the elastic snapped him back to the floor. Barney—a star athlete in high school—had devised this method as an expressive equivalent to muscular hypertrophy, the condition by which muscles pushed to the limits of performance recover with increased size and strength. He explained: "I was trying to use that process of resistance to create form." With this, he initiated his *Drawing Restraint* series (1987–present), in which he incorporates physical hindrance as a condition of his studio practice, giving greater significance to the process of making art than to the result.

His two-part video *Field Dressing* (1989), made as his senior-thesis project, caught the attention of the New York City art world. In the first part of the video, wearing only football cleats, gloves, and a bathing cap, Barney maneuvered over a bed of Vaseline while suspended in a restraint harness. In the second part, he manipulated athletic equipment while dressed in a wedding gown. Through both, he established his body as a site of questioning, bringing together the issues of physicality, sexual politics, and gender ambiguity that would shape his creative repertoire for more than a decade. His videos quickly grew in theatrical complexity and ambition, featuring characters adapted from mythology and history who played out enigmatic narratives. In *Drawing Restraint 7* (1993), two actors, transformed into satyrs with makeup and prostheses, grapple in the back of a limousine, while Barney, as a young satyr, cowers in the front.

In 1994 Barney began his *Cremaster* films, a five-part series that would occupy his imagination for nearly a decade. Each was set in a personally significant location: *Cremaster 1* (1995) in his boyhood home of Boise, Idaho; *Cremaster 2* (1999) in the Canadian Rockies, the site of a bicycle trip he took with his father as a teenager; *Cremaster 3* (2002) in Manhattan, where he moved after finishing his education; *Cremaster 4* (1994) on the Isle of Man, in honor of his ancestry; and *Cremaster 5* (1997) in Budapest, the birthplace of one of his heroes, Harry Houdini. He named the series after the muscle that controls the position of the testes. The films, extravagantly conceived in terms of costumes, cast, and production, present a visually compelling exploration of gender identity, sexual awareness, and the expressive potential of the human body. There is no linear narrative, but the saga unfolds like a grand myth. In 2002 New York City's Guggenheim Museum hosted an exhibition of every aspect of the *Cremaster* cycle, including related sculptures, drawings, and photographs, a newly created five-channel video piece, and daily screenings of all five films. Curator Nancy Spector hailed the installation as a "pentathlon."

While Barney's work shatters the barriers between objects, film, and performance, he identifies himself as a sculptor. *Drawing Restraint 9* (2005), his first collaboration with his partner, the Icelandic singer Björk, is set on the Nisshin Maru, a Japanese whaling ship. Central to his narrative, along with an enigmatic love story, is the on-deck creation of a petroleum jelly sculpture in the abstracted form of a whale. The physical challenge shifts from man to material, as Barney observes the congealing material released from the restraints of its mold.

1967 Born on March 25 in
San Francisco, California
1973 Moves with his family to Boise,
Idaho
1985 Enrolls as a pre-med student at
Yale University
1987 Begins his *Drawing Restraint*
series
1989 Graduates from Yale with a
degree in the arts; moves to
New York City
1990 Has his *Field Dressing* video
shown in New York City
1991 Featured as the cover story of
the summer issue of *Artforum*;
has a solo debut at the Gladstone
Gallery in New York City
1993 Wins the Europa 2000 prize at the
45th Venice Biennale
1994 Begins work on *The Cremaster
Cycle*, a five-part film project
2002 Completes *The Cremaster Cycle*
2005 Exhibits his *Drawing Restraint*
series at the 21st Century
Museum of Contemporary Art in
Kanazawa, Japan; releases the
film *Drawing Restraint 9*

left page
Matthew Barney, still from *Cremaster 3*, 2002

above
Matthew Barney, 2007

following double page
left
Matthew Barney, still from *Cremaster 5*, 1997

right
Matthew Barney, still from *Drawing Restraint 9*, 2005

FURTHER READING
Nancy Spector, Mark C. Taylor, and
Christian Scheidemann, *Barney/Beuys:
All in the Present Must Be Transformed*,
New York 2006
A film about Barney is *Matthew Barney:
No Restraint*, dir. Alison Chernick, 2007
The *Cremaster Cycle* can be viewed
online at: http://www.cremaster.net

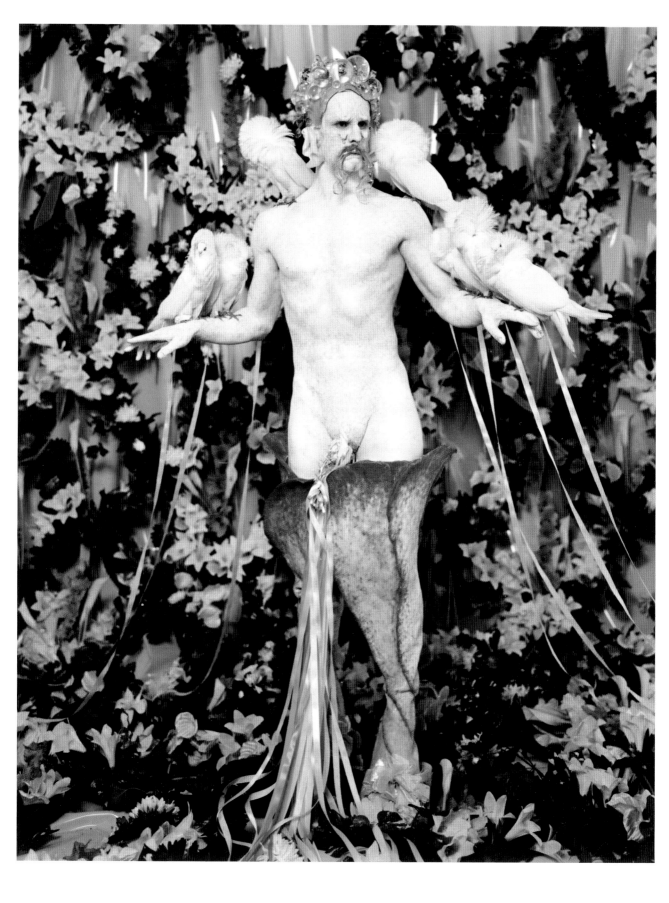

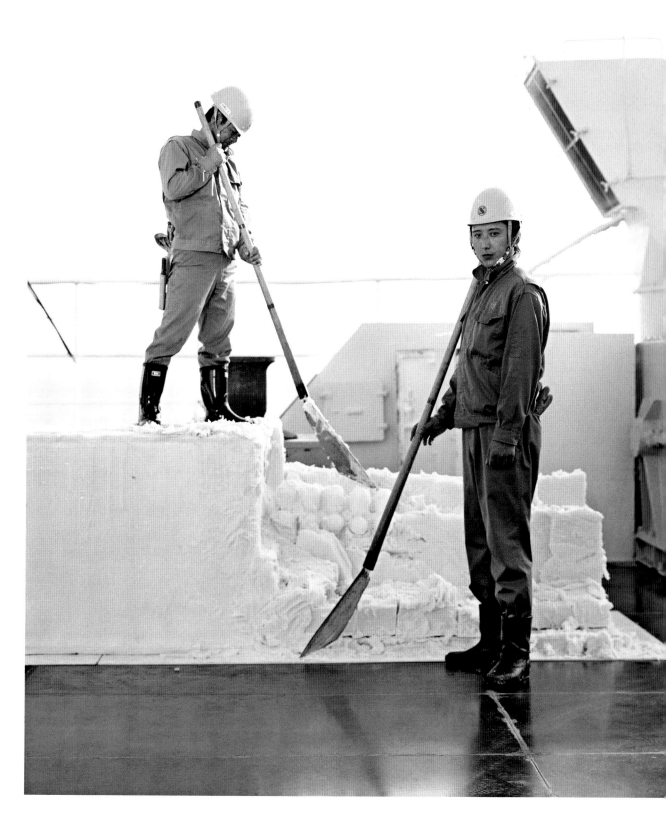

1908 First Ford Model T rolls off the
production line in Detroit

1937 Pablo Picasso
paints *Guernica*

1960–1971 Construction
of the Aswan Dam

1900 Lyman Frank Baum publishes
The Wizard of Oz

1921 Albert Einstein awarded
the Nobel Prize for Physics

1946 Founding of UNESCO

1890 1895 1900 1905 1910 1915 1920 1925 1930 1935 1940 1945 1950 1955 1960 1965 1970 1975

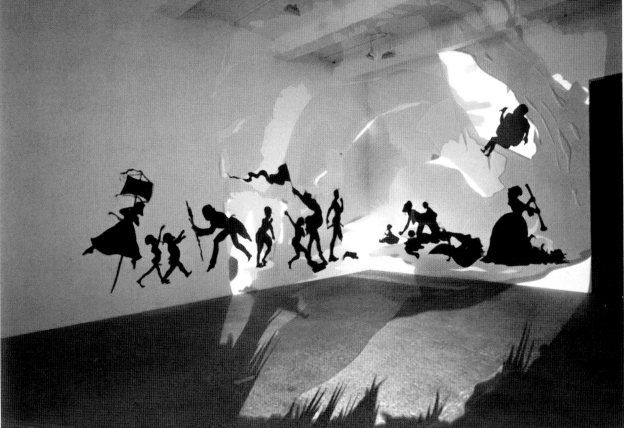

left
Kara Walker, *You Do*, 1993/94, cut paper
on canvas, 140 x 124.5 cm, Collections of
Peter Norton and Eileen Harris Norton,
Santa Monica, California

below
Kara Walker, *Darkytown Rebellion*, 2001,
cut paper and projection on wall,
4.3 x 11.3 m, Collection Musée d'Art
Moderne Grand-Duc Jean, Luxemburg

Chancellor Willy Brandt's **1990** First gene therapy
gesture of humility at on a human being
the monument to the
Warsaw Ghetto Uprising

2008 Escalation of the conflict between
Russia and Georgia in the Caucasus

2000–2005 Second Intifada in Palestine

1980 1985 1990 1995 2000 2005 2010 2015 2020 2025 2030 2035 2040 2045 2050 2055 2060 2065

KARA WALKER

Kara Walker's cut-paper figures act out jarring pantomimes of physical violence and sexual assault. She has revived the genteel medium of silhouette tableaux to depict Old South stereotypes that confront the viewer with ingrained conflicts over race and gender.

As a child Walker transformed everyday events into a cartoon strip that she worked on "all the time." Her desire to draw seemed to be second nature in an artistic household: her mother designed clothes and her father was an art professor. When Walker was eleven, the family moved from northern California to Stone Mountain, Georgia, so that her father could take a position at Georgia State University in Atlanta. Walker noticed a difference in attitude toward race in the South, and as she pursued her studies at the Atlanta College of Art and the Rhode Island School of Design, she responded to the issue of race—as well as that of gender—in her painting, absorbing the ideas that she encountered in life and translating them into her art.

In 1994 she debuted her first large-scale silhouette tableaux at the Drawing Center in New York City. *Gone: An Historical Romance of a Civil War as It Occurred Between the Dusky Thighs of One Young Negress and Her Heart* featured a cast of characters that might have originated in a nostalgic antebellum romance novel: a belle in a hoop skirt, a frock-coated gentleman, a few scrappy children, and a skinny, pigtailed young woman whom Walker identifies as "the Negress," a character she invented for herself as a guise through which she can bridge fiction and reality. The title's reference to Margaret Mitchell's iconic 1936 novel *Gone with the Wind* was deliberate. But Walker subverts the allure of the novel by unmasking the violence, sexual dominance, and deprivation that lay beneath the veneer of gentility in the antebellum South. In her hand-cut paper figures, Walker found the perfect visual analogy for racial stereotype—silhouettes are one-dimensional and "everyone is rendered black"—as well as a refined and seemingly ephemeral medium through which she could engage harsh and persistent truths.

In accord with her impeccable cut-paper technique, Walker pays close attention to detail in crafting her tales. In a process she jokingly

characterizes as "two parts research and one part paranoid hysteria," she studies costume and customs so that the worlds she creates on walls have the ring of historical truth. For inspiration she turns to historic slave narratives, historical romance fiction, and history painting. But her narrative is always her own, and she uses the beauty of her medium and the allure of epic history as subversive techniques through which she interrogates the origins—as well as the persistent influence—of American racial prejudice.

Over the years Walker has continued to experiment with scale and medium. In 2002 she installed the 89-foot- (27-meter-) long tableau *Emancipation Approximation* in the rotunda of the University of Michigan Art Museum, recalling the nineteenth-century spectacle of the cyclorama. For *Slavery! Slavery!* (2002), inspired by a traditional history painting and diorama of the Battle of Atlanta, she used opaque projectors to color the walls and incorporate the viewer's shadows into the tableau. Walker has explored other modes of narrative: film, fragments of text type on note cards, a pop-up book (*Freedom, A Fable: A Curious Interpretation of the Wit of a Negress in Troubled Times*, 1997), and a book commemorating the disastrous aftermath of Hurricane Katrina (*After the Deluge*, 2007). Her work combines beauty with bitter humor, and her interpretation merges the seduction of romantic fantasy with unflinching social critique. But ultimately, Walker is a storyteller who bears witness, saying, "We tell stories of events to allude to the unspeakable."

1969 Born on November 26 in Stockton, California
1982 Moves with her family to Stone Mountain, Georgia
1991 Receives her bachelor of arts degree from the Atlanta College of Art
1994 Receives her master in fine arts degree in painting and printmaking from the Rhode Island School of Design; exhibits her first silhouettes at the Drawing Center in New York City
1997 Becomes the youngest-ever recipient of the MacArthur Foundation "genius" grant
2001 Joins the faculty of the Columbia University School of the Arts in New York City
2002 Represents the United States in the São Paulo Bienal in Brazil
2006 Curates the exhibition "After the Deluge" at the Metropolitan Museum of Art
2007 Designs the cover for the August 23 issue of the *New Yorker* to commemorate the second anniversary of Hurricane Katrina

FURTHER READING
Annette Dixon (ed.), *Kara Walker: Pictures from Another Time*, Ann Arbor, MI, 2002
Kara Walker, *Kara Walker: After the Deluge*, New York 2007

GLOSSARY

Abstract Expressionism

The term "Abstract Expressionism" was first used in European art criticism as early as 1919 to describe the work of Vasily Kandinsky. After World War II, critics applied it to the painters of the New York School—Arshile Gorky, Willem de Kooning, Jackson Pollock, and Mark Rothko—whose abstract aesthetic stood in stark contrast to the realism of the American Regionalist style. Inspired by European Modernism and Surrealism, the Abstract Expressionists explored an automatic and even aggressive manner of applying paint that seemed to reflect an artist's psychological turmoil. In the process, they obscured and eventually obliterated the notion of representational art. Throughout the late 1940s and early 1950s, the raw intensity of these paintings attracted widespread international acclaim, effectively making New York City the new epicenter of the art world.

American Expatriate Artists

Throughout the nineteenth century, Americans went to Paris to advance their art careers and build their art collections. But the new prosperity that followed the Civil War in the United States fueled an unparalleled rise in art travel that continued until the outbreak of World War I. Aspiring artists "finished" their educations at Paris's prestigious École des Beaux-Arts, and ambitious artists sought to enhance their reputations at the Salon, the official annual exhibition. Some, including Mary Cassatt, James McNeill Whistler, and John Singer Sargent, thrived in the sophisticated art circles of Europe, and while they never repudiated their American origins, they chose to pursue their careers abroad.

The Armory Show

From February 17 to March 15, 1913, the "International Exhibition of Modern Art"

was held in New York City's 69th Regiment Armory. Organized by the Association of American Painters and Sculptors, the exhibition introduced American audiences to avant-garde Modernist art made by hundreds of European and American artists, including examples of Cubism, Fauvism, and Post-Impressionism. The show stunned viewers and critics, some of whom ridiculed bold statements in form such as Marcel Duchamp's *Nude Descending a Staircase* (1912). Despite a mixed critical reception, the show inspired many American artists to begin to experiment with Modernism.

The Chicago Imagists

The Chicago Imagists, including Ed Paschke, Roger Brown, Jim Nutt, Gladys Nilsson, and Karl Wirsum, became a defining force in the Chicago art community during the late 1960s and the 1970s. Meeting as students at the School of the Art Institute of Chicago, they began to show their work together at the city's Hyde Park Art Center. Like Pop artists, they adopted imagery from the mass media—cartoons and advertising—as well as naïve and folk art. Their colorful aesthetic, lighthearted humor, and often shocking content differentiated their work from the more austere formality and cerebral spirit of the contemporary New York City scene.

Conceptual art

"Conceptual art" has come to be a blanket term for art in which the idea behind the work is more important than the material product. This notion has its roots in the "ready-mades" of Marcel Duchamp, but it was not until the late 1960s that the philosophy developed into a large-scale movement, within which artists began rethinking traditional aesthetic concerns. In some cases they eliminated the physical art object altogether. Joseph Kosuth's landmark work *One and Three Chairs* (1965) invited the

viewer to consider the notion of "chairness" through an installation that consisted of a physical chair, a photograph of a chair, and a written definition of the word "chair." Such works repudiated the conventional formal element of art and directed the viewer's attention to its concept, giving the idea priority over the object.

The Eight

The group of artists known as The Eight portrayed the grittier aspects of early twentieth-century New York City street life. Core members, including John Sloan, William Glackens, and George Luks, began their careers as newspaper illustrators in Philadelphia, and they followed their friend Robert Henri to New York City. Their bleak and dingy aesthetic countered the genteel tone of American Impressionism. Although The Eight exhibited together only once (at the Macbeth Gallery in 1908), their approach to the urban landscape influenced painters of the next generation, including George Bellows and Edward Hopper.

The Harlem Renaissance

During the 1920s and 1930s, the New York City neighborhood of Harlem became a hub of artistic activity that gave form and voice to the African American experience. Influenced by W. E. B. Du Bois's essays on identity, the uplifting principles of the New Negro Movement, and the expanding black middle class, African American artists developed new aesthetic ideas and addressed subjects that reflected their own vision rather than the conventions of white European art. Community responsibility was a core feature of the movement, and many artists, including Aaron Douglas, Augusta Savage, and Jacob Lawrence, taught at the Harlem Art Workshop and the Harlem Community Art Center. This vital movement sparked international interest and inspired black

artists in other cities, such as Archibald J. Motley in Chicago, to take on the theme of African American life.

Hudson River School
The artists of the Hudson River School drew inspiration from the natural splendor of the Hudson River Valley in New York state. The rapid growth of nearby metropolitan areas in the early nineteenth century raised fears that the preservation of the valley was in jeopardy. Painters such as Thomas Cole and Asher B. Durand responded to this impending loss by painting Romantic landscapes, heightening the impressive vista with an idealized sense of drama. Although not a school in the institutional sense, this vision inspired a younger generation of artists, including Frederic Edwin Church and Albert Bierstadt.

Minimalism
Minimalism sought to reduce the medium of sculpture down to its purest form. Minimalist sculptors created spare, geometric objects that rejected illusionism and asserted their simple, concrete tangibility. In the 1960s the Minimalist movement was informed by Post-Painterly Abstraction as well as Minimalist music, both of which sought to reduce their aesthetic to its purest expression. Some artists, such as Donald Judd, employed a Minimalist approach to create universal statements that held no ambiguity—offering only the truth and specificity of their "object-hood." Others, like Maya Lin, used the emotional power of simplicity, as seen in her Vietnam Veterans' Memorial in Washington, D.C. (1981–1983).

Painters of the West
From the time of the earliest European settlements, artists documented the rugged landscapes and the indigenous people of the North American continent. John White,

whose watercolors offered one of the first glimpses of the "New World" to people in England, eventually became the governor of the Roanoke Colony. As the United States expanded its territory, artists ventured further west to portray the majesty of the western landscape and to document the customs of Native Americans. These images, widely circulated across the nation, as well as to Europe and beyond, shaped the idea of the "Wild West" for more than a century.

The Peale Family
In the Peale household, art was a family business. Under the influence of the patriarch Charles Willson Peale, nearly every member of the extended Peale family dabbled in some field of art, and a few of them rose to prominence. To encourage his children, Peale named several of them after famous painters, including Raphaelle Peale (1774–1825), who went on to become a renowned still-life painter; Rembrandt Peale (1778–1760), who had a highly successful career as a portrait painter; and Titian Ramsay Peale (1799–1885), a naturalist who made zoological illustrations, in addition to becoming a pioneer in the use of photo-graphy as an art medium.

Pop Art
In contrast to the formal experimentation of the artists of the New York School, Pop artists created representational imagery drawn from vernacular and consumer culture. The movement began in Great Britain, taking the name "Pop" as shorthand for "popular." The idea was quickly picked up in the United States, where the vast consumer market represented rich inspiration to artists such as Jasper Johns, Robert Rauschenberg, Roy Lichtenstein, and Andy Warhol. Nothing was considered off-limits by these artists, and they built a repertoire of familiar icons such as the American flag, comic books, and

photographs of celebrities. Their playful use of source material continues to influence such contemporary artists as Jeff Koons and Takashi Murakami.

Popular Portraiture
Until the development of photography, painted and engraved portraits documented and circulated the images of important citizens. The first President of the United States, George Washington, was repeatedly painted during his term of office (1789–1797). Some of the best-known portraits were made by Gilbert Stuart, who painted Washington at least 104 times. Among these works is an unfinished painting known as The Athenaeum Portrait (begun 1796), which would later be used for Washington's likeness on the one-dollar bill.

Post-Painterly Abstraction
Post-Painterly Abstraction developed in the late 1950s and 1960s, as many Abstract Expressionist painters began shifting away from the intensity of the visceral, painterly style of the New York School to a more serene and rational approach to constructing images. These artists concentrated on the elemental properties of painting—color and shape—to attain a greater purity in their medium. This new approach ranged from the hard-edged abstractions of Ellsworth Kelly and Frank Stella to the poured paint and stained canvases of the Color-Field painters Helen Frankenthaler, Morris Louis, and Richard Diebenkorn.

Regionalism
During the 1930s, some painters consciously rejected the influence of European Modernism and strove to develop a dis-tinctive American style. Led by Grant Wood, Thomas Hart Benton, and John Steuart Curry, the "Regionalists" advocated a realist style, narrative subjects, and an emphasis on

rural life over the urban experience. They chose accessible and affirming themes— American lore and the virtue of agricultural labor—to craft an identity that celebrated the farming states of the Midwest. Their romanticized view of America's heartland reassured a nation in the throes of the Great Depression. The popular appeal of Regionalism waned in the years following World War II, as the advent of the New York School ushered in the era of Abstract Expressionism.

Stieglitz's Modernists
Photographer Alfred Stieglitz promoted the cause of Modernist art to an American audience in the early twentieth century. His gallery "291," named for its street address at 291 Fifth Avenue in New York City, was the site of some of the first American exhibitions of avant-garde European artists, including Rodin, Cézanne, Matisse, and Picasso. At this time, many of these artists were virtually unknown outside of their home countries. "291" also featured Modernist American artists such as Arthur Dove, John Marin, and Charles Demuth, as well as Stieglitz's wife, Georgia O'Keeffe, whose art was first shown there.

The Works Progress Administration's Federal Art Project
To bolster the crippled American economy in the midst of the Great Depression, President Franklin D. Roosevelt initiated an economic recovery plan called the New Deal in 1933. It included employment opportunities for out-of-work artists. The Public Works of Art Project (PWAP), organized by the Department of the Treasury, lasted less than a year (1933–1934). It was succeeded in 1935 by the Works Progress Administration's Federal Art Project (FAP). Both the PWAP and the FAP paid artists a regular salary for producing works of art that were installed in public buildings like schools, hospitals, and libraries. The FAP employed many painters and sculptors who would later rise to prominence in their own right, including Jackson Pollock, Mark Rothko, Marsden Hartley, Paul Cadmus, and Alice Neel. In 1943 the government dismantled the program to turn financial support to the war effort.

Acknowledgments
Books are the work of many hands, and for their help I would like to thank my research assistants Vrinda Agrawal, Nika Levando, Michal Raz-Russo, Robert Samaratino, and especially Dylan Rabe for his contributions to the list and the boxes. Thanks as well to Brandon Ruud, Kristan Hanson, and Holly Stec Dankert for sharing their insights and expertise. I have truly appreciated the skill, support, and patience of Laura J. Hensley for editing the text, and of Claudia Stäuble and Andrea Weißenbach for managing the project. Last but certainly not least, I want to thank Chris Lyon for conceiving the project and bringing me on board.

Debra N. Mancoff, December 2009

PHOTO CREDITS

The illustrations in this publication have been kindly provided by the museums, institutions and archives mentioned in the captions, or taken from the Publisher's archives, with the exception of the following:

Akg-images, Berlin: p. 123
Akg-images/Tony Vaccaro: p. 95
Art Institute of Chicago: pp. 40, 50, 68/69, 76
Artothek/Peter Willi: p. 98
Estate of Romare Bearden: p. 105
David Berglund: p. 79
Louise Bourgeois Archive: p. 100
Bridgeman: p. 122
Samuel Brody: p. 89
Christopher Burke: pp. 102, 103
CNAC/MNAM/Dist. RMN/Droits réservés: p. 87
Courtesy Gladstone Gallery, New York: pp. 146 (Chris Winget), 148 (Michael James O'Brien), 149 (Chris Winget)
Gianfranco Gorgoni: p. 130

Lizzie Himmel: p. 145
Courtesy of the artist and Metro Pictures: pp. 142, 143
National Gallery of Art, Washington: p. 14
Joseph Painter, Courtesy Fleisher/Ollman Gallery, Philadelphia
Robert Petersen: p. 115
John Reed: p. 107
Rafa Rivas/AFP/Getty Images: p. 132
Dieter Schwerdtle: p. 133
Courtesy of the artist and Sikkema Jenkins & Co.: p. 150
Scott Wintrow/Getty Images: p. 141
Yale University Art Gallery: p. 66
Courtesy David Zwirner, New York/The Estate of Alice Neel: p. 88

INDEX